The Photographs of Terry Evans

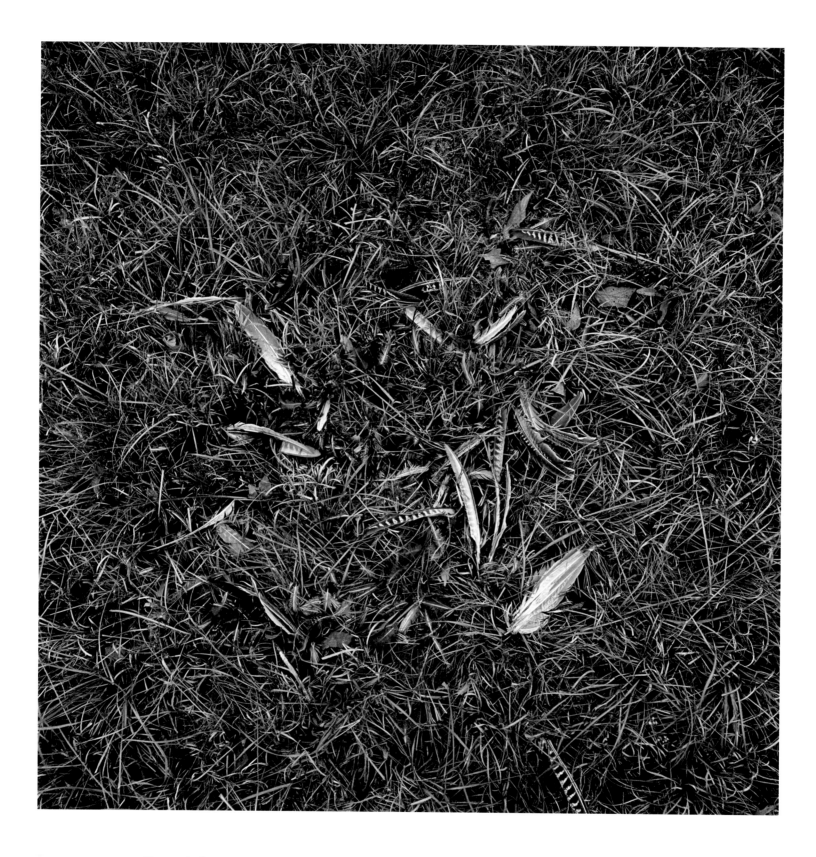

FRONTISPIECE *Pheasant feathers, Fent's Prairie*, November 11, 1978.
Gelatin silver print. Collection of the artist.

HEARTLAND

The Photographs of Terry Evans

KEITH F. DAVIS

JANE L. ASPINWALL

APRIL M. WATSON

with contributions by
Kaitlyn Bunch and Terry Evans

Director's Foreword by
Julián Zugazagoitia

Hall Family Foundation
in association with
The Nelson-Atkins Museum of Art

Distributed by Yale University Press
New Haven and London

This volume is one in a series based on the Hallmark Photographic Collection at The Nelson-Atkins Museum of Art. Previous titles, all distributed by Yale University Press, include *The Origins of American Photography, 1839–1885: From Daguerreotype to Dry-Plate* (2007); *The Photographs of Homer Page; The Guggenheim Year: New York, 1949–50* (2009); *Timothy H. O'Sullivan: The King Survey Photographs* (2011); and *The Photographs of Ray K. Metzker* (2012).

Financial support for this publication has been provided by the Hall Family Foundation; the Mellon-Frick-Rothschild Publication Fund, The Nelson-Atkins Museum of Art; Molly McGee in honor of Dale and Norman Hoyt, and Margaret and Frank McGee; and Swiss Re.

HEARTLAND: *The Photographs of Terry Evans*

Published to accompany an exhibition of the same name at The Nelson-Atkins Museum of Art, Kansas City, Missouri, October 20, 2012–January 20, 2013.

Unless otherwise noted, all photographs reproduced in this volume are by Terry Evans, American (b. 1944), and held in the collection of The Nelson-Atkins Museum of Art.

COVER: *Train north of Matfield Green, Chase County, Kansas,* July 2009

ISBN: 978-0-300-19075-5

Library of Congress Control Number: 2012943877

Writings and Photographs by Terry Evans © 2012 Terry Evans

Hall Family Foundation
P.O. Box 419580, MD 323
Kansas City, Missouri 64141-6580
www.hallfamilyfoundation.org

The
Nelson-Atkins
Museum
of Art

4525 Oak Street
Kansas City, Missouri 64111
www.nelson-atkins.org

Distributed by
Yale University Press
302 Temple Street
P.O. Box 209040
New Haven, Connecticut 06520-9040
www.yalebooks.com/art

Contents

Director's Foreword

JULIÁN ZUGAZAGOITIA

Menefee D. and Mary Louise Blackwell Director / CEO
The Nelson-Atkins Museum of Art

Terry Evans is one of the nation's finest landscape photographers, widely recognized for her studies of the land and people of the Midwest. Her photographs have been collected by many major museums and have been reproduced in numerous books and catalogues. We are proud to note, however, that this project marks her first true career retrospective—the first full look at her forty-year achievement with the camera. The result, we think, will both impress and surprise our viewers. Many know something of her photographs—one or two individual series, perhaps—but few have grasped the remarkable depth and range of her life's work. This project aims to document and celebrate that rich achievement.

Evans's pictures encourage us to see what is right around us—the Midwest prairie and its inhabitants—with new eyes and new understanding. A number of other artists have tackled this challenging subject, but none have worked as hard or succeeded as consistently as Evans. Her photographs honor the part of the world we inhabit. She sees this land as beautiful, subtle, and sustaining, while its inhabitants are represented as generous and enduring. However, while her photographs celebrate the virtues of our land and people, they contain a strong note of caution and concern. Her work suggests that nothing should be taken for granted and that human actions have profound and lasting consequences. Evans's pictures remind us that the land is at once the source of our sustenance and a record of our past—and that our treatment of it is, ultimately, an ethical matter.

While this retrospective is merited by the significance of Evans's achievement, we note with pleasure that she is a hometown success story. Born and raised in Kansas City, Missouri, Evans's formative art experiences took place at The Nelson-Atkins Museum of Art. As a child, her Saturday morning art classes at the museum provided the foundation for a lifelong commitment to art. This museum continued to serve as a key resource for her through high school, during her undergraduate studies at the University of Kansas, and up to the present.

In part, then, this celebration of Evans's career underscores the life-changing impact of art itself. Nearly all of us can remember our first "Ah ha!" experience in a great museum—the moment when *something changed*, and we began to think and care about art in a new way. For some, that experience may have happened at the Louvre in Paris, the Prado in Madrid, or the Museum of Modern Art in New York. We need to remember that these transformative moments often happen closer to home—and that this museum has been providing them to Kansas City residents and visitors for nearly eighty years.

Terry Evans's story reminds us that future artists are a critical part of our audience. Art grows organically from its own history, from its own resources and traditions. Every generation of artists has been inspired and challenged by the legacy of the past. In fact, few cultural "conversations" could be more important: the creative dialogue of today's viewers with the achievement of the distant and more recent past. And that, of course, is precisely what a great art museum encourages. In this way, in fact, *all* art has a "contemporary" element. Every work is new when seen for the first time, and every one carries the potential to change minds and lives. Nothing would please us more than to be able to write these same words again in fifty years for the retrospective of an artist who remembered the inspiration, as a child, of seeing Terry Evans's work at the museum in 2012.

This book, and the accompanying exhibition, are part of an important program derived from the Hallmark Photographic Collection at The Nelson-Atkins Museum of Art. The Hallmark Photographic Collection was begun in 1964 with a large acquisition of work by Harry Callahan. This collection grew steadily over the years and was seen widely in original publications and traveling exhibitions. By the end of 2005, when it was generously transferred to the museum, the Hallmark collection had grown to a total of 6,500 works by 900 artists. Since the opening of the museum's new Bloch Building in June 2007—with its dedicated photography galleries—this collection has provided the foundation for one of the nation's most active photography programs.

Like Terry Evans herself, this project is very much "home grown." It was conceived and organized by the staff of our photography department: senior curator Keith F. Davis, and associate curators April M. Watson and Jane L. Aspinwall. And, as always, essential support for acquisitions and the production of this volume was provided by the Hall Family Foundation. In addition, of course, the quality of this book and exhibition reflect the talents of our museum staff. In the department of photography, invaluable help was provided by project assistant Kaitlyn Bunch; department coordinator Natalie Boten; and collections coordinator Tara Brungardt. Deep thanks also go to Cindy Cart, curator of exhibitions management, and to the members of the other departments that contributed to this project, including Conservation and Collections Management, Registration, Imaging Services, Curatorial, Presentation, Education, Membership, and the Spencer Art Reference Library.

This project could never have happened without the help and support of a number of generous friends and patrons. First, of course, we deeply appreciate Terry Evans's enthusiasm for this project and her gift to the museum of a number of her prints. Very special thanks go to Molly McGee, for her generous contribution toward this publication in honor of Terry Evans's parents, Dale and Norman Hoyt, and her own parents, Margaret and Frank McGee. We are additionally grateful to Swiss Re for their support for both book and exhibition. At Swiss Re's global headquarters, in Zurich, we thank Mr. Andre Pfanner for his enthusiasm for our photography program and for his ongoing partnership with the museum. For other gifts of Terry Evans's prints, our sincere thanks go to Jeanne and Richard S. Press and Ralph and Nancy Segall; Jeffrey Hantover, Mee-Seen Loong, and Lixian Hantover; and the members of the museum's Photography Society. For additional support of this exhibition, we thank the Mildred and Rolland Middlekauff Foundation; William M. Lyons; and Michael Michaelis. And, for their generous loan of a key work to this exhibition, we also thank Elizabeth and Marc F. Wilson. We are enormously grateful for all these expressions of confidence and support.

We once again thank our distributor, Yale University Press, and our copublisher, the Hall Family Foundation, for their partnership on this project. We remain enormously grateful for the Hall Family Foundation's ongoing support for this museum, and for the art of photography in particular. Our deep thanks go to the Hall Family Foundation's Board of Directors and, specifically, to Donald J. Hall and William A. Hall, for their confidence and support.

Preface and Acknowledgments

KEITH F. DAVIS

Senior Curator of Photography
The Nelson-Atkins Museum of Art

Terry Evans's photographs not only depict the Midwest prairie; in some important respects, they are analogous to it. At once vast and subtle, this landscape is a rich ecological fabric shaped by at least a century and a half of human habitation. The prairie may look "simple" to casual observers, but that is far from true. It is an enormously rich and complex terrain —an open book of surprises and pleasures for viewers with the patience and curiosity to seek them.

The Midwest prairie has long been underappreciated. The very definition of "fly-over country," it is for many either too familiar or too plain to be considered genuinely notable. Is it really any surprise that Ansel Adams, the most popularly renowned American landscape photographer of the twentieth century, never recorded the prairie? Why, one might ask, would he have forsaken the nearly baroque drama of Yosemite and the Sierra Nevada for the seemingly uneventful sameness of the Great Plains? Correspondingly, it is probably to be expected that our generic mental image of the American landscape is more often of spaces we admire from afar than of the one that sustains us and, for so many, serves as home.

As a scenic wonder, the prairie cannot compete with Yosemite Valley, the Grand Canyon, or the Big Sur coast. The prairie is quieter, more subtle and elusive. It is not a subject distinguished by large-scale visual "events"; instead, it provides an encompassing and inclusive experience. The prairie is a finely textured *environment* —an intricate union of land and sky, flora and fauna, topography and ecosystem. Most important, it represents a synthesis of nature and culture: an unmistakable intersection of the world we have been given and the one we have made. The state of that union tells us a great deal about ourselves—more, in fact, than some might care to know. Thus, while Yosemite represents an ideal of nature's spectacle, the prairie cannot be understood apart from cultural history: it is at once the stage for, and a product of, the human experience.

For all these reasons, some may have trouble considering the prairie as "landscape" at all—at least in the honorific way this term is often used. At its simplest, "landscape" denotes an ideal, aesthetically coherent and pleasing vista. Views deemed dramatic and beautiful easily lend themselves to the traditional artistic categories of the sublime and the picturesque. However, these European conceptual templates could never be comfortably matched to the reality of the North American prairie. At once too minimal and too vast, the prairie seemed to defy either adequate journalistic description or artistic representation. The reasons are straightforward: it is almost always easier to render the dramatic and the exotic than the subtle and the familiar.

These difficulties make Terry Evans's devotion to the landscape of the Midwest all the more admirable. The prairie is an inherently—perhaps even uniquely—challenging subject. It takes real time and insight to understand its complexity: the prairie reveals itself slowly, even to its most attentive and sympathetic investigators. In truth, the prairie demands new modes of seeing and thinking—a perceptual attention learned only

from the actual experience of the place. Terry Evans has that quality of attention. She developed it through years of thought and careful study of the prairie, and it informs everything she does as an artist.

Evans took up photography roughly forty years ago and has enjoyed a national reputation for at least the last thirty. Her work has been widely exhibited, published, and collected. However, no single exhibition until this one has attempted to survey the full range of her achievement—to bring the complete scope of her career into focus. The pleasant challenge of this task stems from the sheer range and depth of her work. While best known for her landscapes, Evans is also a brilliant portraitist. She has recorded every conceivable facet of the Midwest prairie, but has also made sustained explorations of other subjects: natural history museum specimens, the city of Chicago, the steel industry, Greenland, and more. The beauty of her work lies, in part, in the way these thematic threads combine to form a seamless artistic fabric. However divergent they may be, these varied subjects are united by the depth of Evans's curiosity and the quality of her imagination.

Like the Midwest landscape itself, Evans's photographs are at once straightforward and richly complex, familiar and endlessly surprising. They accomplish a daunting artistic task: allowing us to discover the beauty and the importance of things we thought we already knew. Through her eyes, the commonplace is made remarkable, the simplest subjects are revealed as emblematic of larger forces and processes. In her many years of devoted work, Evans has perfected the art of looking carefully, and clearly, at the things that truly matter. Her photographs encourage us to do the same.

The present volume explores Evans's career with, we sincerely hope, an appropriate sense of care and accuracy. Key selections from all of her major series are reproduced here. We have made this selection as current as possible: it includes several photographs taken only a few months ago. Evans shows no sign of slowing down, and she is certain to make important pictures for years to come. Nevertheless, we hope this volume provides a compelling overview of this enormously rich and important forty-year span of her career.

Our texts aim to illuminate several key facets of Evans's life and work. My essay explores her development as an artist, beginning with her early family life and her childhood interest in drawing. It traces her photographic career from her first social documentary efforts to her discovery of the landscape and all that has followed. Jane L. Aspinwall's text provides a sense of historical and artistic context by examining previous depictions of the prairie by writers, painters, and photographers. The prairie is notoriously difficult to represent in an original and compelling way; thus, the real success of Evans's work is only emphasized by the best efforts of those who have preceded her. April M. Watson's essay focuses on the importance of vantage point in Evans's work—specifically, the way the aerial view has both informed and expanded her understanding of the prairie's complexity. The plates composing the heart of this volume

are arranged in roughly chronological sequence, with individual projects delineated and introduced by brief descriptive texts. Kaitlyn Bunch's chronology provides an overview of Evans's career, with data on life events, trips, projects, publications, and exhibitions not mentioned in the other texts. This chronicle illuminates a fertile intersection in Evans's career: the dual importance of her own interests and instincts, and the influence of key friends and associates. Finally, we have asked Evans herself to compose a personal bibliography: a list of books that have been of lasting importance to her. This list is a succinct form of intellectual autobiography, a compilation of the works, thinkers, and images that have shaped and clarified her creative thought.

This volume is published to accompany an important exhibition at The Nelson-Atkins Museum of Art. All the works included in that exhibition are reproduced here. However, in an effort to use the form of the artist's monograph to best advantage, we have also included a number of works not in the exhibition. We trust that this book builds logically on the artist's previous monographs while providing a broader perspective that illuminates the fundamental creative logic of her work.

Many people have made essential contributions to this book. First, we thank Terry Evans not only for her wonderful work but also for her patient and enthusiastic assistance. We also thank her most loyal supporters: her husband Sam, son David, and daughter Corey. Evans's artistic journey has been a long one, and these three have been with her every step of the way. Evans was born and raised in Kansas City, Missouri, and we are proud that this project celebrates "home grown" talent. It is, in fact, the first major survey of a contemporary artist of regional origin by our photography department. The concept and scope of both the exhibition and this book were determined collectively by the photography department curatorial staff—April M. Watson, Jane L. Aspinwall, and me—with the invaluable collaboration of project assistant Kaitlyn Bunch. We also thank our department coordinator, Natalie Boten, and collections coordinator, Tara Brungardt, for help throughout the course of this effort. For their memories of the history surveyed in this volume, and related help, our sincere thanks go to Terry Evans's friends and associates James Enyeart, Thomas W. Southall, Saralyn Reece Hardy, Patricia McDonnell, John M. Simpson, Lawrence McFarland, and Larry Schwarm.

We strongly second our director's thanks to the friends and patrons who have made this project possible: the support of Swiss Re and Mr. Andre Pfanner; Molly McGee's generous gift in honor of Dale and Norman Hoyt, and Margaret and Frank McGee; the Mildred and Rolland Middlekauff Foundation; William M. Lyons; and Michael Michaelis. For their generosity in adding most of the photographs illustrated here to our holdings, our deep thanks go to Terry Evans; the Hall Family Foundation; Jeanne and Richard S. Press and Ralph and Nancy Segall; and Jeffrey Hantover, Mee-Seen Loong, and Lixian Hantover; and the members of our Photography

Society. We also appreciate the help and generosity of the artist's representatives: John O'Brien and the Dolphin Gallery, Kansas City; and the Catherine Edelman Gallery, Chicago. In addition, we thank Elizabeth and Marc F. Wilson for their loan of one key work to the exhibition.

For assistance with photography and imaging, we thank our superb Nelson-Atkins staff: Mona Vassos, coordinator, Imaging Services; John Lamberton, photographer; Lou Meluso, head, Imaging Services; Zak Meek, assistant, Visual Resources; and Stacey Sherman, senior coordinator, Rights & Reproductions. Thanks, too, to Aron Gent, of Document, Chicago, for digital files of works from the artist's studio. For images outside our own collection, we thank Kathy Lafferty, Spencer Research Library, University of Kansas, Lawrence, KS; Heidi S. Raatz, Minneapolis Institute of Arts; Jackie Burns, The J. Paul Getty Museum, Los Angeles, CA; Richard Sorensen, Smithsonian American Art Museum, Washington, D.C.; Bruce Bradley, Linda Hall Library of Science, Engineering & Technology, Kansas City, MO; Linda Hein, Nebraska State Historical Society, Lincoln, NE; and John M. Simpson, Kansas City, MO. For copyright permissions, we thank Lucie Amour, VAGA, New York, NY; Tammy Carter, Center for Creative Photography, Tucson, AZ; Carousel Research, New York, NY; and Richard Grant, The Richard Diebenkorn Foundation.

Every department of the Nelson-Atkins made a contribution to this project. We thank Bret Gottschall and Mark Milani, of the preparation department; Michele Boeckholt, Susan Patterson, and Amanda Ramirez, of our superb design team; and Judy Koke, Adam Johnson, Rose May, and Rosie Riordan, in education. Our special thanks to director Julián Zugazagoitia, for his foreword and his ongoing guidance; Karen Christiansen, chief operating officer; Cindy Cart, curator exhibitions management; Allison Stevens, Julie Mattsson, and Christine Droll, registration; John Hamann, of the museum's bookstore; and Marilyn Carbonell and Roberta Wagener, of the Spencer Art Reference Library.

This book is the result of a superbly talented production team. Thomas Palmer, Newport, R.I., produced the black-and-white tritone separations and oversaw the presswork; Malcolm Grear Designers, Providence, R.I., designed the volume; and it was produced by Meridian Printing, East Greenwich, R.I. Special thanks go to Thomas Palmer, Pat Appleton of Malcolm Grear Designers, and Daniel Frank at Meridian for their care and attention. Thanks, too, to Liz Smith, Durham, N.C., for her efficient editorial work, and to Terry Evans and Trish Davis for their comments on various portions of the text. Finally, we thank our distribution partner, Yale University Press, and particularly Patricia M. Fidler, publisher, art and architecture, and Lindsay Toland, art book publishing coordinator, for their enthusiasm for this project.

Finally, as always, the generosity of the Hall Family Foundation is very deeply appreciated. For their ongoing support of this program, we offer sincere thanks to Terri R. Maybee, director; William A. Hall, president; and Donald J. Hall, chairman.

FIG. 1 *Path to the ice fjord leading to the mouth of Jakobshavn Glacier* (detail), June 26, 2008, morning. Inkjet print. Collection of the artist.

Terry Evans and the Art of Landscape Photography

BY KEITH F. DAVIS

On March 18, 1968, Robert F. Kennedy changed Terry Evans's life.

Just two days earlier, Kennedy had announced his candidacy for the 1968 presidential race. This was a bold and controversial move—he was challenging, and thus repudiating, Lyndon B. Johnson, a fellow Democrat and his brother John's former vice president. Johnson had assumed the presidency with a broad mandate of support on November 22, 1963, and easily won reelection in 1964 on a platform of civil rights and a national "war on poverty." By the first months of 1968, however, he felt besieged on all sides. The urban riots of 1967 had cast a pall over his domestic programs, and the Vietnam War had become a bitterly divisive issue.

Kennedy announced his candidacy on Saturday, March 16, jumping immediately into a national campaign.[1] Because of a speaking commitment set months before, his first full day of campaigning, Monday, March 18, would be in Kansas. In the morning he addressed a crowd of 14,500 at Kansas State University, in Manhattan. Tentative at first, Kennedy drew energy from the audience and finished to thunderous applause. That afternoon's appearance at the University of Kansas, in Lawrence, was even more electric. Energized by a crowd of nearly 20,000 in Allen Fieldhouse, Kennedy gave a rousing speech. One reporter described the scene as "emotion beyond reason, cheering until saliva ran, clapping until hands hurt."[2]

Kennedy suggested a grand vision of a new and better world. He stressed the vital importance of idealism and activism; the greater cause, he said, involved nothing less than "the national soul of the United States."[3] He spoke of the problems of racial relations, the crisis of America's cities, and, especially, the plight of the poor—"the disgrace of this other America." As he outlined these problems, Kennedy's repeated refrain was "we can do better." These words were at once cautiously realistic and radiantly optimistic. The "we" was important: Kennedy gave voice to widely shared questions and stressed that the answers could be found only in collective values and actions. At the end of his remarks, he cited George Bernard Shaw: "Some people see things as they are and say, 'why?' I dream things that never were and say, 'why not?'"

It was a powerful message, radical in ambition and populist in its commonsense simplicity. Kennedy called on America's youth to change the destiny of their country. The overlap of the personal and the political was implicit: the quality of individual lives had everything to do with the collective life of the nation. Every attempt to "do better"—every act of compassion, generosity, and concern, no matter how small—would make a difference. And as citizens became better educated, more altruistic, and more creative, a better society would arise, as rich in spirit as in material things.

The deaths of Martin Luther King Jr., on April 4, and of Kennedy himself, on June 6, shocked the nation, derailing any dream of rapid change. This was a violent and momentous year, a period in which the nation seemed to be tearing itself apart—or struggling to be born anew. Despite the death and disappointment, something enduring was born in 1968: ideas that changed lives. Hopes for a better world were chastened and tempered, but not abandoned. Instead, grand ideals were reduced in size, made more personal and pragmatic.

Terry Evans was primed for this encounter with Robert Kennedy. She was more devoted to progressive ideas than to him, specifically, as a

candidate. Nevertheless, Kennedy helped clarify her thinking; his words lent urgency and importance to the ideas of personal commitment and social justice that she had been grappling with. Further, in the most specific way possible, that day in Allen Fieldhouse changed everything: Bobby Kennedy made Terry Evans a photographer.

A Young Artist

Terry Jo Hoyt Evans is a product of the Midwest. Her father, Norman Hoyt, grew up poor in Lake Taneycomo, Missouri. He finished high school in Minnesota, where he lived with relatives, before coming to Kansas City, Missouri, to work as an accountant for a gas service company. Her mother, Dale Larson, was born and raised in Bucklin, Missouri. Dale's parents were fixtures in their community: her father served as postmaster and the two ran the town's funeral home for many years. Dale's mother was resourceful and artistic, using her sewing skills to make beautiful things—quilts, dolls, rugs, teddy bears—for family and friends. After high school, Dale moved to Kansas City and worked in a jewelry store in Union Station, the city's main train depot.

Norman and Dale met at a church picnic and were married in 1940. Their first daughter, Terry Jo, was born in 1944, followed by their second, Sandy, in 1948. Terry recalls a nearly idyllic childhood. The Hoyt household was warm and nurturing, with an emphasis on family, church, community affairs, and the arts.

Terry loved visiting her maternal grandparents in Bucklin. She embraced the small-town atmosphere—the charms of the soda fountain and other old shops on Main Street. More than this, however, she sensed the importance of the town's social fabric—the familial and business relationships, the friendships and simple social graces that made the community vital and welcoming.

These relationships informed her appreciation for her grandparents' funeral home business. She remembers watching her grandmother preparing bodies for wakes. There was nothing frightening about this activity; instead, she viewed it as an expression of compassion and respect. These inert bodies were the remains of people with very specific names and histories—people who had been loved and who would be long remembered. The funeral home normalized the idea of death by weaving it into the sustaining texture of communal life. Death carried profound sadness but not horror, since it was an inescapable part of the cycle of nature. These were potent lessons for a thoughtful child—a suggestion,

FIG. 2 *Terry's father, Norman Hoyt, at Loose Park, Kansas City, Missouri,* 1948. Gelatin silver print (printed 1970s). Gift of the artist, 2012.18.9.

on one hand, of the fundamental rhythms of the organic world and, on the other, of the majesty and frailty of every life.

Creativity and the arts were highly valued in the Hoyt household. Dale Hoyt loved music and often played the piano at home. This ability was passed to Sandy, who became a talented singer. Norman's interest in the visual arts was taken up by the couple's older daughter.

Some of Terry's fondest childhood memories were formed at the Nelson Gallery (now The Nelson-Atkins Museum of Art), in Kansas City. She loved to draw, and as a schoolchild she was encouraged by her parents to take Saturday-morning classes at the Nelson. She was awed by the museum's size and by the range of works on view, from a great Buddha figure with glass eyes to Chinese scroll paintings, painted miniatures, and boldly contemporary paintings. She learned to look carefully at pictures. After an art teacher explained that Renaissance painters used a base layer of green to give flesh tones more depth, she searched for hints of that color in Old Master faces. The museum was a realm of grandeur and mystery, a place of contemplation and discovery removed from the concerns of the

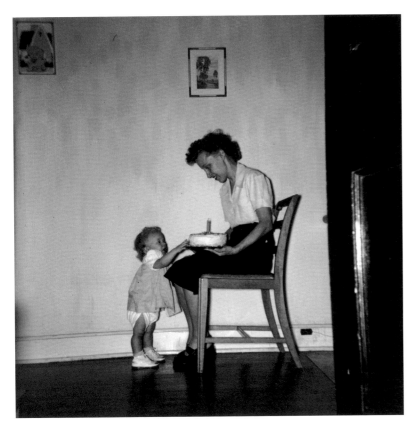

FIG. 3 *Terry's mother, Dale Hoyt, and sister, Sandy, at home, Kansas City, Missouri,* 1949. Gelatin silver print (printed 1970s). Gift of the artist, 2012.18.10.

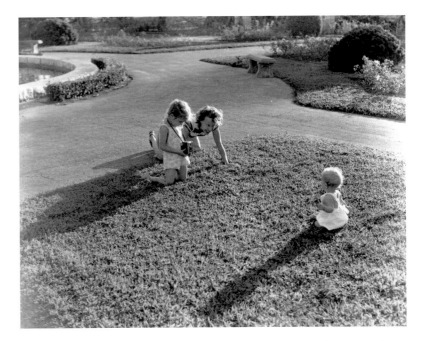

FIG. 4 Norman Hoyt, American (1914–2001). *Mom, Terry with camera, and sister, Sandy, at Loose Park, Kansas City, Missouri,* 1948. Gelatin silver print (printed 1970s). Gift of Terry Evans, 2012.18.11.

everyday world. It was also liberating: it inspired and validated her own youthful passion for picture making, exploration, and self-expression.

Terry's interest in pictures dominated her childhood and adolescent years. She was always drawing, with whatever was at hand. For example, she enjoyed visiting an elderly neighbor who lived in the same apartment building as the Hoyts. This neighbor had a front apartment with an open-air porch, and Terry loved making "drawings" in water on the weatherproofed wood floor. This interest in picture making also included some activity with a camera. Terry's parents gave her a simple camera when she was four, and she used this to make charming family snapshots [FIGS. 2–3]. These childhood images are emblems of value: records of the people and situations of greatest importance to her.

Terry's first photographs were powerfully motivated by her father's example. Norman Hoyt photographed his growing family [FIG. 4] and worked as an avid amateur through her childhood. Terry remembers accompanying him on photographic quests for "scenery" on the outskirts of the city. Photography had long been a central thread in Norman

Hoyt's life. Beginning in 1930, when he was sixteen, he had photographs published in the weekly rotogravure supplements—such as *Mid-Week Pictorial*—to major newspapers in St. Paul, Denver, St. Louis, and other cities. Between 1930 and about 1935, he had many images of animals and landscapes accepted for publication. Mechanically inclined, he also rigged cameras so that inquisitive animals would trip a taut string to take their own pictures. He explored close-up photography, producing quasi-abstract studies of such everyday forms as the holes of a salt shaker, the grooved edges of coins, and the bristles of a hairbrush. He even wrote articles for popular magazines on these subjects, including a three-part introduction to close-up work titled "Trick Photos" for *Everyday Science and Mechanics*; "Nature and Wild Life," in *American Photography*; and "How I Make Money [in Photography]," for *Boys' Life*.[4] In later years, he sold scenic Kodachrome transparencies to the Eastman Kodak Company and to a local calendar manufacturer.

This talent prompted Norman Hoyt to supplement the income from his office job with a weekend photographic business. Beginning in

1947, he established a freelance wedding photography practice. As this business prospered, it became a family enterprise. In about 1958, when Terry was in eighth grade, her father left his accounting job to become a full-time professional portrait photographer. Working in close partnership, her parents established Norman Hoyt Photography in a storefront at Sixty-Third and Brookside, in Kansas City. Norman, the more introverted of the pair, specialized in the artistic work of taking the photographs and the craft of the darkroom. His more outgoing wife was the public face of the business—she greeted customers and arranged the details of each sitting. She also became adept at the oil coloring of portraits.

This was an explicitly people-oriented business. In addition to individual, family, and wedding portraits, the pair developed a further specialization in high school class portraits, and fraternity and church groups. Like the work of Dale's parents, this business lay at the heart of its community: it commemorated and honored life's most important milestones.

Through high school, Terry worked at the portrait studio during the summer and at other busy times of the year. However, this experience did not instill any special interest in the medium—in part, of course, because photography represented both the domain of her parents and *work*. Thus, she remained devoted to drawing and painting throughout her years at Southwest High School. There, she had a talented and inspiring teacher in Ruth Beck. Beck believed in art as a serious endeavor and provided unwavering support. She entered Terry's work in the Scholastic Art Awards competitions, and many years later she sent her a warm note of congratulations on the publication of Evan's first prairie book. One of Beck's most important lessons involved the perception and rendition of light. In the course of outdoor watercolor sessions, Beck encouraged her students to study patterns of sunlight and shade in order to build their watercolors around those relationships.[5]

After high school, Terry delayed going to college to spend a year in Europe. Her parents had always been eager to learn about the world and participated in the student foreign exchange program: in Terry's senior year in high school, the family hosted an exchange student from Chile. Within a month of graduation, Terry began her year abroad. From the summer of 1962 to the summer of 1963, she lived with a family in Heilbronn, a medium-sized city in southern Germany. This year fostered enormous intellectual growth. It opened her eyes to the rich diversity of global cultures, prodding her to think about her own country in a new way. The result was a deeper sense of what it meant to be an American, and a more critical view of the tension between national ideals and social realities.

Terry entered the University of Kansas, in Lawrence, in the fall of 1963. She began in a liberal arts program, but soon decided to major in art. Her favorite class that first semester was an introduction to art history, team-taught by the department's faculty. Each section was led by a professor with deep expertise, and the result was inspiring. She continued to take art history courses throughout her studies, even as she devoted most of her time to drawing and painting. In deference to her parents' practical concerns, she completed a double major in painting and commercial art. This required a total of five years of classes, and she graduated in the summer of 1968.

Terry particularly loved the painting and life drawing classes taught by Peter Thompson. Thompson had studied in the 1950s with painter Al Held, and he would later become dean of the University of Kansas (KU) fine art program. Only a few years out of graduate school, Thompson was a superb teacher and role model—at once practical and theoretical, and always encouraging. The lessons he imparted about the dynamics of visual space were especially memorable: the challenge of translating the three dimensions of worldly experience onto the two dimensions of a canvas or sheet of paper. Terry also remembers lengthy philosophical conversations with him about the nature of art and what it meant to be an artist.

This was a time of profound questioning and searching. While her year in Germany had significantly broadened her outlook, Evans remained a curious and thoughtful student, still maturing intellectually and artistically. Her private journal entries of 1966 to 1968 document an earnest philosophical quest, with brief quotes by a variety of writers, musicians, filmmakers, artists, and political leaders.[6] These quotations center on the need to see and to think in new ways—a quest for new truths appropriate to the challenge of contemporary life.

In this period, Evans looked to a variety of art-historical models for inspiration. She admired highly gestural and intuitive artists such as Arshile Gorky, Jackson Pollock, and Willem de Kooning, as well as the cool geometric clarity of Josef Albers and Ellsworth Kelly. The exquisite interiors of the seventeenth-century Dutch artist Johannes Vermeer and the contemporary work of the California painter Richard Diebenkorn, both introduced to her by Thompson, were also instructive. From Vermeer, she learned about formal structure—the basic architecture of picture making. From Diebenkorn, she learned how to flatten and abstract "real world" perspective—to translate spatial representation into the purely graphic language of the canvas [FIG. 5].

Evans's own works of this period tended to be large, loose, and figurative, with an emphasis on erasure and over-drawing. Reflecting the

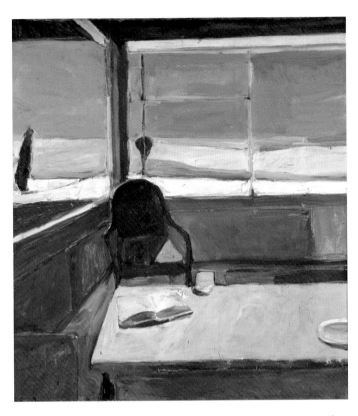

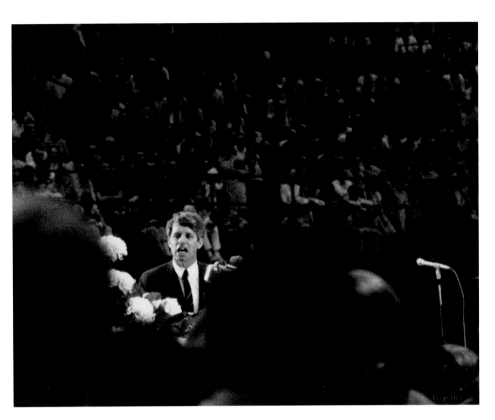

FIG. 5 Richard Diebenkorn, American (1922–1993). *Interior with a Book*, 1959. Oil on canvas. Gift of the Friends of Art, F63-15. © The Richard Diebenkorn Foundation.

FIG. 6 *Robert F. Kennedy, Allen Fieldhouse*, March 18, 1968. Gelatin silver print. Collection of John M. Simpson, Kansas City, Missouri.

powerful legacy of abstract expressionism, this approach emphasized intuition and emotion over factual precision. However, while Evans deeply admired that tradition, she felt conflicted about its ultimate meaning. Another of her KU professors, Dick Shira, stressed the importance of *intensity*—the white-hot fire of primal creative need. Terry loved art and had at least some of the inner demons that greatness apparently required. However, she felt no allegiance to the masculine bravado of abstract expressionism, with its associated antisocial and self-destructive tendencies. In some important way she was simply too "nice," too balanced emotionally, to fit that particular model of artistic achievement. More generally, her vision was too literal, too rooted in the real. When Shira instructed her to paint "the essence of a chair," she was unsure what to do. The chair was clear; its Platonic essence was not.

This tension came to a head in her last year of studies. In looking back on this period ten years later, in a private journal entry of April 1978, Evans described a debilitating creative impasse: "The paralysis . . . came because I wanted to be profound and metaphysical, and I didn't know

how. So I pressured myself and hated myself until I could no longer paint. I wanted to make 'ART'; I wanted to please my teachers. I wanted to be a star. And of course it didn't work."[7]

It was at this juncture that Robert F. Kennedy came to speak. Evans was deeply interested in the political contests of that year, and she went to see all the national figures—including Nelson Rockefeller and Mark Hatfield—who campaigned at the University of Kansas. However, Kennedy was both the first and the most exciting of these political celebrities to visit campus. Upon hearing of his upcoming appearance, Evans devised a plan to gain special access to the event. She borrowed one of her father's Nikon cameras and secured a press pass to be on the floor of Allen Fieldhouse. Practically a novice with the camera, she made at least one successful exposure [FIG. 6].

While she would finish the paintings required for her art degree, a vital seed was planted on that day in March 1968. On one level, Evans was impressed by the simple authority of the camera—the privileged access it allowed to events of such importance. However, a deeper realization began

to take shape—one that went to the heart of her stalemate in painting. True artists, she had been taught, had to pull their work out of themselves—it had to come from the gut, from the raw emotion of the id. Evans had pushed herself to find and channel this visceral intensity, but without real success. The experience with Kennedy provided a revelatory insight: a rich world of subject matter was right there in front of her. It was not necessary to plumb the depths of the psyche for aesthetic profundity: an astonishingly fertile realm of subject matter already existed, in plain sight, just waiting to be addressed. From a philosophical and political point of view, this realization had the added benefit of transforming an intrinsically solipsistic activity into a far more vital and nourishing engagement with the world at large.

This idea was at once elemental and entirely logical. In the summer of 1967, for example, Evans had written in her journal a passage from Mary McCarthy's essay "Settling the Colonels' Hash":

> The writer must be first of all a listener and an observer, who can pay attention to reality, . . . and who is willing, always, to be surprised by the messages reality is sending through to him. And if he gets the messages correctly he will not have to go back and put in the symbols; he will find that the symbols are there, staring at him significantly from the commonplace.[8]

All the key elements of Evans's mature style are contained in this quote. In 1967, this was one idea, of many, that she found significant. After 1968, it would become a central and guiding principle.

Evans had never before thought of photography as the artistic equal of drawing or painting. In 1968, however, she began to consider the medium's enormous potential—and to sense that it could provide a way out of her creative impasse. Although it did not happen overnight, her change in attitude was decisive. After completing her degree requirements at KU, Evans ceased all serious work in drawing and painting. She helped her parents in their portrait business that summer, and learned from her father how to process film and to print. Her artistic direction was entirely uncertain, but she set out to remake herself as a photographer.

The Art of the Real

Evans's life changed profoundly in the fall of 1968, when she married Samuel Dean Evans Jr. and moved to his hometown of Salina, Kansas. Sam's family owned the Evans Grain Company, a business that had grown over the years to include interests in banks and grain elevators in Kansas and Nebraska. Sam had studied business at KU and returned to Salina to help run this family enterprise. Intellectually curious, with interests in a wide variety of subjects, he would be his wife's strongest and most loyal supporter.

Evans embraced her role as a wife and, soon later, a mother: the couple's son, David, was born in 1970, and their daughter, Corey, in 1974. Evans's marriage and children caused a natural shift in her priorities, testing and strengthening her basic social commitments. Her life provided a real-world context in which ideas could be put into practice. Her new stature in Salina, as part of a respected and influential family, represented both a challenge and an opportunity to make a difference.

In 1970, Evans helped start the Salina Consumers for a Better Environment—a group of local mothers hoping to encourage ecologically friendly practices. Another of the group's cofounders was Dana Jackson, the wife of Wes Jackson, a former university professor with radical new ideas about the future of American agriculture. The Salina Consumers effort was a natural outgrowth of the environmental concerns of the period. The first Earth Day, April 22, 1970, enjoyed broad popular support, leading to a series of important political actions: the establishment of the Environmental Protection Agency in 1970, and the passage of the Clean Air, Clean Water, and Endangered Species Acts in 1970, 1972, and 1973, respectively.

Evans's interests at this time included both the natural and the social environments. Reflecting Bobby Kennedy's concern for "the disgrace of this other America," she took a deep interest in the problems of poverty and social inequality. She tutored black Muslim youths in Kansas City's urban core the summer after her graduation from KU. This experience prompted her to become involved in the Carver Center in Salina, an agency that helped underprivileged black youth. She began a photography class there for African American girls, with cameras donated by a local photography shop and a darkroom she set up herself. She guided this program for several years, meeting with the girls on a weekly basis to provide instruction and encouragement.

These activities overlapped with her first major photographic work: a project to document poverty in Kansas, from 1971 to 1973. Starting from her base in Salina, she made contacts in antipoverty offices around the region. In Kansas City, Kansas, for example, she worked closely with the Rev. Donald C. Bakely, head of the Crosslines Cooperative Council. Through Bakely and other social workers, she contacted poor families to ask permission to visit and to photograph. Not all said yes, of course, but those who did often provided further introductions. Ultimately, Evans

would photograph in Salina, Belleville, Lawrence, and Kansas City, Kansas. This work resulted in a warm and respectful book, *If . . . A Big Word with the Poor* (1976), with poems by Bakely and twenty-eight images by Evans.[9]

While simple in technique and style, Evans's Poverty in Kansas photographs are dignified and informative. She maintained a polite arm's-length distance from her subjects, never pretending to an unearned intimacy [PLS. 3–7]. Evans always gained the full participation of her subjects and never worked in a sensational or exploitive manner. Notably, these are environmental portraits: the individuals she depicts are given dimension and depth by the details of their surroundings. These images refer to political ideas—the group portrait of Rev. Martin Luther King Jr. and the two Kennedy brothers, for example [PL. 5]—and to the enduring importance of family bonds [PLS. 6, 7]. More subtly, an image of a young blind woman combines an attention to the eloquence of body language with the emotional resonance of a soiled and shadowed porch wall [PL. 4]. The result is a purely visual suggestion of isolation, spareness, and limitation. Despite the somewhat tentative nature of some of these images, Evans was already thinking contextually: the true richness of her subject lay in the relationship of people to the spaces they inhabit.

When she undertook this work, Evans had already begun a wide-ranging process of self-education. Lacking any formal instruction in photography, she was excited to learn as much as she could. She discovered the existence of a vibrant and growing photography world, sought creative inspiration from notable practitioners, and explored the history of classic documentary practice. This period of rapid growth began with Evans's decision to attend a photography workshop in Aspen, in July 1970, taught by Jerry N. Uelsmann. A celebrated contemporary figure, Uelsmann was the recognized master of combination printing—a means of creating surreal, dreamlike images by printing from multiple negatives. While Evans would not seriously pursue that technique, she loved Uelsmann's commitment and inspiration. As her first photographic training outside the basic instructions provided by her father, this session made a powerful impression. Evans reinforced this experience several years later, attending workshops at Apeiron, in Millerton, New York, for three summers, beginning in 1974.

While Evans explored many aspects of photography, she was particularly focused on the history and current state of documentary practice. Her instincts were good, as these concerns were of increasing importance to many others. This period saw a new focus on the Farm Security Administration (FSA) work of the 1930s and on that agency's two most prominent photographers: Dorothea Lange and Walker Evans (no relation). Lange

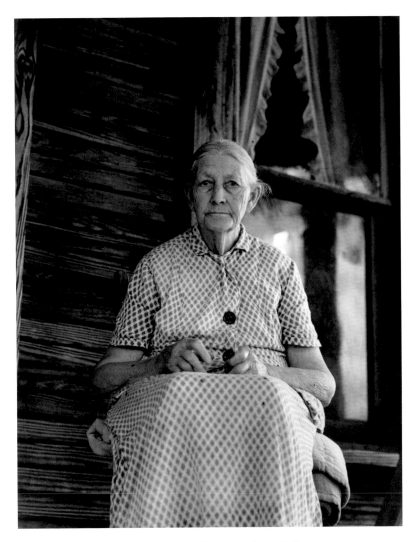

FIG. 7 Dorothea Lange, American (1895–1965). *Ma Graham, An Arkansas Hoosier Born in 1855, Conway, Arkansas*, 1938. Gelatin silver print. Gift of Hallmark Cards, Inc., 2005.27.4205.

was given a major retrospective at the Museum of Modern Art in 1966, just as Walker Evans also began getting new attention.[10]

This new concern for Dorothea Lange, Walker Evans, and the FSA grew from multiple roots. Cultural nostalgia played some role—an emotional longing, despite the obvious economic crisis, for a putatively simpler, "traditional" America.[11] More substantively, FSA photographs carried real social and artistic authority. They documented momentous events, they had served transformative political ends, and they endured, thirty years later, as historical and visual icons. The best of these photographs were original, powerful, and influential—both in terms of *what* they showed and in their graphic sophistication as *pictures*. With the passage of time, the personal nature of this work had become obvious. Lange and Evans had both recorded something of the essence of their era, but in radically different ways. Thus, by the early 1970s, their photographs were celebrated not simply as records of a period, but as emblems of the medium's expressive—artistic—potential. As a result, Lange and Evans provided a crucial model for contemporary practice: a way to unite the concerns of fact-gathering and personal expression, social engagement and art.

Terry Evans shared this deep respect for the legacy of the FSA and, in particular, for the achievement of Dorothea Lange. Lange's primary subject was people, and she was unequalled at finding universal meaning in the commonplace. Lange had the eye of an artist and the heart of a social worker. Her background in studio portraiture gave her the ability to capture the most telling expressions or postures with deceptive ease. She was particularly attentive to the language of the body—the truths revealed in the subtleties of stance, expression, and gesture—and the vital bonds of family and community [FIG. 7]. Lange's photographs were direct but never simple. Her vision was humane and bittersweet, as clear and mysterious as life itself.

In the period of 1972–73, Evans made a pilgrimage to Washington, D.C., to study this work in the FSA files at the Library of Congress. She went through hundreds of Lange's images, the very famous as well as the little known and unpublished. Evans learned much from this immersion in Lange's 1930s work. Evans's natural attitude of deference to her subjects was reinforced by Lange's consistent sense of dignity and respect. Indeed, in many cases, Lange made her subjects subtly heroic: because she held a reflex camera at waist level, she literally looked up to most of the people she photographed. Evans was inspired by both the greatness of Lange's pictures and her sheer determination. Many of Lange's photographs were considerably less than iconic, of course, but they underscored the logic of her working method. Lange's lesser-known photographs taught Evans

patience—how to work around a subject in order to tease out individual facets of meaning. This larger sense of artistic engagement—of never being satisfied with one's first or most obvious impressions—resonated strongly with her.

As the nation's bicentennial year approached, the idea of a broad photographic survey of the country's people and places took on some urgency in the American photographic community. The idea of other FSA-like photographic projects had long been in the air: Dorothea Lange had been advocating such an idea since at least 1952, but her Project One never got off the ground.[12] In the years leading up to 1976, various proposals—regional at first, and then national—were raised and debated. In 1975, the Minnesota senator Walter Mondale argued for the establishment of an American Bicentennial Photography and Film Project, citing the precedent of the FSA. Mondale's proposal failed, but the idea prompted the National Endowment for the Arts to institute a new Documentary Survey grant category in 1976.[13] During the existence of this category, from 1976 to 1981, the NEA funded nearly seventy documentary projects across the United States.

James Enyeart is an important figure in this history as well as a key mentor to Evans. A photographer, writer, and historian, Enyeart began his career in the Midwest before moving on to hold some of the most prestigious positions in the field of creative photography.[14] In 1968, he became the first curator of photography at the Spencer Museum of Art at the University of Kansas. With modest resources but real prescience, he built a survey holding of photographs for the museum—one of the earliest such collections in a major university museum. In the course of this work, he developed wide-ranging contacts in the field.

Enyeart met Evans in about 1971, and the two quickly became close friends. Enyeart recognized Evans's inherent talent and admired her commitment and drive. Evans, in turn, was enriched by the young curator's critical eye and his deep knowledge of the medium. It was through him that she truly became aware of the size and vitality of the greater photography world. Most important, the two shared a deep interest in the idea of contemporary documentary practice and the legacy of the FSA.

In 1972, Enyeart gave Evans her first one-person show. He hung a group of her Poverty in Kansas photographs in Spooner Hall, then the home of the university art museum. This represented a major confirmation for the young photographer. Evans had been working with the camera seriously for less than two years and remained self-conscious about her lack of formal training. The show represented a great expression of faith on Enyeart's part—his way of both celebrating and encouraging a strong

new talent. He admired Evans's passion and sensitivity—the fact that she had tackled a difficult subject with real humanity and artistic insight.

In 1973, Enyeart invited Evans to collaborate on a documentary project funded by the Kansas Committee for the Humanities. Kansas in Transition explored disappearing ways of life in the rural parts of the state. The two divided their duties, reflecting the complementary visual traditions of Walker Evans and Dorothea Lange: Enyeart photographed architecture, while Evans focused on people. Working with a 35mm camera, she recorded traditional activities—the making of sausage and bread, blacksmithing and horseshoeing, quilting, and similar activities—in several communities with Czech roots north of Salina. Kansas in Transition did not result in a catalogue, but a show of original prints toured to at least a half dozen venues across the state. Each of these bookings opened with a panel discussion: Evans and Enyeart discussed the pictures, and community questions and feedback were encouraged.

Building strategically on this experience, Enyeart crafted a more expansive documentary survey in 1974. He had applied for a personal NEA grant to photograph Kansas. By the time he received it, however, he had decided to "expand the conversation."[15] With the informal agreement of Brian O'Doherty, director of the Visual Arts Program, Enyeart used the grant money to fund a group survey of the state. This was a conscious effort to test a methodology that might serve as a model for a new generation of documentary endeavors. That was the case: the Kansas Survey ended up providing a template for the NEA Documentary Survey grants that began in 1976.

Enyeart invited Evans and Larry Schwarm, a talented KU graduate student in photography, to join him in the Kansas Survey. The division of duties was simple: Enyeart focused on architecture, Evans made portraits, and Schwarm dealt broadly with the landscape. Working during the height of the summer, the three met periodically to share their results; otherwise, they traveled and photographed independently.

The resulting catalogue, *No Mountains in the Way: Kansas Survey: NEA*, was published in 1975 by the KU Museum of Art [FIG. 8]. It is significant that Enyeart's introduction provides an overview of documentary photography, with an emphasis on the FSA. In summarizing this history, he noted, "Despite an incredibly long tradition, the documentary photograph defies precise definition and cannot be relegated to a specific style." Instead, he suggested, documentary practice was characterized by an attitude, a quality of attention and respect. "Expressed in other words, one usually finds in a documentary photograph honesty, empathy, and straightforward contact with the subject."[16] From the start, then, the Kansas Survey had a

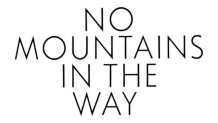

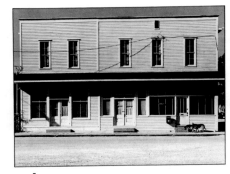

kansas survey: nea

FIG. 8 *No Mountains in the Way*, 1975
(cover photograph by James Enyeart).

dual agenda: to capture representative facets of present-day Kansas, and to explore the aesthetic possibilities of modern documentary practice.

Evans's Kansas Survey photographs represent both an extension and a refinement of her earlier work. Technically, they reflect a significant advance: a change from her original 35mm camera to a 2¼-inch Hasselblad.[17] The Hasselblad's sharper lens and bigger negative gave her images a new precision and subtlety of description. In addition, the square format required Evans to rethink the compositional strategies that had worked in the rectangular frame (a 2:3 ratio) of the smaller camera. She embraced the new format, finding it a perfect vehicle for her vision of the world. The square frame has a distinctive formal dynamic. Geometrically neutral, it equalizes vertical and horizontal graphic energies. The result is a format with a "bull's-eye" kind of compositional simplicity and the potential for great formal and graphic subtlety.

This was easily Evans's most accomplished body of photographs to date. While the empathy and humanity of her earlier work is unchanged, these photographs reveal a new confidence and graphic sophistication. The images are elegantly constructed, direct, and strong [PLS. 8–10]. At the same time, they encompass a range of visual ideas: people recorded individually, in pairs, or in groups; environmental portraits in which

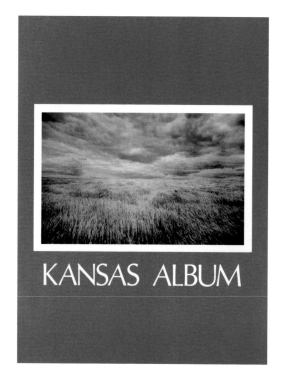

FIG. 9 *Kansas Album*, 1976
(cover photograph by Lawrence McFarland).

figures and the surrounding spaces carry roughly equal weight; records of unpeopled interiors; and graceful vignettes of everyday objects and artifacts (apples in a wheelbarrow; worn pants on a clothesline).

After completing this work in the early summer of 1974, Evans attended an Apeiron workshop, in Millerton, New York, taught by Charles Harbutt.[18] A noted photojournalist and art photographer, Harbutt had recently released *Travelog*, a monograph of personal photographs.[19] Harbutt had an eclectic and intuitive approach. Drawn to oblique and often surreal vignettes of everyday life, he celebrated a spirit of uncertainty, discovery, and surprise. In his Apeiron workshop, Harbutt stressed the importance of personal work, the quest to make pictures for—and ultimately about—oneself. He emphasized the significance of private symbols: repeated motifs or visual ideas that spoke to deeply rooted values and concerns. He encouraged young photographers to recognize and cultivate their own symbols—to establish a truly individual expressive vocabulary. Evans vividly recalls Harbutt's most provocative lesson. He told his class: "This is your last assignment on earth; tomorrow you will be shot into space, never to return. All that you will be able to take with you are twelve photographs—go out now and make them."

The week with Harbutt had a major impact on Evans. In part, it highlighted a central tension in her work: the play between fact-gathering and personal expression. Harbutt emphasized the inevitable union of these ideas—the use of photography to know both the world and the self more richly. In addition, Harbutt's example gave Evans "permission" to focus on her own world, to seek her own set of pictorial symbols. Evans was pregnant with her daughter Corey when she took this workshop. After the child's birth in November 1974, Evans devoted the next two years to making personal images of her family.

This "home" work represented both an artistic interlude—accomplished around the demands of raising two young children—and a deliberate stylistic and conceptual exploration. Taking up Harbutt's challenge, Evans explored the photographic possibilities of her own familial and domestic space. Using both her 35mm camera and the larger Hasselblad, she made fresh and spontaneous images of her children in various states of activity: falling asleep, dressing, and playing [PLS. 11–13]. Unlike her portraits of strangers, these home pictures feel entirely candid. Evans recorded characteristic moments of activity: what distinguished these images was not unusual content, but a vitality of perception. The challenge was to find the appropriate visual expression for the familiar patterns —the joys and the tensions—of family life.

These pictures are informed by a new set of influences and ideas. Dorothea Lange's spirit is still here, but it has been supplemented by that of a younger generation of small-camera photographers, including Robert Frank, Garry Winogrand, and Harbutt. There is a fresh visual energy in these pictures, as well as a new uncertainty—a preference for oblique angles, ambiguous actions and gestures. These images rarely center on a single person or thing. Rather, they capture a web of visual relationships. Like the drawings she made in college, these works stem from intuitive, spontaneous decisions. And like her landscape pictures to come, they suggest the often surprising ways a richly articulated visual field can cohere as a pictorial whole.

Overall, this was a time for testing new ideas. Evans returned to Apeiron in the summers of 1975 and 1976, taking workshops with photographer Ralph Gibson, and the writer and theorist Jose Arguelles.[20] In the course of these visits, she also came to know Mark Goodman, then working on an extended photographic study of the residents of Millerton.

The culmination of Evans's social documentary work came in 1976, with her Kansas Album project [FIG. 9]. A logical extension of the earlier Kansas in Transition and Kansas Survey endeavors, the Kansas Album represented an even more ambitious exploration of the legacy of the FSA and the idea of a contemporary documentary collective. This project was unusual, however, for being shaped outside the framework of state or

federal arts grants. Evans conceived the project herself and—with the help of her husband, Sam, and father-in-law—solicited funding from the Kansas Banker's Association. With this substantial underwriting—well over two hundred banks are listed in the credits at the back of the volume—Evans assembled one of the most notable artistic documentary projects of the Bicentennial year.

Evans built this project around her Kansas Survey colleagues. Jim Enyeart agreed to serve as the book's editor, and Larry Schwarm signed on as a photographer. In addition to Schwarm and herself, Evans selected seven other photographers—a combination of talents from the region and beyond. These included Earl Iversen, a professor at the University of Kansas; Jim Richardson, staff photographer for the *Topeka Capital-Journal*; Jim Alinder, head of the photography program at the University of Nebraska-Lincoln; Lawrence McFarland, a recent M.F.A. graduate of the University of Nebraska's program, then still residing in Lincoln; Robert Grier, of Alliance, Nebraska, the staff photographer for *Nebraskaland* magazine; Mark Goodman, of Boston; and Garry Winogrand, then living in Austin, Texas.

The photographers worked independently, with complete freedom to choose their subjects and itineraries. All the work was accomplished between June and October 1976. Some photographers worked throughout this period; others came in for shorter, more focused efforts. Their working methods differed widely. For example, starting with a deliberately conceptual strategy, Lawrence McFarland made at least six extended trips through Kansas. He began by driving the perimeter of the entire state, staying on roads just inside the border. He then drove long diagonal routes from corner to corner, tracing a virtual X through the territory.[21] On the other hand, Winogrand was in the state for about a week, accompanied by his wife and young daughter. He photographed the state fair in Hutchinson and street life in Wichita and Salina. In addition to hosting several of these photographers in her home, Evans made portraits throughout the Salina area.

The result reflected a clear aesthetic strategy. As Enyeart observed in the book's introduction, "The photographers were not selected on the basis of where they live, but according to the different perspectives and attitudes towards documentary photography which they represent."[22] These perspectives ranged from traditional photojournalistic fact-gathering to an explicitly formal and subjective vision.

Building on the earlier Kansas endeavors, the Kansas Album project represented a sophisticated meditation on the intrinsic possibilities—and the very meaning—of documentary practice. In so doing, it also suggested

the limits of this inquiry. At some point, concerns of style could equal or trump those of subject matter. From that point forward, the primary importance of the pictures lay in the realm of aesthetics—they functioned more clearly as works of personal expression than as public communication. Thus, while artistic practice and the classic documentary idea had broad areas of overlap, they remained discrete concerns. The group documentary projects of this decade grew from a broad desire to test the compatibility of fact-gathering and art. That the results were impressive was in part because of the limits they helped clarify.

Evans's own work exemplifies the inherent tensions of this project. Her portraits retain many of the qualities of her earlier images, but with a new intimacy and conceptual edge suggesting her respect for the work of Goodman and Winogrand [PLS. 14–17]. In addition to a familiar sense of warmth and respect, these images convey a more overt sense of confrontation, tension, and even irony. In a few of them, Evans used a flash to open and flatten the space of the image, resulting in what sometimes feels like a human specimen, a social type rather than a three-dimensional individual. In other cases, she seems to suggest the very limits of portraiture itself: surfaces are beautifully described, but the subject's inner life remains a complete mystery.[23] In general, these pictures have a more visceral and aggressive edge than her earlier work; the physical intimacy of these views often carries a sense of challenge or confrontation. Evans moves in very closely to her subjects, at once monumentalizing them and—in a few cases—triggering a response of wariness and caution [PLS. 14, 16]. Implicitly, her presence is felt in these images as never before.

This project marked something of a culmination and a close for Evans, the high point of her intensive exploration of social documentary photography. She would continue in this direction through 1978 (and even beyond), expanding logically on her Kansas Album work [PL. 18]. In 1978, a group of her portraits of Kansas men was included in Jim Alinder's exhibition *Twelve Photographers: A Contemporary Mid-America Document*, at the University of Nebraska's Sheldon Memorial Art Gallery. Accompanied by a substantial 172-page catalogue, this exhibition toured the region under the auspices of the Mid-America Arts Alliance.[24] In 1977, Evans began a portrait project centering on the idea of couples. She worked in Kansas and traveled to New Mexico and California to seek out additional subjects. This work continued into 1978 and took on a distinctly political dimension: she made a trip to San Francisco to record gay couples at the beginning of the national gay rights movement.

By June 1978, however, she had set aside nearly all this work. As she has said, "the prairie intervened."[25]

Discovering the Landscape

In the years leading up to 1978, Evans had taken something more than the average citizen's interest in the land, but it had never been an artistic subject. She had followed various aspects of the sustainable agriculture debate as a result of her general interest in ecology, the nature of the Evans's family business, and the overwhelming importance of agriculture in the regional economy.

As it happened, Wes Jackson, the seminal figure in the radical agriculture movement of the period, was a friend in Salina. Born and raised on a farm near Topeka, Jackson had at first followed an orthodox academic path. After receiving an M.A. in biology and a Ph.D. in genetics, he taught for several years at California State University, in Sacramento, heading one of the nation's first environmental studies programs. With his publication *Man and the Environment* (1971), he became one of the period's most informed and passionate environmental advocates. He left academia to return to Kansas, seeking to find practical ways to solve the problems of modern industrial agriculture. In 1976, with his wife Dana, he founded the Land Institute in Salina, a nonprofit education and research institution. Jackson promoted the terms "sustainable agriculture" and "Natural Systems Agriculture." Seeking to cure the environmental degradations of modern farming, he aimed at a more natural alternative. A prime inspiration lay in the perennial polyculture of the native prairie. These grasses do not need plowing or seeding—they come up every spring on their own. In addition, the prairie's profusion of species helps maintain the fertility of the soil, while the dense root system prevents erosion. Terry and Sam Evans followed this work with great interest given their friendship with the Jacksons, and Sam served on the Land Institute's first board of directors.

In April 1978, Jackson asked for Evans's photographic assistance. As a central part of his study of prairie ecology, Jackson was analyzing the variety and interdependence of native grasses in an eighty-acre plot of virgin prairie north of Salina. He established a simple but effective methodology: a detailed inventory of all the plant species contained within sample one-meter squares. To aid this work, he asked Evans to make visual records of these sectors of ground. She was happy to oblige and produced a number of images, most as color transparencies, in the following weeks. In the course of this work, however, she began to see the ground, and to think about it, in a radically new way.

Evans's first visit to the virgin prairie coincided with a major crisis of confidence. She found herself questioning the significance of her pictures—and the prairie provided the answers. The resulting revelation was slow in coming, but of overwhelming profundity. In her journal for May 15, 1978, she noted simply, "My prairie slides have such a wealth of clear information in them." With the work for Jackson accomplished, she began returning to the eighty-acre field on her own, to walk, to look, and to photograph. She continued recording square sections of ground, looking straight down on the tangle of grasses. Her approach consciously adopted the rigor of a scientific study: she used a consistent viewing position, a single lens, and only black-and-white film. She also made the decision to work strictly on overcast days. She loved the gentle neutrality of diffused natural light; absolutely even, it drew no attention to itself while revealing her subject with sublime clarity. Despite this methodological rigor, however, Evans's quest was explicitly artistic in nature.

She returned repeatedly to these acres, working for perhaps an hour at a time, shooting roll after roll of film. The longer she looked, the more she discovered. The prairie ground was a fabric of astonishing richness and variety. The earth was a glorious tapestry of life; at once radiantly simple and unfathomably complex. No single photograph could capture the real vitality of what she saw. Before long, she realized that one hundred and even five hundred pictures still failed to exhaust the prairie's aesthetic possibilities. In the span of about twelve months, she would make more than four thousand exposures of the prairie grasses, nearly all identical in approach and vantage point [FRONTISPIECE; PLS. 19–21].

Evans had truly discovered a new world. In her journal for November 6, 1978, she wrote:

> From May 15 to Oct. 16: no entries, because photographing the prairie consumed me, filled me, nourished me, gave me ecstasy. The questions about my work are different now, and have nothing to do with fear of failure or emptiness. The questions now are about the work itself, how to clarify it technically and in content. But the organic evolution is happening. The process is in motion. The revelations are occurring. The prairie has shown me the web of spiritual and physical life. The prairie has shown me cosmic order, if only I could see it. I continue looking . . .

What, exactly, did Evans see in the prairie grass? The deep resonance of this subject stemmed from its elemental and universal nature. There are few things more basic than grass.[26] As Walt Whitman recognized more than a century earlier, this simplicity lends itself to metaphor and analogy—meditations on the play between small and large, the specific and the universal, the commonplace and the miraculous. Grass *roots* us in a relatively literal way: it brings us back to the skin of the

world, the boundary between earth and sky. The meanings of the word "ground" include this sense of a beginning point and a foundation: "the basis on which a belief or action rests"; "to instruct in first principles."[27] And, indeed, Evans's engagement with prairie grasses represented nothing less than a personal and artistic re-*grounding*; a quest for a renewed set of "first principles."

For Evans, the prairie grasses suggested a vision of the universe itself: intricately textured, all encompassing, and buzzing with life and energy. Every square meter of land was at once enormously complex in detail and radiantly simple in pattern. Moreover, these areas of ground were perfect demonstrations of the endless cycle of life, death, and renewal. Individual plants grow, reproduce, die, and decay, returning nutrients to the soil to sustain following generations. Each patch of ground was a "world" in itself—a microcosm of much larger, and absolutely fundamental, forces and rhythms.

From a philosophical—and perhaps even spiritual—point of view, the prairie landscape satisfied a deep yearning for wholeness, synthesis, and balance. It provided a kind of conceptual gravity that pulled Evans's varied interests tightly together. The dense polyculture of the prairie provided a proto-political symbol of integration and cooperation. This glorious variety of flora and fauna existed together in life-sustaining harmony—each species distinct, and all interdependent. Indeed, the organic diversity of the prairie was at once its defining characteristic and its supreme survival mechanism. It was not hard to find analogies here between a diverse and healthy ecosystem and an ideal vision of human society.

And, of course, the prairie had a powerful aesthetic appeal. The dense pattern of grasses had an unmistakable logic—but it was the logic of nature, not culture. There were no straight lines in nature: everything was a result of probabilities and contingencies, organic patterns and relationships. The formal energy of this process of natural growth can be difficult to grasp at first: it appears dense, random, and even chaotic. The surprise comes from the understanding that in nature these are virtues, not failings. The organic world has no use for the artifice of human geometry; it builds structures in more complex and accommodating ways. As a result, it forces us to see—and to think—differently.

Evans was struck powerfully by the aesthetics of the prairie. On one hand, the complexity of the grasses suggested an ultimate kind of drawing. The lines she saw were at once bold and delicate, powerful and graceful, broadly similar, yet never precisely the same. The patterns at her feet encompassed an entire visual vocabulary: a truly universal system of denotation derived from the living body of the world.

This discovery led to a slow—and appropriately *organic*—process of looking and thinking. The interconnectedness of the prairie biome suggested all manner of other references and connections. In this period, Evans was inspired by Gregory Bateson's idea of the "pattern that connects," the idea of individual, society, and nature as a series of overlapping systems.[28] Evans found conceptual linkages in art, science, anthropology, psychology, and religious and spiritual thought. Prairie grasses made her think in new ways about Chinese calligraphy, the rock art of American Indians, Persian miniatures, Greek icon paintings, Mimbres pottery, the Renaissance artist Albrecht Durer, feminist theology, and maps of all kinds. The spiral pattern of the bristles of porcupine grass and the center of the Black Sampson flower prompted her to consider the larger importance of the spiral in nature, and the pattern of growth described by the Fibonacci sequence.[29] In these ways, and many more, the rich tapestry of the prairie reshaped and enriched her thinking. It provided a new organizing principle, a fresh context for ideas both old and new.

One of her key realizations involved the importance of *form*: the deeper meaning of natural structure. She has written, "As I learned about the form [of the prairie] I was being initiated into the mysteries of form in art and life. I began to understand that sacred and symbolic knowledge, knowledge that goes beyond the world of appearances, is transmitted through form and structure."[30] The structure of a living thing reveals something basic about its nature and the larger codes of Nature. Similarly, pictorial form has the potential to carry its own kind of "content" or meaning. For example, as Evans has observed of various aspects of pre-Renaissance art, flat, non-perspectival images utilized a sophisticated visual language: "form itself expressed a spatial awareness."[31] This notion would inform all her subsequent work.

A Spiral Journey

Evans's discovery of the prairie made her a landscape photographer. More properly, perhaps, it suggested the living reality of the land: its power, fragility, and essential presence. It may be too much to suggest that the land became her prime "character," but it is important to note that Evans never stopped making portraits. From 1978 on, she would balance these two great themes—usually working more intently on one than the other, but never forsaking either. She sought a larger form of artistic truth—one that acknowledged the value of both people and the land, past and present, growth and entropy, celebration and critique. With this broader view came a new sense of belonging. Evans remained happily wed to the reality of

the world, but that world now implicitly included *her*—the intensity of her curiosity and the quality of her imagination animated everything she saw.

The course of Evans's work since 1978 has been a result of both deliberation and intuition. She has undertaken many projects in this time. While most represented logical extensions of what had come before, several marked surprising departures. In hindsight, however, the direction of her creative path is eminently clear. From the creative seed of that first encounter with the prairie, a remarkably vital and diverse body of work has grown. The following examines Evans's artistic progress since 1978 in something like the literary equivalent of a time-lapse film: a rapid survey highlighting her major themes and conceptual moves. While each body of work demands and rewards close study, I focus here on the unfolding dynamic of Evans's creative vision.

While Evans has called herself a "slow learner" on various occasions, she is in fact thoughtful, patient, and trusting of her instincts. She takes on projects that interest her and tries to work at her own pace, avoiding the pressure of absolute deadlines. Bodies of work evolve in reasonably similar ways: she explores the possibilities of a given subject or theme, reads to gain relevant knowledge, works steadily and intuitively once a degree of confidence has been achieved, and stops with the satisfaction of her original curiosity. This process represents a potent union of personal and emotional involvement, factual specificity and purely aesthetic concerns. Her movement from project to project traces a kind of grand, spiraling path: forays into new territory and periodic returns to familiar themes, followed by additional fresh tangents. In each cycle, the lessons learned in the pursuit of new subjects inform Evans's approach to her perennial themes.

For about twelve months, beginning in the spring of 1978, Evans produced rigorously controlled black-and-white studies of prairie grasses [FRONTISPIECE; PLS. 19–21]. In the spring of 1979, she made a simple but dramatic move: standing on the same ground as before, she looked out to the horizon and up to the sky [PLS. 22–26]. These moves radically enlarged her vision; she turned from a deliberately formal aesthetic strategy, based on a detached viewing position a few feet above the ground, to a much broader embrace of the experience of the land.

This shift in strategy implicitly acknowledged her own presence —and physical movement—within the landscape. Evans had previously viewed the land graphically, emphasizing the evenness of the light and the flatness of the grassy surface. With her visual movement through it, she accepted the infinite contingencies of the place: the dimensions of the space and the variations of time and light. She also embraced the greater drama of the organic world—the symbiosis of life and death, creation and destruction. Her views of the early season prairie fires are very important in this regard. Begun in the spring of 1981, these photographs present an almost apocalyptic vision of destruction—a process necessary for the health of the new season's growth [PL. 26]. In this period she also began photographing in color—another means of capturing the full sensory texture of the experience.

This process of exploration continued in subsequent years, as Evans's thinking and her circle of friends and influences continued to grow. For example, the photographs of Robert Adams and Joe Deal had a powerful impact on her. Working in his home state of Colorado, and through the northern Great Plains, Adams made elegantly spare, bittersweet views of an occupied—and frequently abused—landscape. At once rhetorically restrained and laden with emotion, Adams's photographs provided a powerful model for a contemporary, socially aware, artistic practice.[32] Joe Deal worked in an even more formal mode, making horizonless, downward-looking views of desert and suburban landscapes. Employing the same 2¼-inch square format that Evans used, Deal created information-rich images that also functioned as exquisitely taut networks of visual incident.

Evans also appreciated the friendship and ideas of Thomas W. Southall and Saralyn Reece Hardy. Southall, who replaced Enyeart as the curator of photography at the Spencer Museum of Art in 1977, became a close friend and supporter. He presented exhibitions that Evans studied with great interest—the work of Harry Callahan, David Hockney, the Rephotographic Survey, and "New Color Photojournalism," for example —and he brought in speakers such as Mark Klett and Susan Meiselas. In 1983, he organized a two-person show of Kansas images by Evans and Earl Iversen.[33] Southall and Evans had many stimulating conversations about her work and the larger realm of landscape photography.[34]

In Salina, Saralyn Reece Hardy was Evans's most important artistic friend and sounding board. Hardy arrived in Salina in 1980 and worked for the Salina Arts and Humanities Commission before becoming director of the Salina Art Center in 1986. Evans is quick to credit the pair's regular walks and talks for the maturation of her artistic vision. Hardy remembers Evans's extraordinary aesthetic sensitivity, even in the most familiar contexts—her attention to the quality of light, for example, or to the beauty of a dead bird found by the sidewalk. Their conversations centered on the ideas of aesthetics and place: the potential for art not merely to illustrate a certain locale, but to actively define it. This involved a rigorous process of vision: pointedly direct, sympathetic but never sentimental, and always cognizant of a larger web of connections and

FIG. 10 *Irma, Salina, Kansas,* 1989.
Chromogenic prints. Collection of the artist.

fully explore the ideas of form and structure that had been important since her days as a painting student. This work continued for several years, until Evans felt she had exhausted the visual potential of the untouched prairie. In 1985, she turned to other pursuits, including the production of multi-frame portraits inspired by the recent composites of David Hockney [FIG. 10].

In 1989, she returned to the landscape, but with a new focus on the inhabited prairie. In another entirely logical move, Evans now looked to the overlapping rhythms—and histories—of nature and culture. She has stated, "I realized that I could not understand [the] prairie if I didn't look at the whole of it. The disturbed, cultivated, militarized, industrialized prairie had been abused and I began to photograph it."[36] While Evans is never polemical in this work, her decision was an explicitly political one: her central theme had shifted from the integrity of the natural ecosystem to the complex legacy of human habitation. For the next five years, she worked steadily on the Inhabited Prairie, photographing from the air, at first in color and then in black and white, around Salina [PLS. 28–35].

As always, Evans's instincts were astute: the question of art and political agency was again in the air. For landscape photographers of the time, the major influences included the key figures of the New Topographics approach of the 1970s: Robert Adams, Joe Deal, Stephen Shore, Frank Gohlke, Henry Wessel, and Lewis Baltz. Despite their stylistic differences, all these photographers focused exclusively on the human-altered landscape. They also shared a stance of relative neutrality—a coolly descriptive, unemotional mode of address. Much of this work carried an implicit sense of irony or critique, but it was only obliquely "political," with little overt engagement in public or topical concerns.

Many photographers of the 1980s were inspired by the laconic clarity of the New Topographics aesthetic but explored more direct ways of joining art and social engagement. In this regard, one of the most important events of the period was the conference The Political Landscape, held in October 1989 at the Anderson Ranch Arts Center, in Snowmass, Colorado. Many photographers came to meet, share ideas, and hear presentations by the historian Patricia Nelson Limerick and the writer and philosopher Alston Chase.

At this conference, photographer Robert Dawson and historian Ellen Manchester invited a diverse group of practitioners—including Evans, Laurie Brown, Gregory Conniff, Peter Goin, Wanda Hammerbeck, Sant Khalsa, Martin Stupich, and Mark Klett—to discuss the theme of Water in the West. Despite inevitable differences of viewpoint, the group agreed to work collaboratively on this large, open-ended project.

relationships. What mattered above all, perhaps, was a fundamental quality of attention: the ability to take a close, patient, and fresh perspective on the seemingly ordinary.[35]

Evans's work was pushed forward by influences such as these and by her own restless curiosity. In 1980, she made her first aerial flight over the virgin prairie. The airplane allowed her to see familiar ground in a completely novel way, opening a new set of artistic options [PL. 27]. The formal sympathies between micro and macro were particularly interesting: the rhythms and structures common to both the most intimate and the most encompassing perspectives. The aerial view also allowed her to more

The goal was the creation of a visual archive that would contribute to a growing cultural dialogue on an essential and dwindling natural resource. Over the next decade, the group met periodically to share work and ideas: the 1991 gathering took place at Evans's house in Salina.

The 1989 conference and the Water in the West Project were important to Evans for several reasons. They helped clarify the significance and the complexity of the political issues involved in contemporary landscape practice. They also reinforced a sense of artistic community, underscoring the fact that other talented photographers were engaged in related kinds of work. Finally, they stimulated important new friendships; Evans was particularly happy to meet Gregory Conniff, of Madison, Wisconsin, who has remained a close colleague and confidant all these years later.

Overlapping with the aerial work of her Inhabited Prairie series, Evans began a new project in 1990—a study of the small community of Matfield Green, in Chase County, Kansas. Located in the Flint Hills, the heart of the tallgrass prairie, Matfield Green was selected as the site of a Land Institute ecological study. Introduced to the town by Wes Jackson, Evans began a long and warm relationship with the place and its people. Despite her other projects in these years, Evans worked at Matfield Green steadily through 1998, and again beginning in 2008. While the landscape has a continuing presence in these photographs, Evans's prime focus is on human stories [PLS. 60–72]. She began this work, in her own words, as "a poem about people rooted in a place."[37] This poetic approach is unmistakable, but Evans's devotion to the subject ends up revealing Matfield Green as a kind of social and historical case study: a microcosm of life in a tiny but enduring prairie community.[38] This intimate vision perfectly complemented the broad aerial perspectives of the Inhabited Prairie.

While the Matfield Green pictures record a characteristically warm and harmonious relationship between people and the earth, Evans soon undertook a more charged subject. This new work stemmed from her gradual move to Chicago in 1993–94 (because of Sam's employment with YMCA of the USA) and her friendships with ecologist Jack White and with Gerald Adelmann, of Openlands, an organization devoted to conservation and historic preservation. White introduced her to the Joliet Arsenal, an abandoned military munitions plant near Joliet, Illinois, that had operated from 1940 into the 1980s, and Adelmann helped facilitate her work there from 1995 to 1997. This property, which included many acres of tallgrass prairie, had been contaminated by decades of industrial waste. Like Matfield Green, the Joliet Arsenal was a previously little-known subject with broad symbolic resonance—in this case, as evidence of decades-long environmental abuse.

Evans saw the Joliet Arsenal as a palimpsest of history with superimposed layers of narrative: the land itself, the old Indian burial site of Plenemuk, and abundant evidence of the military presence from the Civil War era through the 1980s. While there were no people to record, Evans otherwise worked in a familiar mode, recording artifacts of the human presence and the landscape itself [PLS. 36–39]. Latent environmental damage is essentially invisible to the eye, but the idea of toxicity runs through this series. Ultimately, Matfield Green and the Joliet Arsenal convey complementary messages about history and human stewardship. One presents a vision of organic health and harmony, the other of industrial poison and abandonment. However, the animating optimism of the Joliet Arsenal work stemmed from its most recent layer of history: it was being transferred to the U.S. Forest Service, to be reborn as the Midewin National Tallgrass Prairie.

In 1996, thanks to a Guggenheim Fellowship, Evans began her most expansive project to date. Extending the notion of an increasingly inclusive perspective on the prairie, she decided to explore the full expanse of mixed-grass prairie, from the Canadian province of Saskatchewan south to central Texas. She worked systematically on this Canada to Texas project for three years, 1996–99, photographing entirely from the air [PLS. 40–48]. This marked the ultimate spatial extension of the idea that had begun in 1978 with her one-square-meter studies of grass. In twenty years, she had moved organically from micro to macro: from a view of the world at her feet to a territory nearly 2,000 by 500 miles in size. The wonder lay in the logical connection of these approaches and the fact that the same messages could be gleaned from both sets of photographs. The artistic coherence of this quest may not have been in Evans's mind in 1978, but it underscored the deep logic of her intuitive sense of growth and exploration.

Evans knew that the reality of her subject was only partially a matter of space; just as important, it had natural, cultural, and historical dimensions. While still engaged with the Canada to Texas work, Evans began a new project in 1997: recording lovingly preserved specimens of prairie plants. Just as her Guggenheim work represented the ultimate macro view, Evans's Specimens provide a fresh expression of the micro perspective. Beginning with a single bound volume of botanical specimens discovered at Matfield Green [PL. 49], Evans sought out other examples in the Field Museum of Natural History, in Chicago [PLS. 50, 51]. There, she used a 4 x 5-inch camera to record prairie plants collected by nineteenth-century naturalists. She loved the idea of the botanist's work: the process of finding, collecting, cataloging, and preserving was analogous to the practice of photography. In each case, the goal was to gather *representative* samples:

objects or images that were at once aesthetically satisfying and usefully characteristic. Before long, Evans's Specimens series expanded to include the Field Museum's holding of Kansas fauna: birds, rabbits, snakes, and other animals [PLS. 52–58].

This series has both deeply personal and broadly conceptual facets. It calls to mind Evans's childhood experience of watching her grandmother's work in the family funeral parlor—and the almost sacred presence of those lovingly tended bodies. Evans's adult fascination for the dead birds and mice she found on her walks is also germane here. Beginning in the 1970s, she carried many of these creatures home, preserving them in plastic bags in the freezer with the hope of photographing them. Her work with the extraordinary collections of the Field Museum represented an ideal extension of this impulse to collect, study, and preserve.

In addition, Evans's Specimens work constitutes a rich meditation on the idea of representation. Evans's pictures are essentially documents of documents, or facsimiles of references. Her photographs and the specimens she records share a conceptual foundation as representations. But the notion of representation has divergent meanings here: categorical reference or equivalence (one example standing for an entire species) and mimetic exactitude (a precise rendition of a singular subject). Both kinds of representations are important in the natural sciences, but they represent distinct realms: the abstract logic of our organizing systems and categories, and the contingency of the actual world. In addition to paying homage to past generations of naturalists who studied and loved the prairie, Evans's Specimens thus point to larger issues of fact-gathering and knowledge.

Evans embraced yet another facet of the prairie with her Revealing Chicago pictures of 2003–5. In partnership with Gerald Adelmann, of Openlands, she received funding for a major aerial survey of the city and its surroundings. Evans recorded all aspects of the metropolitan area: the towering central city, industrial areas, the lakefront, and the far western edge where suburbs meet farmland [PLS. 74–80]. While the prairie is effectively invisible in these pictures, it plays a key conceptual role. The metropolis rests upon the plains and thus charts its topography. Just as important, Chicago may be considered the greatest of prairie cities; for more than a century it was a primary destination for livestock, grains, and other products of the agricultural Midwest. Historically, then, Chicago may be viewed as the most visible emblem of the wealth extracted from the Great Plains.

In the course of nearly fifty flights over the Chicago metropolitan area, Evans spotted the subject of her next major project. At the industrial south end of the city, she made several flights over vast, dark steel mills [PL. 80]. Surprised, in part, that such heavy industries still existed in twenty-first century America, Evans received permission through a contact of Gerald Adelmann's to visit one on foot. Fascinated by the almost medieval nature of the mill—its size, heat, and noise—she embarked on a new project: Steel Work. Over a period of three years, 2005–7, she made more than thirty visits to steel mills at Indiana Harbor and Burns Harbor, Indiana; Cleveland, Ohio; and Coatesville, Pennsylvania [PLS. 81–85].

To some, the relevance of this subject to Evans's best-known series of landscapes and portraits was not immediately obvious. In fact, however, this work grew directly from her study of Chicago. And if Chicago represented the historical accretion of prairie-derived wealth, that wealth was expressed in the steel of the city's towering buildings. Furthermore, in the great contrast between prairie and city, agriculture and technology, the steel mill stood as a perfect exemplar of the forces of urbanization and industry. The classic nineteenth-century technology of steelmaking had long been a shrinking industry in the United States as a result of global competition. It was interesting for Evans to ponder the lifespan of technologies: the invention, flourishing, and potential demise of entire industries.

Steel suggested other symbolic connections to the natural world, beginning with the idea of the sublime. There may be few man-made things that genuinely evoke the awesome power of a violent storm or a tornado, but the interior of a steel mill probably comes close. A steel mill's vast size, noise, heat, and flames create a deeply visceral, otherworldly experience. It is an environment of immense forces and great danger, all in the service of a pre-modern kind of alchemy. This is as far from a quiet landscape as one can get, and yet, on some level, there is a shared sense of enormous power and of relentless transformation.

Evans was also interested in steel as an extractive industry, entirely dependent on iron ore, coke (carbonized coal), and limestone pulled from the ground. Steelmaking played a key role in the history of industrial land use and abuse. Logically, then, following her work inside steel mills, Evans made aerial photographs of open-faced iron-ore mines, limestone quarries, and coal mines in Minnesota and Kentucky [PL. 86]. She continued this work—at once seductive in form and dystopian in content—for nearly three years, from 2007 to 2009.

In 2008, as a result of her environmental interests and contacts, Evans was invited by the University of Kansas's Spencer Museum of Art to travel to Greenland to observe the work of the university's Center for Remote Sensing of Ice Sheets (CReSIS). In an attempt to measure and

predict the effects of global climate change, the CReSIS group was studying the melting of glaciers. Evans embraced the technical importance of this work, but also savored the astonishing and disorienting visual experience of the place [PLS. 87–89]. When working from the air, she noted, "I could not understand what I was seeing because there were no human markers below me on the ice." On the ground [FIG. 1; PL. 88], she observed that the rocky and treeless landscape of Greenland "was splendid to my eye. I kept remembering the prairies of Kansas."[39] Greenland was alien to her, but she remembered that the Kansas grassland had also begun as a mystery. She knew just as clearly that the natural world operates by a single set of rules: the forces that shaped the prairie were also at work in the Arctic. By extension, the vulnerability of the Arctic ice suggested the potential fragility of every ecosystem. In underscoring concerns about global climate change, this trip added something important to Evans's thinking about more familiar landscapes.

In 2011, Evans began her most consciously political project to date: North Dakota Oil Boom. This study was undertaken in partnership with Elizabeth Farnsworth, a writer and PBS *Newshour* special correspondent. Fascinated by reports of the frenetic oil and natural gas development in the region, and the controversy over the technology of "fracking," the two began making trips to North Dakota to see for themselves what was happening. They have interviewed both supporters and critics of the energy boom, and visited the temporary workers' settlements, or "man camps," that have sprouted up in and around Williston.

In North Dakota, Evans has applied the full repertoire of her photographic skills. Working from the air and on the ground, she is making landscapes, portraits, and studies of oil and gas operations [PLS. 90–102]. In many respects, this work draws on everything she has learned in forty years. Thus, it is important to note the distinctly pointed quality of this work—its synthesis of fact and opinion, elegy and anger. Evans's vision of North Dakota is far from comforting: it is one of nearly explosive development, the threat of environmental degradation, and deeply mixed human emotions.

Evans's feelings about the environmental impact of this work are clear. Her aerial photographs depict obvious violence to the landscape—the scraped clearings of individual drilling pads and the scars of roads and pipeline paths that connect them. Evans mourns this industrialization of the land with a clear sense of how quickly it is spreading across the region. Her portraits testify to the wrenching human complexities of this energy boom. The new wealth of energy production has saved some families from hardship but diminished the lives of others. Some North Dakota residents have willingly sold the rights to the minerals below the surface of their land; others have refused. Some landowners have been surprised to find that they do not own those rights and have no say over drilling activities on their property. Workers are grateful for weekly paychecks, while many farmers and ranchers protest the present reality and future potential of environmental damage. There are no easy answers, and the full consequences of this activity may not be clear for years. This is an enormously complex human story centering on the quality—and ethics—of our relationship to the land.

Farm

In more than forty years of activity with the camera, Terry Evans has achieved something akin to that first square of prairie grass she studied so long ago. Her life's work is at once singular in sensibility and enormously rich in its details. It is the product of a visual intelligence that has remained completely true to itself, while gaining sustenance from a myriad of resources and influences. Her work reflects a spirit of growth and change, curiosity and adventure, wholeness and balance. It is a celebration of beauty and of belonging, the forms of nature and the complexities of the human condition. There is an inspiring, organic logic to this achievement—the unity of nature's perennial cycles and the integrity of a well-lived life.

No matter how often or far Evans travels to photograph, she makes regular visits back to the family farm outside Salina. For many years, it has served as a pasture for horses and as a retreat for Terry and Sam Evans from their primary residence in Chicago. This place is home in several respects. It was first purchased by the Evans family when Terry's husband, Sam, was young. It is also near the eighty-acre virgin prairie that first made Evans a landscape photographer in 1978. Every return to the farm serves as a reminder of her maturity as an artist, and of the roots of her creative vision in *this* experience.

Not surprisingly, Evans has been making personal pictures at the farm for years. These include landscapes, exterior views of outlying buildings, interior studies of the house, and a quiet, poetic view of Sam reading outdoors by the warm glow of sunrise [PLS. 103–108]. There is no overarching theme in this series beyond a deep and abiding love of place—a passionate celebration of the intimate, the local, and the familiar. As an artist, Evans has made this place her own. That is entirely appropriate, of course, since the place has done so much to make her.

ENDNOTES

1 The following is indebted to Thurston Clark, *The Last Campaign: Robert F. Kennedy and 82 Days That Inspired America* (New York: Henry Holt, 2008), 19–50.

2 Ibid., 48.

3 For the original text of this speech, see "Remarks of Robert F. Kennedy at the University of Kansas, March 18, 1968," John F. Kennedy Presidential Library and Museum website, http://www.jfklibrary.org/Research/Ready-Reference/RFK-Speeches/Remarks-of-Robert-F-Kennedy-at-the-University-of-Kansas-March-18-1968.aspx.

4 "Trick Photos," *Everyday Science and Mechanics* (June, July, September 1932); "Nature and Wild Life," *American Photography* (February 1933); "How I Make Money," *Boys' Life* (ca. 1934–35). Norman Hoyt scrapbook; collection of Terry Evans.

5 Email from artist, July 3, 2012.

6 These include William Golden, Bob Dylan, Sir Herbert Read, Thomas Carlyle, Harold Rosenberg, Thomas Merton, Mary McCarthy, Wayne Thiebaud, Michelangelo Antonioni, Marshall McLuhan, Federico Fellini, Constantin Brancusi, Pablo Picasso, Claes Oldenburg, Richard Artschwager, Robert F. Kennedy, the Beatles, and H. Rapp Brown.

7 Personal notes, provided by the artist.

8 Ibid. McCarthy's essay was originally published in the February 1954 issue of *Harper's Magazine*.

9 Donald C. Bakely, with photographs by Terry Evans, *If… A Big Word with the Poor* (Newton, KS: Faith and Life Press, 1976).

10 The Robert Schoelkopf Gallery, in New York, presented the first of a series of Walker Evans exhibitions at the end of 1966. In January 1971, the Museum of Modern Art mounted a large retrospective of his work, accompanied by an influential book by the curator John Szarkowski, *Walker Evans* (New York: Museum of Modern Art, 1971). This show traveled to seven more museums across the United States and to nine in Europe. (For details on all these early exhibitions, see Appendix C, "Selected One-Person and Group Exhibitions," in Judith Keller, *Walker Evans: The Getty Museum Collection* [Malibu, CA: The J. Paul Getty Museum, 1995], 381–82.) Two years later, the Library of Congress published a complete visual inventory of Evans's FSA work: Jerald C. Maddox, *Walker Evans: Photographs for the Farm Security Administration, 1935–1938* (New York: Da Capo, 1973).

11 This point is made by Mark Rice, *Through the Lens of the City: NEA Photography Survey of the 1970s* (Jackson: University Press of Mississippi, 2005), 9–15.

12 Linda Gordon, *Dorothea Lange: A Life Beyond Limits* (New York: W. W. Norton, 2009), 411–13.

13 See Rice, *Through the Lens of the City*, 16–35; and Merry Foresta, *Exposed and Developed: Photography Sponsored by the National Endowment for the Arts* (Washington, D.C.: Smithsonian Institution Press / National Museum of American Art, 1984), 9.

14 After his time at the University of Kansas, Enyeart was executive director, Friends of Photography, 1976–77; director, Center for Creative Photography, 1977–89; director, George Eastman House, 1989–1995; and founding director, Marion Center, College of Santa Fe, 1995–2002.

15 Conversation with the author, May 29, 2012. This section is significantly informed by my conversation with Mr. Enyeart.

16 James Enyeart, Terry Evans, and Larry Schwarm, *No Mountains in the Way: Kansas Survey: NEA* (Lawrence, KS: University of Kansas Museum of Art, 1975), n.p.

17 This camera was a Christmas gift from her husband, Sam, in 1973.

18 Founded in 1971 by Peter Schlessinger, a former student of Minor White, Apeiron provided the model for the photographic workshop experience of the day.

19 Charles Harbutt, *Travelog* (Cambridge, MA: MIT Press, 1973).

20 Arguelles had recently published *The Transformative Vision: Reflections on the Nature and History of Human Expression* (1975), which Evans read with great interest.

21 Email from the artist, June 7, 2012.

22 James L. Enyeart, ed., *Kansas Album* (n.p.: Kansas Banker's Association, 1977), 2.

23 These observations are based, specifically, on the images on pages 10 and 11 of the *Kansas Album*.

24 Jim Alinder, ed., *Twelve Photographers: A Contemporary Mid-America Document* (Kansas City, MO: Mid-America Arts Alliance, 1978). Six of Evans's photographs are reproduced on pages 6–17.

25 Terry Evans, interview with Kaitlyn Bunch, December 19, 2011.

26 For a powerful introduction to this overall subject, see Richard Manning, *Grassland: The History, Biology, Politics, and Promise of the American Prairie* (New York: Penguin Books, 1995). Also recommended are Stephen J. Lavin et al., *Atlas of the Great Plains* (Lincoln: University of Nebraska Press, 2011); and Candace Savage, *Prairie: A Natural History* (Vancouver, B.C.: Greystone Books, 2011).

27 *Random House Webster's Dictionary* (New York: Ballantine Books, 1996), 291.

28 Email from artist, June 30, 2012. This idea is central to Bateson's late meta-science of epistemology, *Mind and Nature: A Necessary Unity* (1979).

29 The Fibonacci numbers begin with 0 and 1, followed by the sum of the previous two numbers in the sequence; thus, 0, 1, 1, 2, 3, 5, 8, 13, 21, 34, etc. This sequence describes a host of natural phenomena, including the branching of tree limbs, the structure of pinecones, the spiral of seashells, and the curl of a breaking wave.

30 Terry Evans, *Prairie: Images of Ground and Sky* (Lawrence: University Press of Kansas, 1986), 14.

31 Ibid.

32 See, for example, Robert Adams, *From the Missouri West* (Millerton, NY: Aperture, 1980).

33 The latter was on view from March 13 to June 5, 1983, and documented in Thomas W. Southall, *Terry Evans/Earl Iversen: Kansas Photographs* (Lawrence, KS: Spencer Museum of Art, 1983).

34 My thanks to Mr. Southall for his insight on these years and, in particular, for emphasizing the importance of the Political Landscape conference of 1989.

35 Phone conversation with Saralyn Reece Hardy, July 12, 2012. I am deeply grateful to Ms. Hardy for her precise and insightful articulation of these important issues.

36 Artist's project statement.

37 Email from artist, July 9, 2012.

38 William Least Heat-Moon's *PrairyErth (A Deep Map)* (Boston: Houghton Mifflin, 1991), presents a richly textured study of the land, people, and history of Chase County.

39 Artist's project statement.

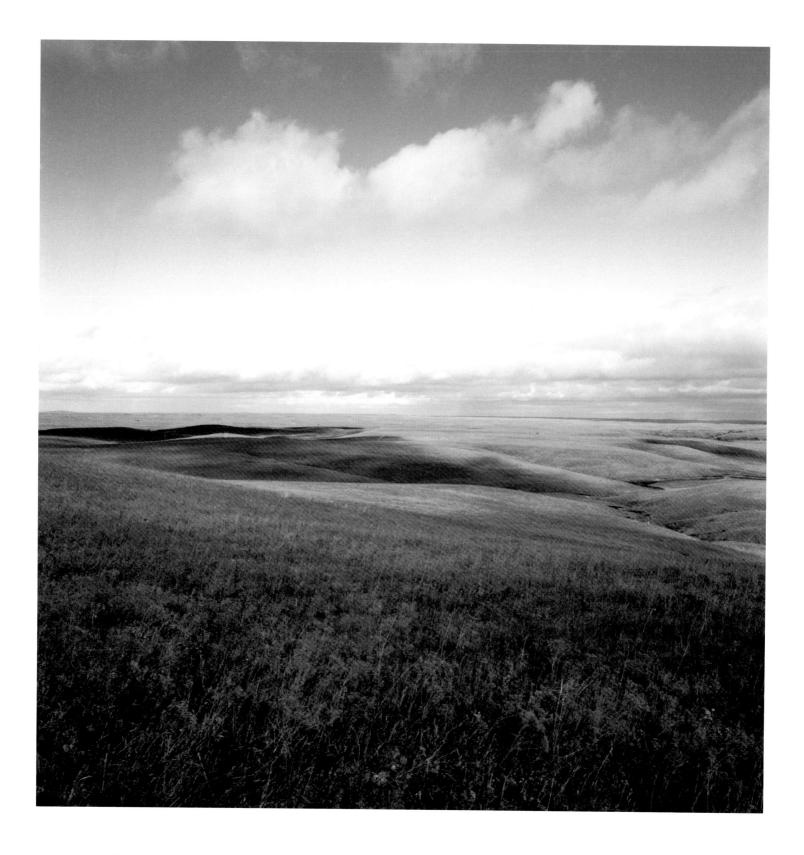

PLATE 1 *Bluestem grassland, Chase County, Kansas,* October 31, 1979.
Chromogenic print. Collection of the artist.

ROOTED IN HISTORY

Depictions of Prairie

BY JANE L. ASPINWALL

Associate Curator of Photography
The Nelson-Atkins Museum of Art

Many Midwest residents and visitors have had this experience. We find ourselves walking through an open field, dry grass crunching under our feet, the sun on our backs. Through the tall, dense grass, it is difficult to see exactly where to take the next step. Bugs fly though the air; their buzzing and the sound of the wind ring in our ears. We can imagine that the field is endless, stretching as far as the eye can see. It is easy to lose track of direction—which way you've come and which way you still need to proceed. This was the experience of the first visitors to the North American prairie. Today, experiences such as this are more difficult to realize. Areas of virgin prairie are relatively small, and man-made landmarks are not difficult to spot—much of this terrain has been transformed by farming and suburban growth.

There are a few people, however, who are still able to experience some of the wonder of this earlier time. Terry Evans, a native to the prairie landscape, has a deep understanding of both its history and its complexity. Evans has devoted most of her professional life to photographing the prairie and has walked many miles through such terrain. And although the prairie is far from its former size, it is still a wonderful and fascinating place. In her words, "The prairie is a subtle landscape; it demands our attention. When we look at it closely, we can see amazing details. Sounds, smell, the wind, the light changing every second . . ."[1]

Evans's photographs are part of a much larger tradition of depicting the prairie landscape. They are indebted to images of and ideas about the prairie—both realistic and romanticized—from the histories of art, literature, and photography. Over time, explorers, painters, writers, and photographers have all used their own unique resources to understand and to reconcile their impressions of this space. Reactions to the prairie have always been mixed. Early visual artists like George Catlin and Charles Savage were overwhelmed and confused by the size and openness of the prairie. Others, like Alexander Gardner, appreciated and admired these same qualities. Early writers like James Fenimore Cooper saw the vastness of the prairie as something to be feared and ultimately conquered. Twentieth-century authors like Willa Cather present an opposing but complementary perspective, evoking a nostalgic view of the pre-settled prairie. In the 1930s, after the prairie was well populated, the Farm Security Administration photographers documented the social realities of the changing prairie economy and the dire results of environmental catastrophe.

Terry Evans's first artistic encounter with the prairie occurred in 1978 when a friend asked her to photograph some survey work in a plot of virgin grassland. Although Evans had grown up in and around the state of Kansas, the prairie had never been a subject for her camera. Her initial reaction on her first encounter in March 1978 was underwhelming; because of the time of year, most of the plants were dormant and there was little to see. But when she returned several weeks later, she was enthralled with all that grew. At first, Evans was not drawn to the endless expanse of prairie that had fascinated and frustrated the photographers of the nineteenth century. Instead, she was interested by what she observed at her feet: a complex ecosystem of flora and fauna. Evans would continue

to photograph in a vertical mode, straight down at the grasses beneath her, for about a year. Eventually, she raised her viewpoint to include the horizon and sky. In search of larger prairie patterns that could be seen only from above, she ultimately opted for an aerial perspective. Comparable explorations of an elevated vantage point can be found in the work of her nineteenth-century predecessors: in the literature of Cooper and William Cullen Bryant, and also in the art of Catlin, Savage, and Gardner, to name but a few. In her quest to "tell the prairie's stories, past and present," Evans not only acknowledges the pictorial representations that have preceded her, but adds significantly to the ongoing dialogue with this landscape. In this essay I provide a brief survey of several key historical figures—painters, writers, and photographers—as a means of contextualizing Evans's creative vision. This is, in her words, a vision that "weaves together history and memory, ecology and beauty and thus suggest[s] a story of a particular place."[2]

Defining the Prairie

The North American prairie, a term often used interchangeably with "Great Plains," refers to a large swath of land created sixty-five million years ago after the emergence of the Rocky Mountains.[3] Over time, as these mountains eroded, the resulting sand, silt, and gravel were carried eastward by streams and deposited in vast deltas that eventually became the prairie. Although the exact geographic boundaries are open to debate, the prairie is generally considered to range from Saskatchewan, Canada, southward to central Texas. This expansive region is made up of eastern Montana, eastern Wyoming, North Dakota, South Dakota, western Minnesota, Nebraska, western Iowa, Kansas, eastern Colorado, western Missouri, Oklahoma, and eastern New Mexico.

More than just a geographical area, the prairie supports a complex ecosystem protected by a tangle of deeply rooted grasses naturally resistant to erosion. The soil and rock below are permeable; water filtered through these layers created the High Plains Aquifer, a subterranean lake extending from southern South Dakota into Texas. Although the prairie is generally considered flat, its physical geography is actually quite diverse. Over half of the prairie consists of irregular plains and tablelands; another 25 percent is hills and bluffs, leaving less than 25 percent as recognizably flat. The climate of the prairie is one of extremes: a combination of hot and cold temperatures; droughts and floods; blizzards, hail storms, and tornadoes.

Early Perceptions: Explorers, Writers, and Artists

The prairie is a distinctly North American landscape. Europeans first visiting the heart of the continent found a terrain at odds with what they knew of western Europe. Instead of mountains, forests, and rivers, the prairie presented a vast space almost devoid of landmarks. In 1540, one of the first explorers of the North American continent, the Spanish conquistador Francisco Vásquez de Coronado, who was searching for gold in present-day Kansas, found the prairie confounding. The only way he could keep his party from getting lost in the vast space was to mark his path with piles of buffalo dung and bones. Coronado and many subsequent explorers would write off the prairie as hopelessly inhospitable, calling it "almost wholly unfit for cultivation" and dubbing it "the Great American Desert."[4]

The next wave of visitors in the early nineteenth century—including Zebulon Pike in 1810 and Major Stephen Long in 1820—came with some prior knowledge of the landscape.[5] Many of these visitors were writers, and their first impressions often resulted in first-person travel accounts like Washington Irving's *A Tour on the Prairies* published in 1832. From about 1827 to 1865, the written text was the primary means by which the prairie was initially described. Some writers traveled exclusively to see the endless expanse of grass, and their writing reflects a greater appreciation for the unique qualities of this landscape. Others who never physically visited the prairie tended to use it as the backdrop for more metaphoric journeys.

For the novelist James Fenimore Cooper, the prairie was appealing for its symbolic value.[6] Never having visited the prairie himself, Cooper relied on other first-person accounts to assist with landscape detail. Drawing on Henry David Thoreau's notion of the far distance as the place where "sky meets the sand," and where "heavens and earth, the ideal and the actual" join, Cooper transformed the prairie landscape from an actual experience into a symbolic imagining.[7] In his novel *The Prairie*, published in 1827 as the fifth of his Leatherstocking Tales, Cooper portrayed the prairie as a wasteland, a barrier to settlement.[8] His descriptions compared its uniformity to the endlessness of the sea. Through the use of this prairie/sea analogy, and by employing classic ideas of the sublime to convey man's insignificance in relation to nature, Cooper made a foreign landscape imaginatively accessible to his audience. By transforming the prairie landscape into a symbolic and mythic experience for his characters, Cooper was teaching his audience to read it.

In *The Prairie*, Cooper described the difficulties encountered in traversing the land: "The wind swept across the wild and naked Prairies

with a violence that is seldom witnessed, in any section of the continent less open. It would have been easy to have imagined, in the ages of Fable, that the god of the winds had permitted his subordinate agents to escape from their den."[9] Like most travelers to the prairie, Cooper sought to understand the vastness of the landscape by experiencing it from an elevated perspective. Many visitors to the prairie, including early survey photographers, did exactly that, climbing any hill within sight. But even from moderate height, Cooper observed, perceptions were challenged and distant objects were difficult to discern.

Another notable writer, the romantic poet and journalist William Cullen Bryant, traveled to the prairie in 1832. He experienced a range of emotions: after a very unfavorable initial reaction, he conceded that "some of the views, from the highest parts of the prairies are what . . . some would call beautiful in the highest degree."[10] Although Bryant had favorably reviewed Cooper's book *The Prairie* in 1827, nothing prepared him for his own encounter with this alien landscape. Upon further contemplation and physical distance from the landscape, however, Bryant wrote the poem "The Prairies" (1833), which extolled the virtues of the vast space: "These are the gardens of the Desert, these / The unshorn fields, boundless and beautiful, / For which the speech of England has no name— / The Prairies. I behold them for the first, / And my heart swells, while the dilated sight / Takes in the encircling vastness."[11] Bryant's poem closely echoes the sentiment of Cooper's book, suggesting the beginning of a literary genre in prairie landscape depiction.[12]

Other notable writers of the nineteenth century turned to this landscape for inspiration. After visiting the prairie in 1840, Herman Melville also likened the undulating, unending space to that of the ocean, an allusion he would use in his famous novel *Moby-Dick* (1851). Walt Whitman made enthusiastic early references to the prairie, although his first visit did not take place until 1879. Even the humorist Mark Twain made a journey across the prairie in 1861 on his way west; these accounts were detailed in his book *Roughing It* (1872).

Visual artists shared the dilemma of depicting a terrain that was unfamiliar and devoid of classic landscape tropes. They confronted similar problems when looking at the prairie: issues of vastness and sameness compounded with the danger of disorientation. Because the prairie had no obvious art-historical precedent, traditional compositional ideas were inadequate. The lack of trees ruled out framing devices for each side of a composition; picturesque winding paths or roads were problematic given the lack of settled areas and the seemingly infinite horizon line. Even the traditional use of elevated perspective as a way to visually define space

FIG. 11 George Catlin, American (1796–1872). *Prairie Meadows Burning*, 1832. Oil on canvas. Smithsonian American Art Museum, Gift of Mrs. Joseph Harrison, Jr., 1985.66.374.

was difficult in the face of the land's size and apparent featurelessness. Because the prairie had no recognizable prospect, it was deemed unsuitable—or at least immensely challenging—as an artistic subject. Many painters simply threw up their hands and avoided attempting to represent it altogether.

The first painter of note to seriously engage the prairie landscape was George Catlin.[13] Catlin had gained some renown as a portraitist, first in Philadelphia and later in Albany. He was especially intrigued by the American Indians he painted in his portrait studio or on reservations. Desiring to record these disappearing tribes, Catlin journeyed to the prairie five times in the 1830s to paint the Plains Indians and their way of life. In many renderings, Catlin devoted remarkable attention to the prairie: instead of designating a small portion of his composition to the landscape, Catlin made entire canvases of these scenes. His paintings and sketches were accompanied by a written account of his travels in which he defended the beauty of the land. However, he also acknowledged the stretches where one is "out of sight of land i.e., out of sight of anything rising above the horizon"; where "the pedestrian over such a discouraging sea of green, without a landmark before or behind him; without a beacon to lead him on, or define his progress, feels weak and overcome when night falls; and where he stretches his exhausted limbs, apparently on the same spot where he has slept the night before, with the same prospect

before and behind him."[14] Catlin also applied traditional art-historical notions to the prairie landscape, using the word "sublime," for example, to describe a raging prairie fire [FIG. 11].

Despite his love for the prairie, Catlin's paintings conveyed the difficulties presented to all visual artists by this unfamiliar landscape. In many of his scenic views, for example, he added bluffs that were not actually there to help balance his composition. Similarly, he used dramatic vantage points that transformed small hills into large and looming ones. Conversely, another American painter, Alfred J. Miller, who traveled to Nebraska just after Catlin's prairie experiences, depicted the more usual reaction to the prairie. Miller's paintings often contained a forlorn figure desperately searching for a landmark in the hopes of navigating through the tall waving grass, thus reinforcing the fear of disorientation prevalent among prairie travelers.

At roughly the same time that Catlin was first visiting the prairie, settlers were moving in to establish homesteads. They immediately set about creating landmarks in the form of houses, barns, trees, fields, fences, and roads. By the mid-1840s, daguerreian artists, often working as itinerants, followed these settlers into frontier towns, documenting what was being built and planted. Later photographers made their way to the prairie for a myriad of reasons. Some were documenting American Indian life; others were employed by government-sponsored surveys to map and study the natural resources of the region; still others charted proposed and actual railroad routes.

The first photographs taken of the prairie were daguerreotypes, but these early plates are too rare to definitively document it.[15] Many of these views focused on the construction of buildings, farms, and houses, and—by implication at least—the decreasing presence of American Indians [FIG. 12]. John F. Fitzgibbon was one of the first known daguerreian artists to photograph the early frontier. Fitzgibbon established his studio in 1847 in St. Louis, where he worked for the next ten years. Although portrait photography was central to his business, Fitzgibbon also traveled the area around St. Louis, photographing frontier scenes, river boats, and Indian chiefs. In a remarkably systematic way, Fitzgibbon attempted to capture a frontier life that was quickly receding.[16]

Early exploration parties also made use of photography. Colonel John Frémont organized an exploration party in 1853 that began at Westport, Missouri, and ended just outside of Salt Lake City. Frémont's party included the daguerreotypist Solomon Carvalho, who found the prairie landscape "sublime" and "felt the conviction of [his] own insignificance, in the midst of the stupendous creation." He noted, "Undulating grass

FIG. 12 Unknown maker. *House on Prairie*, ca. 1855. Daguerreotype. Gift of Hallmark Cards, Inc., 2005.27.100.

seemed to carry my thoughts on its rolling surface, into an impenetrable future."[17] As the party traveled through Kansas, Carvalho made portraits of the American Indians in the region. Unfortunately, because of the limitations of the daguerreotype process, Carvalho's landscape views were far from satisfactory. For example, he had to be content picturing distant herds of buffalo rather than close-up views—the constant motion eluding the capacity of the early daguerreotype process. At the end of the expedition, these plates were brought to New York by Frémont, who saw them as containing "valuable evidence concerning the character of the country."[18] Unfortunately, almost all of Carvalho's original views were subsequently lost in a fire; the only evidence that remains of this group lies in the few copies created by artists and engravers to illustrate Frémont's report and memoirs [FIG. 13].[19]

As the technology of photography evolved beyond the daguerreian process, prairie photographers were able to work in much larger formats than their predecessors. The invention of the wet-plate collodion process also allowed multiple prints to be made from a single negative. Of course, photographers continued to grapple with the same visual issues as before: a lack of identifiable geographic features; the utter starkness of the grassland; and few significantly elevated vantage points.

In 1866, the photographer Charles Savage found the prairie scenery less than inspiring, writing: "There is a certain monotony connected

with the overland route, and the more one sees of it the less he will admire it."[20] After practicing the daguerreotype process in New York City, Savage adopted the wet-collodion technique and set up a studio in Florence, Nebraska, in 1860. He photographed there only a short time before going west to Salt Lake City. In 1866, however, Savage returned east to restock his supply of photographic materials, using his return trip across the prairie to take scenic views. On this trip, Savage observed, "The road from Nebraska City to Fort Kearney presents but few objects of special interest to the photographer. I secured negatives of one or two of the overland stations, and a few rural scenes not remarkable for any particular features different for the same genre of subjects elsewhere [FIG. 14]." His opinion did not change after reaching Ft. Kearney: "The road follows the Platte Valley and a more uninteresting road can hardly be found. Very few trees to be seen, and what with the swarms of green flies and mosquitoes, and the strong wind that blows regularly every day, your photographic enthusiasm gets cooled down so much that you see nothing worth taking. . . . Added to this, you are never free from Indian attacks."[21]

As travelers and settlers pushed further into the frontier, the danger of disorientation was replaced by the threat of hostile American Indians. Although many of the newly settled residents on the frontier had civil trading relationships with local tribes, attacks by rogue bands of warriors remained a constant worry. One unfortunate photographer, Ridgway Glover, had left Philadelphia in the summer of 1866 for the purpose of securing photographs "to illustrate the life and character of the wild men of the prairie."[22] In September 1866, while taking views near Ft. Kearney,

Nebraska, Glover and his companion were "scalped, killed, and horribly mutilated."[23] Although most of Glover's negatives were lost, a few were recovered and published as engravings.

As railroad companies worked to complete the first transcontinental line, government-sponsored surveys investigated other possible routes. Survey parties with an accompanying photographer were sent to document the terrain in various parts of the West, and nearly all these routes went through some portion of the prairie. Shortly after the Union Pacific began construction of its transcontinental line in Omaha in 1866, John Carbutt, a Chicago-based photographer, accompanied an elaborate excursion 250 miles west of Omaha to the 100th meridian. This trip was organized by T. C. Durant, vice president of the railroad, as a means of attracting eastern commercial investment. A grand affair, the excursion party included "two hundred and fifty of the most distinguished citizens," two brass bands, reporters, a staff of chefs, a French marquis, an English earl, commissioners, and directors.[24] Most of Carbutt's photographs are group portraits of the excursion party. However, the following year, without this entourage, Carbutt traveled the same road and spent a month photographing the plains. He focused on Indian camps and views of the train tracks and the surrounding landscape. In many of the views, he used a high horizon line, leaving the foreground looming large and his human subjects small and insignificant in the landscape.

Alexander Gardner may have been the first photographer to truly appreciate the unique qualities of the prairie. After immigrating to the United States in 1850, Gardner was employed in the New York City studio

FIG. 13 *Among the Buffalo*, from *Memoirs of my life* by John Charles Frémont, 1887. Engraving after a daguerreotype by Solomon Carvalho, American (1815–1897). Linda Hall Library of Science, Engineering & Technology, Kansas City, Missouri.

FIG. 14 Charles Savage, American (1832–1909). *O'Fallon's Bluff*, 1866. Albumen print. Nebraska State Historical Society, Lincoln, Nebraska, RG2154:8-27.

FIG. 15 Alexander Gardner, American, b. Scotland (1821–1882).
Salina, Kansas, 1867. Albumen print. The J. Paul Getty Museum, Los Angeles, 84.XM.1027.18.

FIG. 16 Alexander Gardner, American, b. Scotland (1821–1882).
Three Chiefs, Fort Laramie, Wyoming, 1868. Albumen print. Gift of Hallmark Cards, Inc., 2005.27.253.

of Mathew Brady. He headed Brady's effort to document the Civil War and in 1862 opened his own studio in Washington, D.C. In 1867, Gardner joined the survey team of the Union Pacific Railroad, Eastern Division. The railroad was promoting plans for an extension of its route from Kansas to the Pacific Ocean. This proposed route—through the central prairie, the mountains of Colorado, and the deserts of New Mexico, Arizona, and California—was intended to accommodate the demands of various Indian tribes while providing access to the markets of the West. Gardner's photographs, compiled in the series *Across the Continent on the Kansas Pacific Railway*, were meant to illustrate the ease of future railroad construction and the potential of the region for economic development. These included ethnographic studies of Indians, records of rock formations, and botanical studies of indigenous vegetation. This 1867 series represents the earliest systematic photographic documentation of the Great Plains: of the 127 known plates, nearly 50 are devoted to the central prairie.

Although Gardner was sympathetic toward the prairie, it remained a challenge to depict. His photographs embraced a wide range of subjects and varied considerably in visual approach. Some focus on one clear theme, while others seem distinctly disorganized; some are gracefully orchestrated, while others are starkly minimal [FIG. 15]. However, in the context of this series as a whole, Gardner's mastery becomes evident. Throughout this work, Gardner used the railroad as a unifying visual thread, a formal and thematic complement to the prairie itself.[25] Taking compositional cues from the prairie (levelness, great distance, low horizon), his photographs emphasize the gentle grades of the region. While other government-sponsored surveys came back with evidence of difficult terrain and daunting construction challenges, Gardner's emphasized the appeal (from an engineering standpoint) of the prairie landscape.

The use of the railroad as a visual benchmark served several purposes. It promoted the importance of the railroad and the ease with which tracks could be laid west. Ground was level, water was available, and towns provided needed accommodation and supplies. Safety was also an issue: the military presence was apparent in the views of established forts. The Indian presence was suggested in views of ancient hieroglyphics and peaceful settlements—reservations and missions—embedded within the landscape. To knit together a complete picture of the prairie, Gardner alternated between bustling town views, transportation routes, hunting scenes, geological and botanical specimens, and even a few views of the flat, limitless prairie. In the latter images, Gardner variously used a low horizon line to stress the vastness of the sky, or a high one to emphasize the breadth of the land and the height of the grass.

Gardner returned from his survey work in spring 1868 and almost immediately undertook another assignment in the West: to document the peace talks with the Indian tribes at Ft. Laramie, Wyoming. Gardner was part of an Indian Peace Commission made up of both commissioners sympathetic to the Indian cause, and military personnel fully committed to a more permanent "solution" to the Indian issue. In this series, Gardner continued to use the landscape as an important element in his compositions. He made group portraits of American Indian chiefs standing outside—the figures looming large in the foreground as the prairie fades to softness in the far distance [FIG. 16].

The Prairie, 1860s–1930s

After the Civil War, national attention turned west and to the Great Plains. The prairie was seen as a tabula rasa onto which ideas of national identity and destiny could be projected. The railroad was the unifying force that would bring the country together as one entity and expand its boundaries to vast economic possibilities. The prairie had long been seen as a space that needed to be tamed and conquered; federal and corporate enterprise promised to transform this "desert" into a verdant garden. With the Homestead Act of 1862 and the completion of the transcontinental railroad in 1869, more and more emigrants traveled through and settled on the prairie.[26] The frontier was rapidly domesticated, as American Indian tribes were disarmed and relocated on reservations. With the invention of barbed wire in 1874, huge portions of free-range prairie were transformed into individual plots for grazing or farming. Soon, the former pioneer was thought of as an agricultural industrialist, an idea promoted by journalism of the period.[27] The *Western Monthly*, a trade magazine first published in Chicago in 1869, proclaimed the virtues of the prairie. Filled with the biographical profiles of prominent men who had created fortunes by taming the former prairie wilderness, the magazine extolled this land as the place for entrepreneurial spirit to flourish. It is interesting, however, that none of the men featured in these profiles made their fortunes through farming. In becoming bankers, railroad owners, and mining investors, these men established their identities—and their fortunes—through finance or industry.

As the landscape came to be viewed less as an area to move through and more as a place to live, the prairie novel helped transform the notion of the prairie from a place full of alien images into a symbolic realm somewhere between realism and romanticism. Settlers saw the prairie

from one fixed place, with only the weather and the human presence to vary the view. Early writers such as E. W. Howe (*The Story of a Country Town*, 1883) and Joseph Kirkland (*Zury: The Meanest Man in Spring County*, 1887) were the first to depict the prairie as a settled landscape. The American realist author Hamlin Garland (*Boy Life on the Prairie*, 1899) was a prolific writer on the prairie experience, drawing from memories of his own Midwestern upbringing. Garland's writing about the bleak prairie of the Dakotas continues the legacy of the elation/deflation experiences of early prairie explorers and travelers: a combination of fascination and revulsion for the austere, endless landscape.

Willa Cather's prairie novels of the 1910s–30s pay tribute to the prairie's pioneers. Considered by many to be the first significant novels about the Great Plains, Cather's books provide the model narrative: pioneering, settling the land, and coming to understand and appreciate the prairie's foreignness. Although earlier writers certainly wrote about the prairie, Cather was the first to use this landscape as a central "character" and not simply as a setting. Loosely based on her childhood experience of moving to Nebraska from Virginia, Cather's novels represent a coming to terms with the strangeness of this landscape. Through her various plots, Cather explored the settlement of the prairie as a uniquely American experience and investigated the human effect of being transplanted to what was, in essence, an entirely new country.

In her earliest novels, Cather's characters struggle to understand their prairie environment. Writing in polarized terms, Cather described the land as both open and flat, desolate and spacious. Many times, the prairie landscape destroyed homesteaders' spirits, eluding their efforts to comprehend its vastness or to cope with its powerful natural forces. But once the prairie was settled and the characters forgot their old traditions, Cather's viewpoint changed from realism to romanticism. When the harshness of the prairie was filtered out, what remained was the mythic landscape, one that was remembered nostalgically once it was safely in the past. Generations to come would read Cather's novels in an attempt to understand and appreciate this uniquely American region.

Although he is recognized as a western writer, Wallace Stegner's early literary themes centered on the prairie and pioneering. Born in Iowa, Stegner spent his early years moving between Montana, Utah, and Saskatchewan, Canada. In his book *On a Darkling Plain*, published in 1939, Stegner recognized the recuperative power of the prairie. Instead of highlighting the isolating nature of the space, Stegner saw the reality of being alone as an opportunity for introspection and growth. He acknowledged the wonderful strangeness of the prairie; the sheer size of the open plain emphasized man's insignificance in Nature. Like others before, Stegner's characters feel stymied when it comes to describing the prairie landscape; words are totally inadequate for the actual experience: "That is the magnificence of this country. It takes my breath sometimes, the sweep of it. But I can't get a flash of it into poetry that satisfies me."[28] Stegner returned to the plains landscape in 1962 in the book *Wolf Willow*, based on his boyhood home in Saskatchewan, where his family had homesteaded in the 1910s.

The Depression and Beyond

By the early twentieth century, nearly half of the tall-grass prairie had been plowed and many of the wetland areas had been drained. Once, a single acre of prairie had supported over a hundred different species of plants and grasses; now, increasingly, vast fields were devoted to a single crop. In the false belief that "rain would follow the plow," farmers plowed more and more of the original prairie, exposing formerly protected soil to the forces of wind erosion. By the mid-1930s, the prairie landscape had been completely transformed by cultivation, excessive grazing, and drought.[29]

American farmers were already reeling from bad years in the 1920s, and the Depression left them in terrible shape. By 1929, nearly one-third of all farms (some 1.7 million in all) had a gross yearly income of less than $600. In 1933, President Roosevelt proposed a program to help poor farmers. The Agricultural Adjustment Administration aimed to raise agricultural prices to a level capable of supporting a family. To do this, farmers were paid to take land out of production in the hopes that reduced yields would lead to higher prices. In the end, this scheme was successful only for large farmers. Small farmers had little land to leave idle, and in the Midwest, where renting was common, thousands of families were permanently put off their land. Most displaced workers migrated west in the hope of picking up work in California. Others stayed, trying to scrape crops out of worn-out soil.

The photographs that have become iconic of the American experience during this time were created by the Farm Security Administration (FSA). This agency, originally called the Resettlement Administration, was formed in 1935 to help solve the problems of the rural poor: small landowners and tenant farmers who had been in a steady state of economic decline. A photographic division, headed by Roy Stryker, was created to document economic conditions and the government's relief programs. While the division was clearly intended to serve government

FIG. 17 Arthur Rothstein, American (1915–1985). *Farmer and Sons in Dust Storm, Cimarron County, Oklahoma*, 1936. Gelatin silver print. Gift of Hallmark Cards, Inc., 2005.27.4330.

FIG. 18 Wright Morris, American (1910–1998). *Abandoned Farm and Windmill, Western Nebraska*, 1947. Gelatin silver print. Center for Creative Photography, University of Arizona, 2003.6.15. © 2003 Arizona Board of Regents.

interests, Stryker employed a total of eleven photographers between 1935 and 1943 "to record what they saw, really saw: people, towns, roads signs, railroad stations, barber shops, the weather, or the objects on top of a chest of drawers."[30] He directed the activities of his team by issuing detailed "shooting scripts," resulting in a historical visual archive of 1930s America. In his "Suggestions for Pictures to Be Watched for in the Plains Country—Kansas, Nebraska, Eastern Colorado, Wyoming, and Montana," Stryker requested "shots which give the sense of great distance and flat country . . . house; barn and windmill on horizon; lots of sky." He directed his photographers, "Search for ideas to give the sense of the loneliness experienced by the women folks who helped settle this country . . . an abandoned dwelling on a plains homestead."[31] Although Stryker attempted to guide his photographers to produce images that were purely documentary and not overtly artistic, inevitably many images transcended the specific subject depicted to address larger humanistic issues and ideas.

Many of Stryker's photographers worked in the Great Plains, including Dorothea Lange, Russell Lee, Carl Mydans, Marion Post Wolcott, John Vachon, and Arthur Rothstein. Although none of them could be considered pure landscape photographers, their images clearly reveal the transformation of the prairie from verdant garden into something like the American desert so feared by the earliest explorers of the region.

John Vachon's initial reaction to the landscape of Nebraska, in 1938, was less than inspired: "I was awake as we went thru Omaha. I was kind of disappointed, because it looks so damned unspectacular, ordinary. It looks like it will be tough to photograph."[32] When he reported later in 1942 after driving from Ft. Smith to Tulsa, the landscape took a backseat to the dire human circumstances Vachon saw all around him: "real grapes of wrath stuff, shacks and tin houses, all those starved faces."[33]

In 1936, Arthur Rothstein traveled to the Dust Bowl of Oklahoma, Kansas, and Texas to photograph the effects of erosion and drought. Most

of these photographs focused on people, but in several the prairie terrain is stark and the few structures that remain appear overwhelmed and fragile. In Cimarron County, Oklahoma, he shot his best-known image of a farmer and his two small sons in a dust storm [FIG. 17]. In South Dakota, Rothstein later photographed a steer skull on the parched earth. These photographs have become symbols of both the environmental and the human toll of the prolonged drought.

Stryker fully understood the usefulness of the written word to support the impact of his team's photographs. In addition to his shooting scripts, Stryker recommended books to be read by his photographers before and during their trips to the prairie. In 1941, for example, he recommended *The Great Plains* by Walter Prescott Webb and *A Son of the Middle Border* by Hamlin Garland.[34] Additionally, to ensure that each image was tied to an unambiguous narrative, Stryker insisted that his photographers submit detailed captions for every shot. It was clear that the meanings of the photographs were powerfully shaped by the captions written to accompany them. Without this supplemental information, each photograph possessed the ability to tell many different (and more universal) stories.

Perhaps more than any other interpreter of the Midwest, Wright Morris connected all these threads—the historical literary traditions, the practice of descriptive captions, and the making of well-crafted photographs—into one body of artistic work. After growing up in a small town in Nebraska, Morris became a writer while working casually with the camera. Fascinated by the connection of words with images, Morris began to experiment with "photo-texts." In 1939–40 and again in 1942, he took lengthy cross-country trips to make photographs and notes. The result of his 1942 trip was the book *The Inhabitants* (1946), which combined photographs with a fictional text focusing on the lives and thoughts of people who may have lived in the places he encountered. In 1947, Morris returned to Nebraska to photograph on his uncle's farm near Norfolk. Again uniting text and images, *The Home Place* (1948) included pictures of common, well-worn farm objects, speaking to the simplicity of a vanishing way of life [FIG. 18]. In *The Home Place*, Morris writes: "What is it that strikes you about a vacant house? I suppose it has something to do with the fact that any house that's been lived in, any room that's been slept in, is not vacant any more. From that point on it's forever occupied . . . with the people gone, you know the place is inhabited."[35] In this way, Morris eloquently echoes the longing for the prairie past felt by writers Willa Cather and Wallace Stegner.

Terry Evans and the Prairie

Terry Evans's work reflects a deep sympathy for the tradition of prairie literature and photography. In her earliest prairie photographs, Evans searched for a vantage point that would convey the wonder she felt—first looking at the native grasses at her feet, then encompassing more distant views of land and sky, and finally taking in large sections of the prairie as seen from above. In her Specimens series—examples of prairie flora and fauna in the collection of the Field Museum in Chicago—Evans embraced a more systematic way of documenting her understanding of the place and its history. Like the writers who have gone before her, she understands the prairie as both a natural and a human subject. In her series on Matfield Green, she photographed a small rural community located in east-central Kansas. Evans made repeated visits to Matfield Green over a number of years, even locating her darkroom there for a time. Her photographs of people and structures underscore her commitment to documenting the rich reality of life in a modern rural community. While the motives of the FSA photographers from the 1930s may have been different from Evans's, they share a deep commitment to a fundamentally human story: the essential connection between people and the land. Even the photographs taken at Evans's family farm near Salina, Kansas, or in the town of Matfield Green of everyday objects and structures pay implicit homage to the work of Wright Morris.

The prairie landscape remains a visual quandary to this day. Visitors driving through often fail to appreciate its subtle beauty, instead labeling it monotonous and dull. What they miss is the prairie's complexity, its multilayered history. Over the past 150 years, the prairie landscape has been completely transformed by farming and by urban and suburban development—so much so that it is difficult to imagine what early travelers saw and felt. It is the richness of this story that attracts Terry Evans to the prairie, for, above all, she is a story finder and storyteller. Through her photographs, Evans has learned not only to look for abuse but also to see patterns of use as stories in the land, "layers of loss and recovery, and loss again."[36] Evans recognizes in the prairie the traces of what has gone before and what is destined to come: a single record of past and present, virgin and damaged land, human concern and human disregard. It is through her understanding of the interconnectedness of the land, people, and time that Evans hears the stories of the prairie and conveys them eloquently to all who care to listen.

ENDNOTES

1 Cited in Andy Grundberg, ed., *In Response to Place* (Boston: Bulfinch, 2001), 68.

2 Robert F. Sayre, "Sizing Up the Country," in *Recovering the Prairie* (Madison: University of Wisconsin Press, 1996), 204.

3 The following section is greatly informed by David Wishart, "Settling an Unsettled Land," in Michael Forsberg, *Great Plains* (Chicago: University of Chicago Press, 2009), 25-40.

4 Stephen Long, "General Description of Country Traversed by the Exploring Expedition between the Meridian of Council Bluffs and the Rocky Mountains," in Edwin James, *Account of an Expedition from Pittsburgh to the Rocky Mountains, Performed in the Years 1819 and '20*, in Reuben Gold Thwaites, ed., *Early Western Travels, 1748–1846* (Cleveland: Clark, 1904–7), 17:147–48.

5 Zebulon Pike traversed the Great Plains in 1806 and 1807. Major Stephen Long explored the area between Council Bluffs and the Rocky Mountains in 1820.

6 On the subject of literary prairie traditions, I am indebted to the work of Robert Thacker, *The Great Prairie Fact and Literary Imagination* (Albuquerque: University of New Mexico Press, 1989), and Robert Thacker, "Landscape and Technique: The Background and Development of the North American Prairie Novel" (Ph.D. diss., University of Manitoba, 1981).

7 Henry David Thoreau, *The Journal of Henry D. Thoreau*, ed. Bradford Torrey and Francis H. Allen (1906; rpt. Boston: Houghton Mifflin, 1949), 1:473–74. Thoreau's premise is not specific to the prairie landscape but rather refers to the overall distant view.

8 The Leatherstocking Tales are a series of novels by Cooper, each featuring the hero Natty Bumppo. The tales include *The Pioneers* (1823), *The Last of the Mohicans* (1826), *The Prairie* (1827), *The Pathfinder* (1840), and *The Deerslayer* (1841).

9 James Fenimore Cooper, *The Prairie: A Tale* (1827; rpt. Albany: State University of New York Press, 1985), 85.

10 William Cullen Bryant, *Prose Writings* (1884; rpt. New York: Russell and Russell, 1964), 2:16.

11 William Cullen Bryant, "The Prairies," in *The Poetical Works of William Cullen Bryant*, ed. Parke Godwin (1883; rpt. New York: Russell and Russell, 1967), 1:228–32.

12 Thacker, *The Great Prairie*, 117.

13 For a good discussion of George Catlin, see Thacker, "Landscape and Technique," 108–20; Joni Kinsey, Rebecca Roberts, and Robert Sayre, "Prairie Prospects: The Aesthetics of Plainness," in Sayre, *Recovering the Prairie*, 17–18; and Joni Kinsey, *Not So Plain: Art of the American Prairies* (Lincoln, Neb.: Center for Great Plains Studies, 1995), 64–67.

14 George Catlin, *Illustrations of the Manners, Customs, and Condition of the North American Indians with Letters and Notes*, 2 vols. (1841; rpt. London: Henry G. Bohn, 1866), 1:218.

15 For a good overview of early prairie photography, see Robert Taft, *Photography and the American Scene* (New York: Dover, 1938), 248–310.

16 Some of Fitzgibbon's daguerreotypes are in the collection of the Missouri Historical Society.

17 S. N. Carvalho, *Incidents of Travel and Adventure in the Far West* (New York: Derby and Jackson, 1860), 30.

18 John Frémont, *Daily National Intelligencer*, Washington, D.C. (June 14, 1854), n.p.

19 Carvalho's only extant daguerreotype from this expedition, *Indian Village*, ca. 1853, is in the collection of the Library of Congress.

20 Charles Savage, "Photographic Tour of 9000 Miles," *Philadelphia Photographer* 4:46 (October 1867): 315. For more information on Savage, see Bradley Richards, *The Savage View: Charles Savage, Pioneer Mormon Photographer* (Nevada City, Calif.: Carl Mautz, 1995), and John Carter, "Photographing across the Plains: Charles R. Savage in 1866," *Nebraska History* 71 (Summer 1990): 58–63.

21 Savage, "Photographic Tour of 9000 Miles," 314.

22 Ridgway Glover, "Photography Among the Indians," *Philadelphia Photographer* 3:32 (August 1866): 239–40.

23 "Obituary," *Philadelphia Photographer* 3:36 (December 1866): 371.

24 *Omaha Weekly Republican*, October 27, 1866, 2.

25 For an excellent discussion of Gardner's work, see Jane Simonsen, "On Level Ground: Alexander Gardner's Photographs of the Kansas Prairies," in Robert Sayre, *Recovering the Prairie* (Madison: University of Wisconsin Press, 1996), 61–85.

26 The Homestead Act of 1862 granted a 160-acre parcel to anyone remaining on land for five years.

27 For a good overview of this subject, see Kinsey, Roberts, and Sayre, "Prairie Prospects," 29–33.

28 Wallace Stegner, *On a Darkling Plain* (New York: Harcourt, Brace, 1939), 127.

29 This paragraph was informed by Wishart, "Settling an Unsettled Land," 36–39.

30 Cited in Alan Trachtenberg, "From Image to Story: Reading the File," in Carl Fleischhauer and Beverly Brannan, eds., *Documenting America, 1935–1943* (Berkeley: University of California Press, 1988), 58.

31 Roy Stryker, "Suggestions for Pictures to Be Watched for in the Plains Country—Kansas, Nebraska, Eastern Colorado, Wyoming, and Montana: F.S.A. 1941," in Stu Cohen, *The Likes of Us: America in the Eyes of the Farm Security Administration* (Boston: David R. Godine, 2009), 176.

32 Cited in Miles Orvell, ed., *John Vachon's America: Photographs and Letters from the Depression to World War II* (Berkeley: University of California Press, 2003), 16–17.

33 Ibid, 17.

34 Stryker, "Suggestions for Pictures," 176.

35 Wright Morris, *The Home Place* (Lincoln, Neb.: University of Nebraska Press, 1948), 132.

36 Terry Evans, *The Inhabited Prairie* (Lawrence: University Press of Kansas, 1998), ix–x.

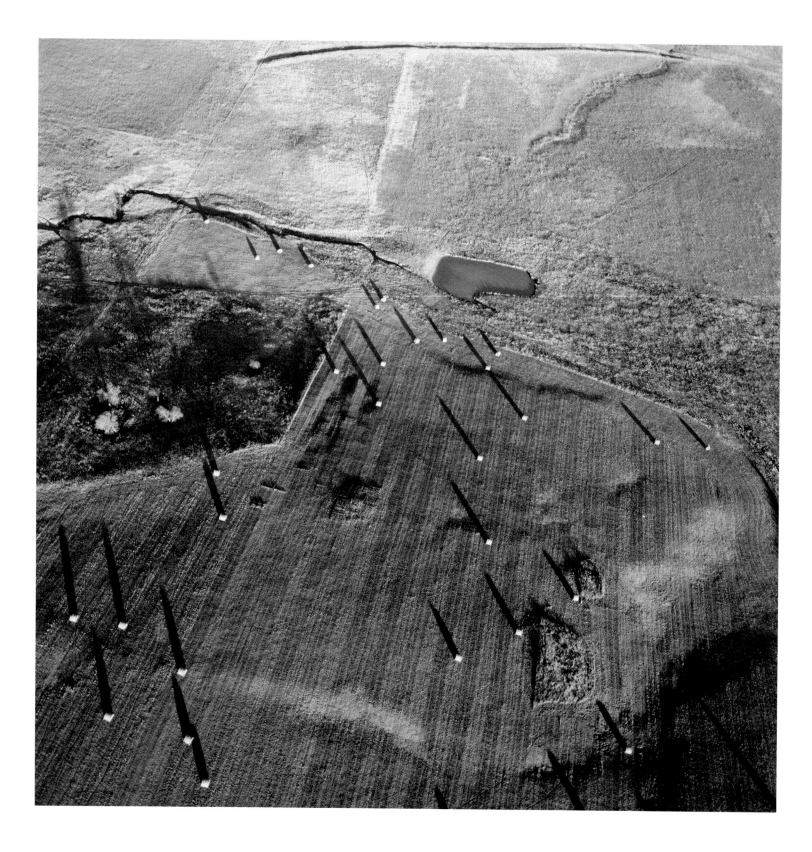

PLATE 2 *Hay bales, Saline County, Kansas*, November 1989.
Chromogenic print. Gift of Jeffrey Hantover, Mee-Seen Loong and Lixian Hantover, 2010.45.

"AS ABOVE, SO BELOW"

The Humane Perspective of Terry Evans's Aerial Landscapes

BY APRIL M. WATSON

Associate Curator of Photography
The Nelson-Atkins Museum of Art

In 1978, after spending eight years photographing people, Terry Evans had an epiphany. Invited by friends to photograph survey work they were conducting on local virgin prairie, Evans walked the ground and soon realized that the most astounding aspect of the prairie was not its vast open spaces, seemingly endless horizon, or mercurial skies. Rather, it was the beautiful complexity of the world at her feet. The rich biotic tangle of grasses and flowers had her transfixed: it was a universe unto itself. Holding her Hasselblad camera at waist level, and pointing straight at the ground, she began to configure the patterns of this uniquely diverse ecosystem into the square format of her photographic frame. These pictures became, in essence, her first aerial views [PLS. 19–21]. This elevated, horizonless vantage point opened up for Evans a new way of seeing the world, as well as a unique way of understanding and relating to it as an all-encompassing experience. "I realized that this 'aerial' perspective was inclusive," she noted. "It encircled me. It differed from linear perspective in the ways that early cave drawings, Chinese scroll paintings, and Persian miniatures differed from paintings created during and after the Renaissance. It was not just about structure as a description of something. Rather, structure *was*, in fact, the thing itself."[1]

Evans recognized that this shift in vantage point was more than simply an aesthetic transformation of her subject. It was also a philosophical, intellectual, and spiritual insight into the way she looked at the prairie—her native landscape, the nation's heartland—and, perhaps more important, the way she positioned herself within it. After a period of intense work, Evans was prompted by the intricate constellation of flora and fauna at her feet to look upward [PL. 25]. It was not long before she took to the sky herself. Looking down from above, she found a similarly wondrous, interconnected pattern of natural and anthropogenic traces. The prairie from 500, 700, or even 1,000 feet, as it turned out, did not look that different from the prairie from waist level. At once, Evans comprehended the resonance of the ancient notion "As above, so below," which has been a conceptual underpinning for her landscape photographs ever since.[2]

Though she has photographed a wide array of subjects throughout her career, both on the ground and from the air, Evans is perhaps best known for her aerial views of the American Midwest. The aerial view's synoptic vantage point, revealing relationships between natural and human-altered topographies that are impossible to see on the ground, has proved to be Evans's preferred means for understanding the prairie's complexity. It was, in part, the immense difficulty of dealing pictorially with the prairie's insistent horizontality—a longstanding conundrum for artists and early travelers to this part of the country—that propelled Evans to seek a more satisfying view from the air.[3] Once aloft, and always at a relatively low altitude (her preference is to fly at a height of 500 to 600 feet), Evans could more readily comprehend the interrelations that occur at the boundary between specificity and abstraction. By repeatedly exploring this aesthetic correspondence, while flying over the actual, topographical distinctions that separated regions within the Great Plains,

Evans found a way to fuse descriptive particularities with the poetic resonances of place. Seeing familiar subjects woven into a tapestry of unusual patterns, textures, and forms, Evans composed her frames to present a fresh perspective on the land. Her aerial views, taken collectively, are *re*orientations of the prairie: visions of disarming natural beauty, at times tinged with and even overwhelmed by the disturbing realities of land use and environmental degradation.

It is the fascinating tension between the specific and the abstract that lies at the heart of Evans's aerial landscapes, and lures her time and again up into the sky. The interplay between these two modes of perception has proved to be a rich visual vein to mine. It has enlarged an aspect of her artistic practice by deepening both her factual knowledge and her intuitive feelings for the prairie, and has provided an effective means for engaging both the intellect and the emotion of those who view her photographs. For Evans, striking that balance is difficult but crucial. This chapter considers the ways in which Evans's aerial views provide a new mode of looking at—and thinking and feeling about—the prairie's multiplicity: its geography and topography; its natural ecosystems; its people, politics, and history. Further, it explores how this richer understanding encourages us to more clearly see, and to value, the prairie's distinct beauty and character.

First Flights: Early Aerial Views and the Inhabited Prairie

Evans first ventured skyward in 1980, flying in a Cessna 172 with a pilot named Ed Himburg who worked for the Evans Grain Company. Her earliest aerial views focused on the virgin prairie: land undisturbed by human interventions, which retained the rich and delicate ecosystem that had developed over the centuries. One of these early aerial views depicts the undulating terrain of a verdant Konza Prairie in Geary County, Kansas [PL. 27]. Illuminated by striations of raking sunlight, and bathed in a warm golden light, the green earth appears almost Edenic in its undisrupted state. Only from the sky could Evans perceive the way sun and shadow gently sculpted the topography's dips and swells.

By 1985, Evans felt that she had photographed the undisturbed prairie "to the limits" of her vision. For three years, she grappled with how to approach the subject of the inhabited prairie. She began in 1989 by taking color photographs, but soon switched to black and white. In 1990, she began taking flights in a Cessna 172 with an army-trained pilot, Duane Gulker, who had become a corporate pilot after retiring from the U.S. Air Force, as well as another army-trained pilot, Major Jonathan Baxt, Evans's neighbor in Salina and manager of the nearby Smoky Hill Weapons Range.[4] Evans describes Gulker and Baxt as being her "dance partners" throughout this process.[5] The photographer and her pilots learned to communicate nonverbally, through hand gestures and other signals that would indicate when to bank the plane, or when to circle a particular location if Evans needed to change film. For this five-year project, which would eventually culminate in the book *The Inhabited Prairie* (published in 1998), Evans established parameters close to home, flying in a twenty-five-mile radius from Salina, at a relatively low altitude of 700 to 1,000 feet. This range allowed her to distinguish enough visual information about her subjects without moving into the greater abstraction that inevitably occurs at higher altitudes.

Within this geographic circle, Evans saw and pictured the extraordinary variety of landscapes that constituted her immediate region. In one picture from this series, Evans emphasizes the sinuous curve of the Solomon River oxbow in Ottawa County, Kansas [PL. 28]. From her vantage point, Evans was clearly able to establish how this transitory, meandering ribbon of water, formed by the natural movement of a mature river flowing through flat plains, echoed the serpentine line of trees framing the main riverbed. Working in black and white helped Evans to further accentuate the formal play between light and dark, water and earth, organic and geometric shapes that she saw and composed within the square format of her camera. In this instance, the photograph also documents a transient moment for this particular landscape: soon after Evans made this photograph (on August 2, 1990), perhaps even within a week, the circular bow of water would drain away. Evans's aerial views are thus inherently, and inescapably, records of the passage of time and the myriad ways in which layers of history shape the cultural and natural landscape as a singular, mutable terrain.

This layering of history as read on the land is particularly apparent in another aerial photograph of the inhabited prairie, wherein Evans pictures the raised, rectangular relief of abandoned missile launching pads situated adjacent to the organic, raised lines of a terrace-plowed field [PL. 34]. Here the passage of time is evident in the softened edges of the geometric forms that delineate the former missile sites: they seem more like archeological ruins than militarized zones, an impression made stronger through juxtaposition with the more recently tended adjacent fields. Such a correlation would not have been possible to glean on the ground. In fact, before Evans saw the prairie from an aerial perspective, she was convinced that human interventions had irrevocably ruined it.

Only after seeing the terrain from above did she discover its complexities. By carefully composing formal relationships between pattern, shape, and line in her frame, Evans speaks to the intricate interplay between military and agricultural practices that have shaped the landscape. Significantly, Evans retains enough aesthetic neutrality from her vantage points to neither condemn nor glorify these cultural forces, but rather to picture them as artistically conceived records of the land's history and presence.

One of the most poignant discoveries for Evans in the course of making these photographs of the inhabited prairie was a small cemetery in Assaria, Saline County, situated just off a country dirt road [PL. 33]. As pictured by Evans, a dotting of tiny headstones clustered in a carefully tended lot glint in the late afternoon winter sun, framed on three sides by a row of trees. Just south of the cemetery, a calligraphic loop of deer tracks appears—the work of a single animal—with every hoof print visible. The extraordinary level of detail and information in this photograph, typical for the low-altitude vantage point from which it was taken, was a revelation for Evans. Once she recognized that this perspective provided more information than the human eye could normally take in, she began to understand how the view from above might assist in recalibrating her own vision so that she could more readily recognize many aspects of use and misuse that constituted the prairie landscape. This realization, in turn, enlarged the way she saw things on the ground. Evans had not known of the cemetery in Assaria before she photographed it from the air, though after having seen it from above, she felt compelled to visit it in person. This organic, experiential manner of understanding the specificities and poetic resonances of a landscape from a variety of vantage points is a key aspect of Evans's artistic process.

The militarized prairie landscape also emerged in this early project as having particular significance for Evans—and it was a subject to which she would later return. The Inhabited Prairie includes numerous aerial views of the Smoky Hill Weapons Range, one of the nation's most active Air National Guard bombing ranges.[6] Located ten miles west of her home in Salina, and named for a region of tall- and mixed-grass prairie that extends from north-central Kansas up into south-central Nebraska, the Smoky Hill Weapons Range provides pilot training by situating mock military targets in the landscape. In her aerial views of the range, Evans shows the geometric patterns and shapes of various targets, including a Star of David formation and a series of concentric tire circles, as well as a line of simulated airplanes [FIG. 19]. The simple, elegant geometry of the targets' patterns, nestled within the natural swells of the land, operates in tension with knowledge that these targets and the land in which they are

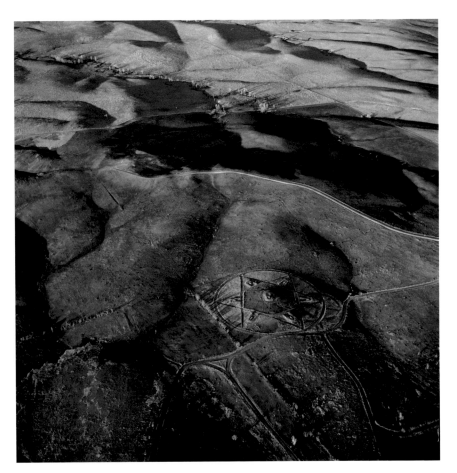

FIG. 19 *Smoky Hill Weapons Range target: Star of David, Saline County, Kansas,* February 19, 1991. Gelatin silver print. Collection of the artist.

situated are regularly bombarded. It is precisely this contrast—between the beauty of the land and the violence leveled against it—that makes the aerial vantage point of these photographs most intriguing.

Evans's aerial views are certainly beautiful landscapes with respect to the aesthetic interplay of light, line, tone, texture, and composition; however, they never fully recede into the kind of abstraction that other aerial photographers rely on to keep the viewer from knowing too much about the way the land is used. The interplay between specificity and abstraction critical to Evans's aerial practice always ensures an interpretive vantage point for the viewer that is at once seductive and disarming. Evans entices us to look at and spend time with these inhabited prairie landscapes; but that engagement is never an escapist retreat from reality. Rather, we come away with a fuller understanding of how Evans's aesthetic choices align with her humane concerns about her native landscape. She

47

has noted of these photographs, "They show the marks that contain contradictions and mysteries that raise questions about how we live on the prairie. All of these places are beautiful to me."[7]

It is important to emphasize that Evans's aerial landscapes are not disembodied views. Rather, they are intimately connected to her uniquely embodied artistic vision, in a way that subverts much contemporary academic thinking on the negative connotations often associated with the "view from above."[8] There is both literal and metaphoric truth to the notion that Evans's perspective as an artist is ultimately shaped by pragmatically standing with her feet "firmly planted on the ground" while allowing herself the creative freedom to take those "flights of fancy" that spark curiosity and wonder, and that derive from her deep concern for the land and its people—herself included. Upon looking at Evans's aerial landscapes, the viewer immediately recognizes that these photographs have nothing to do with the instrumental intentions of surveillance or military reconnaissance. Nor do Evans's views suggest a free-floating "God's-eye view," wherein mundane human vision, prosthetically enhanced by the camera, gives way to a conception of sublime transcendence that renders human activity within the landscape relatively inconsequential. As Evans herself has stated, her interest in landscape has been, at least until her most recent aerial work about the oil boom in North Dakota, to make photographs that are "neither a critique of land use nor a statement about the irony of its beauty."[9]

Photography, History, and the Aerial Imagination

Situating Evans's work within the history of aerial photography, its uses, and how it came to assume both negative and utopian meanings helps to provide some context for her humane and artistic intentions, and to illustrate how this type of photography functions as a viable contemporary artistic practice for her.[10] Human beings had been entranced by the elevated vantage point, or "God's-eye view," long before the invention of photography or flying machines. There is evidence of the aerial imagination in the earliest art forms of many cultures, from the prehistoric cave paintings at Lascaux to sixteenth- and seventeenth-century Mughal miniature book illustrations, both of which have inspired Evans as an artist. The vertical or oblique vantage point, and the commensurate flattening of pictorial space that occurs in these kinds of views, was used by Western artists such as Ambrogio Lorenzetti, in his fresco cycle of 1337–39 on the subject of "good and bad government" for the Palazzo

Pubblico in Siena. Leonardo da Vinci also famously advanced the idea of aerial views in the fifteenth century by using vertical perspective in many of his drawings, and his sketchbooks are well known for including some of the earliest conceptions for flying machines, based on his meticulous study of bird flight.

Filippo Brunelleschi's early fifteenth-century demonstration of linear perspective transformed pictorial representations of three-dimensional space in Western art.[11] Nevertheless, the desire for the view from above continued in other forms of pictorial representation, including mapmaking. Indeed, the prehistory of aerial photography in Western art owes a substantive debt to the activity of mapmaking and surveying, which employed an elevated vantage point to establish a visual context for better understanding the topographical, economic, and social relationships between people and places. With the invention of lithography in the late eighteenth century, bird's-eye views were commonly employed to create maps, particularly of cities and towns. In post–Civil War America, maps were integral components of larger Western and Midwestern survey activities, depicting previously uncharted territory (uncharted, that is, for non-native settlers and explorers) by transcribing what was in reality a highly irregular landscape into more orderly systems that appeared rational and regularized.

Significantly, beginning in the late eighteenth and continuing through the nineteenth century, such two-dimensional, vertically oriented renderings of three-dimensional spaces were thoroughly enmeshed with government policies aimed at settling territories west of the Mississippi River. The Land Ordinance Act of 1785 effectively carved up the interior Great Plains into rectangular parcels as a means to expediently sell, distribute, and settle the vast Western territories of the United States. In 1862, in an effort to accelerate Westward American expansion in the second half of the nineteenth century, the federal government passed the Homestead Act. This legislation granted 160 acres of surveyed public land to heads of households for a minimal filing fee in return for five-year commitment to living on, and farming, the land.

Maps and topographical atlases were critical for this initiative. Not only were such representations perfectly suited for making visual sense of a seemingly featureless, unknown terrain, but the pairing of the bird's-eye view with the grid system conveyed a sense of rational order and control. This cartographic perspective provided reassurance to those contemplating westward settlement that these territories, which were in reality unknown entities, were a safe and assured bet. Illustrated atlases of the period regularly employed the elevated vantage point to present

FIG. 20 A. Ruger. *Bird's eye view of the city of Lawrence, Kansas,* 1869. Kansas Collection, Spencer Research Library, University of Kansas Libraries, R140.

idealized conceptions of prosperous, independent farms neatly positioned on the land.[12] A map of Lawrence, Kansas, from 1869 exemplifies this notion, showing the town laid out in orderly, grid-like fashion from a bird's-eye vantage point, with its important buildings, including the town hall and several churches, highlighted [FIG. 20].

Thus, to *actually* conceive of such governmental plans and policies relied *imaginatively* on an aerial conception; a means of looking down at a large swath of land from above, in order to ascertain how "best" to divvy it up according to a particular set of political and economic criteria. These theories, which often ignored the organic specificities of place in favor of geometric spatial abstraction, fostered certain destructive agricultural practices that eventually proved disastrous for both the prairie's natural ecosystem and the people who drew their livelihood from farming. The Dust Bowl of the 1930s was in part a direct result of decades-long misuse of the land. Various ill-conceived farming practices

that ignored both the natural contours of the land and the vital importance of its rich, complex ecosystem stripped the terrain of the prairie grasses that would otherwise have functioned as anchors for the region's fertile topsoil. Consequently, as extreme drought desiccated millions of acres of overfarmed land, precious topsoil was blown across the Plains in the infamous black blizzards of that decade.

The aerial view was also central to governmental decisions in the twentieth century. In the 1930s, photographers such as Arthur Rothstein made aerial views under the auspices of the Farm Security Administration (FSA), with the idea of juxtaposing them with photographs taken on the ground to help establish regional and geographic contexts, using photographs in much the same manner as maps.[13] Concurrent to the FSA work, the U.S. Department of Agriculture (then known as the Agricultural Adjustment Administration) flew camera-equipped airplanes over farmlands to ensure that farmers were complying with the new agricultural

FIG. 21 Black & Batchelder, American (James Wallace Black, 1825–1896; Perez M. Batchelder, 1818–1891). *Boston as the Eagle and Wild Goose See It*, 1860. Albumen print. Gift of Hallmark Cards, Inc., 2005.27.324.

FIG. 22 Brady Studio, American (ca. 1843–1885). *Professor Lowe inflating Balloon Intrepid*, 1862. Albumen print. Gift of Hallmark Cards, Inc., 2005.27.3781.

policy of terraced and contour plowing, which was an effort to control the extreme soil erosion caused by earlier procedures that ignored the natural swells and dips of the topography. Though the government was essentially using aerial photographs as a form of surveillance—based, at least in part, on a military model—many farmers welcomed the practice, believing this monitoring to be a beneficial means for ensuring the equitable allotment of farm subsidy payments.

One of the primary reasons governmental policies could easily make use of aerial photography was the widespread public belief in the medium's veracity. Unlike earlier technologies such as engraving or lithography, which were always hand-rendered, aerial photographs lent a degree of informational credibility to their subjects previously unknown. Indeed,

the medium's prosthetic capacities to extend and expand human vision were recognized and put to use early on in its history. The Parisian caricaturist-turned-photographer Nadar (Gaspard-Félix Tournachon) is credited with having made the first successful aerial photograph in 1858, from 80 feet in the air, working from his famed hot air balloon Le Géant.[14] On October 13, 1860, the Boston-based photographer James W. Black produced what is credited as the first American aerial photograph, a view of central Boston taken from a hot air balloon at an altitude of 1,200 feet [FIG. 21]. The writer Oliver Wendell Holmes, in describing Black's image in the *Atlantic Monthly*, noted: "Boston, as the eagle and the wild goose see it, is a very different object from the same place as the solid citizen looks up at its eaves and chimneys."[15] Holmes's observation, followed by a

detailed interpretation of the photograph's content, relays something of the profound innovation of aerial photographs.

The same reliance on photography's informational "validity" made the interconnection of the aerial view and military interests—a subject of continued interest for Evans in her own work—a logical, if uneasy, match. As early as 1859, Emperor Napoleon III sought Nadar's talents to take aerial photographs over Italy in France's war against Austria.[16] Americans also saw the strategic value of aerial reconnaissance during the Civil War. The aeronaut Thaddeus Lowe secured President Abraham Lincoln's support to use hot air balloons to gather intelligence for the Union army during the Civil War. Lowe himself did not make photographs from the balloons (though he did take his telegraphic equipment and an operator aloft), but the photographic team of Mathew Brady documented Lowe's project, producing a series of photographs depicting Lowe inflating the largest of his hot air balloons, the Intrepid, in preparation for a reconnaissance mission [FIG. 22].

The invention of the airplane and its practicable conjoining with the camera during World War I marked an enormous increase in military use of aerial photography. Though most aerial photographs were made by photographers in airplanes, at heights of up to 15,000 feet, kites, rockets, and even pigeons were also equipped with cameras during the conflict. The images were intended for informational purposes, but some of them rendered their subjects with an unexpected abstract beauty. An aerial view made by Edward Steichen, who helped establish the first U.S. aerial reconnaissance operations during World War I, suggests this kind of dual effect [FIG. 23].

By World War II, the 35mm Leica camera (introduced in 1924), as well as the medium-format Rollei cameras (introduced in 1929), allowed photographers a wider variety of films and formats from which to choose. Even before the war began, the military had established entire departments devoted to aerial reconnaissance.[17] Steichen served again, directing the Naval Photographic Institute. The photographic historian Beaumont Newhall, who specialized in the interpretation of aerial reconnaissance images, also served. The synoptic "airman's view" entered both intellectual and popular parlance during this time. Writers such as the poet Archibald MacLeish hypothesized about the impact of the airman's view

FIG. 23 Edward Steichen, American, b. Luxembourg (1879–1973). *Untitled Aerial View*, ca. 1917–18. Gelatin silver print. Gift of Hallmark Cards, Inc., 2005.27.2200. © Permission of the Estate of Edward Steichen.

on postwar humanity, emphasizing a utopian belief that such a view would foster a global conception of peace and cooperation.[18] As space exploration of the 1960s and 1970s took aerial photography, quite literally, to new heights, MacLeish grew even more optimistic. In response to the awe-inspiring photographs made during the Apollo missions from 1961 to 1975, in which planet Earth appears as a "big blue marble," MacLeish noted: "To see the earth as it truly is, small and blue and beautiful in that eternal silence where it floats, is to see ourselves as riders on the earth together, brothers on that bright loveliness in the eternal cold—brothers who know now they are truly brothers."[19]

This belief in aerial photography's vast future potential was pragmatic as well as utopian. In an introduction to Hanns Reich's *The World from Above*, published in 1966, Oto Bihalji-Merin suggests a variety of practical uses for the aerial view: "The airplane offers the observer a broader vision and permits the investigation of sources of raw material, revolutionizing the science of surveying and cartography, helping agriculture and forestry, enriching archeological research, and allowing insights into the composition of the earth. . . . The curious mind is driven by the indomitable desire to fathom the unknown, to reach untouched areas of the earth and of knowledge, and to understand the secrets of life."[20]

Familiarity with the aerial view after World War II increased through commercial air travel and the widespread dissemination of bird's-eye views in the newspaper and nascent television media. Many commercial firms entered the aerial survey business, charting boundaries, locating natural resources, and evaluating topography. One of the most iconic series of photographs in this vein was made in 1950 by William Garnett [FIG. 24]. Garnett, who was both a pilot and an aerial photographer, was hired by the Lakewood Park Corporation to document the construction of a new, rapidly built suburban development near Long Beach, California. He photographed the site from the grading of the land to finished product, shooting at an oblique angle, at a relatively low altitude, and in dramatic light to emphasize shadows and the repetitive geometry of the standardized housing. The planners optimistically believed that such housing, made to be affordable for returning veterans, would provide a kind of ideal community. However, the images lent themselves to other interpretations: voracious urban sprawl, environmental degradation, and a soulless lack of humanity. These interpretations derived in no small part from the inclusion of Garnett's images in the 1960 edition of *This Is the American Earth*, published by the Sierra Club. This popular book contained extensive photographic contributions by Ansel Adams and other landscape photographers, with accompanying

text by Nancy Newhall—who somewhat hyperbolically suggested that Garnett's images illustrate the notion, "Hell we are building here on earth."[21] Significantly, the meanings ascribed to Garnett's photographs were not inherent, but reflected the differing sociopolitical agendas brought to them.

Today, the primary source for aerial views is the Internet, through mechanisms such as Google Earth, which puts a virtual bird's-eye view of the entire globe within reach of anyone who wishes to download its program. As its website professes, Google Earth "lets you fly anywhere on Earth to view satellite imagery, maps, terrain, 3D buildings, from galaxies in outer space to the canyons of the ocean."[22] Such devices may offer the latest in technological achievement, but the impetus driving such innovations—the desire to see the world as if freed from its terrestrial constraints—remains relatively unchanged.

In summary, the history of aerial photography is informed by art history, cartography, survey work, and technological developments in both photography and aviation. In visual and conceptual terms, the photographic bird's-eye view may be understood as a particular kind of spatial representation: an aesthetic configuration of shapes, forms, patterns, and textures, made from an airborne vantage point. In contextual terms, aerial photographs may be interpreted as informational documentation or aesthetic configurations, and their conception may be fueled by sociopolitical and military agendas, scientific fact gathering, artistic fascination, or private and corporate interests. Aerial views may be made with or without human camera operators. They have throughout their history been seen to promote utopian visions of shared human goals, or, more recently, as more nefarious Orwellian or Foucaultian tools for surveillance and social control. Though such meanings are not inherent in the photographs, the distinct photographic view of the airborne camera lends itself easily to either interpretation, given the particular way it upends terrestrial-bound, horizon-based Cartesian notions of spatial perspective.

Evans's aerial photographs fit within this history of images and ideas in a variety of ways. The early histories of land use, and the ways in which land was shaped and facilitated by the aerial vision, are for Evans essential components of the contemporary prairie landscape, deeply woven into the tapestry of open fields, furrows, and farmland that compose it. The precedents discussed here are readily apparent throughout her work, though her photographs never remain within the exclusive province of any one category; rather, they borrow freely, in both their intellectual and artistic conceptions, from ideas gleaned from

FIG. 24 William A. Garnett, American (1916–2006). *Foundations and Slabs, Lakewood, California*, 1950. Gelatin silver print. The J. Paul Getty Museum, Los Angeles, 2000.32.26. © Estate of William A. Garnett.

FIG. 25 Steve Kiebler. *Terry Evans in front of Kiebler Plane*, ca. 1996. Collection of Terry Evans.

art history, science, literature, and photographic history, as well as her own direct experience. These influences are woven together by Evans's unique artistic perception and her multivalent—though always human-centered—concerns.

Canada to Texas and Disarming the Prairie

Two projects that Evans began in 1995 and 1996, respectively, are directly related to the idea and techniques of the aerial survey: her photographs of Joliet Arsenal, which resulted in the book *Disarming the Prairie* (1998), and Canada to Texas, a Guggenheim-funded aerial survey of the great mixed-grass prairie, from Saskatchewan, Canada, to central Texas.

Evans first visited Joliet Arsenal, a former munitions manufacturing site located forty miles southwest of Chicago, with the assistance of George Ranney of the civic organization Metropolis 2020 and Gerald Adelmann, director of the Openlands Project. A conservation-based organization

founded in 1963, the Openlands Project is dedicated to protecting and providing public recreational access to natural and open spaces in northern Illinois. Since the early 1980s, Adelmann, his organization, and other like-minded groups had been working on an idea to transform the Joliet Arsenal, along with the security buffer of thousands of acres of open land surrounding the former military installation, back into prairie. When Evans first encountered the arsenal lands in 1995, they were in the process of being transferred from the army to the U.S. Forest Service, to create as a natural area the Midewin National Tallgrass Prairie, the nation's first national prairie park (a process officially completed in March 1997). When she first stood on the grounds, amid "the cow pies, old winter straw grass, and bare, open slope of the heavily grazed cow pasture," Evans was struck by the mystery of the site—its curious mix of natural regeneration with the remnants of an abandoned military presence.[23] She felt there were rich human stories that accompanied the absence, and she set out to integrate that feeling into her photographs. She also realized that in order to fully comprehend the 25,000 acres of former arsenal land, she

53

needed to see it from the air: in essence, to conduct her own survey of this unfamiliar topography.

Evans enlisted the pilot Steve Keibler to take her up to 700 feet in his yellow Piper Cub plane [FIG. 25]. From this height, she began to visually map the area by seeing relationships between the military's deserted architecture and transportation systems—ammunitions bunkers, trains, manufacturing sites—and the creeks, woodlands, and natural dropseed grasses of the Drummond Prairie [PL. 38]. As she created this map in her mind's eye, and made photographs along the way, Evans felt she could better engage with the site when she encountered it on foot, investigating ruins of old buildings [PL. 36], grazing cattle and horses at the Plenemuk prehistoric burial grounds [PL. 37], and traces of a fieldstone fence built by Confederate prisoners in 1861–65 [PL. 39]. In fact, it is precisely this multiplicity of vantage points that suggests the Joliet Arsenal's complex layers of history, natural science, and wartime politics. Significantly, it was a site that was, at that moment, in the process of transforming yet again, turning, as journalist Tony Hiss writes, "bullets into birds."[24]

Evans's Canada to Texas survey proved to be more of a challenge for the photographer, who until that point was used to flying with a single pilot repeatedly over a specific geographic region. Given the vast expanse of unfamiliar territory that needed to be seen and photographed, Evans had to locate and engage a number of pilots. She found them by working systematically, moving from region to region, north to south, and came to rely on their expertise regarding logistical questions such as when to catch the best light, how far to fly, and where to land.[25] Each day required a new plan, and often she identified the ecological boundaries of the prairie as she went. Though she found it stressful in the beginning, Evans soon gave in to the adventure of not knowing exactly what each day would bring. It all seemed new and exciting. She notes: "We would overnight in places with exotic names like Swift Current, Eastend, and Medicine Hat. For five days, a fine retired Royal Canadian Air Force pilot, Art d'Entremont, flew for me. One day, he landed on a small patch of ground south of Prince Albert, Saskatchewan, and we had lunch in a forest clearing at the cabin of an old buddy of his. Each night, we would land at a small airport and take the 'town car,' an old car left at the unstaffed airport for whomever landed there, into town."[26] Evans also found inspiration for this project in the photographic precedent of the great nineteenth-century surveys, such as John Wesley Powell's expedition to the Grand Canyon in 1869.

The photographs in the Canada to Texas series are among Evans's most arresting aerial views, clearly depicting the ways in which topography is transformed by both natural and human forces [PLS. 40–48]. In one photograph, Evans pictures the U.S.-Canadian border, one side distinguished by linear striations caused by plowing, the other left seemingly untouched [PL. 43]. In another, the lush edge of a forest abruptly ends as it meets the neatly groomed edge of the prairie [PL. 40]. On one occasion, as she was flying just south of Regina, Saskatchewan, Evans's line of sight was magically disrupted by a flock of snow geese. Like a sprinkling of snow or a constellation of stars, the birds' white bodies dappled the landscape, a transient moment Evans astutely and serendipitously preserved with her camera [PL. 41].

In the course of working on this three-year survey project, which she completed in 1999, Evans also began using a Fuji 617 panoramic camera, which produced a large 6 x 17 cm negative. She had been intrigued by the idea of extending the square format before this, aligning diptychs and triptychs of the same landscape taken at slightly different moments. John Szarkowski, the former and formidable director of the department of photographs at the Museum of Modern Art in New York City, found the white bars separating Evans's diptychs and triptychs to be distracting, and recommended that she explore the potential of the panoramic camera.[27] Though she felt Szarkowski was simply not sympathetic to what she was trying to achieve with this presentation, Evans, too, had been wondering about the white borders. Thus, taking his advice, she bought the panoramic camera. Ultimately, she found that it produced a very different kind of aerial panorama from what she desired. As she notes: "When looking at the [seamless] panoramic image, it is no longer possible to replicate that experience of looking first here and then there as it was with the diptychs and triptychs. Instead the viewer looks into the panoramic image and moves around inside it. The panoramic frame seems to contain a story that is about the subject, but not about how we look at landscape. The multi-image way of working is about both."[28]

In April 2002, Evans took a hot air balloon ride near Cedar Rapids, Iowa. The unpredictable nature of ballooning resulted in some inevitable meandering aloft, such that Evans found herself hovering over suburban houses and a backyard trampoline. Her close proximity to her subject at this low altitude resulted in a picture whose composition later reminded Evans of Grant Wood's painting *The Birthplace of Herbert Hoover* (1931) [FIG. 26]. Wood's painting, which depicts Hoover's childhood home in West Branch, Iowa, was conceived from a vantage point of roughly similar elevation to Evans's view. Evans considered this photograph an important transitional aerial work, and a precursor to the variety of urban views she would make in Chicago (a city to which Evans moved, from Salina, in 1994).

Revealing Chicago

Evans embarked on another extensive aerial survey project in 2003, when she was commissioned to photograph the city of Chicago and its environs.[29] For this body of work, Evans was invited by Gerald Adelmann, with whom she had worked on the Joliet Arsenal project. Over the course of three years, Evans made forty-six flights: forty in helicopters, which were necessary for navigating within the city itself; four in a hot air balloon; and two in a Piper Cub. The result was a collective "aerial portrait" of Chicago that included urban, suburban, farmland, commercial, industrial, and natural open areas. The photographs suggested that the boundaries between the six counties composing Chicago and its environs were more political than ecological. Evans discovered, in the course of making her many flights over the area, that despite the city's diverse complexity there was also considerable interconnection [PLS. 74–80]. In the project's resulting book, Evans's photographs are often presented with lengthy didactic captions that speak to the subjects' cultural or natural history.

Thus the images, though motivated by aesthetic concerns, are also conceived as site documentations.[30]

Evans's decision to vary her vantage points in the Chicago project facilitates this multivalent understanding of the work. Though they are all aerial views, the images' perspectives vary from one to the next, taken from both oblique and vertical vantage points and, given the variety of "flying machines" she used, from a range of altitudes. In two views of the lakefront—one of Oak Street Beach and another of a jetty near downtown Chicago [PLS. 75, 76], Evans constrains her palette and crafts minimal compositions through an astute handling of light, shadow, and texture. In the view of Oak Street Beach, she juxtaposes the more organic, lacy folds of the rippling waterline with the straight geometry of meticulously mechanically groomed sand, including two human (and three canine) figures that give a sense of scale. Her view of a jetty on Lake Ontario becomes almost a complete abstraction. Here, the juxtaposed forms are distinguished by the difference in their natural states: ice has formed along the man-made linear promontories of the jetty itself, while the larger area of water beyond its boundaries remains a vast, unfrozen expanse. These two images are a counterpoint to other views from this series, which depict the visual urban cacophonies of railways, highways, and sports and amusement complexes, or the industrial structures and materials of nearby steel-producing plants [PLS. 79, 80].

At times, Evans's vantage point seems to hover amid her subjects rather than looking down on them. Such is the case in one view that includes the CNA Center building, a landmark skyscraper designed in 1972 by James Ferris and distinguished by its bright-red exterior [PL. 74].[31] By situating the building along the left edge of the square-format image so that it extends beyond the top and bottom of the frame, and keeping everything in the frame in sharp focus, Evans compresses the space such that the thickets of old and new architecture jostle for attention with vitality and dynamism.

Greenland, Matfield Green, and North Dakota Oil Boom

In 2008, Evans was commissioned by the Spencer Museum of Art at the University of Kansas in Lawrence (her alma mater) to photograph the effects of global climate change in Greenland. The project was a collaboration between the Spencer Museum and the University's Center for Remote Sensing of Ice Sheets (CReSIS), which was established in 2005 with a mission of developing new technologies to study and predict the

rate at which ice sheets in Greenland and Antarctica are receding. Evans found that this aerial work was the most challenging she had faced: the terrain was completely unfamiliar and devoid of the human traces she had grown accustomed to using as a visual guide. Her sense of scale was confused. Though she understood intellectually that she was looking at icebergs and the Jakobshavn Glacier in Ilulissat, Greenland, her visual perception was uncertain. She comments: "Without human markers to judge size, I might have been looking at a knee-high snow drift or a thirty-story mountain of ice. I knew mentally what I was looking at, but my eyes were not sure."[32] The resulting pictures from this project are beautifully disarming. Brilliant in color, with shapes sharply rendered in the crystalline Arctic light, these landscapes seem barely to be a part of this world.

Though Evans continues to find the aerial view compelling, both as a process of picture making and as a way of seeing the world, her recent series in Matfield Green and North Dakota incorporate the bird's-eye view as one of a set of visual devices, rather than an exclusive aesthetic strategy. Evans's work in Matfield Green, Kansas, a small town located approximately sixty miles northeast of Wichita, uses the aerial view only sparingly. The format's lack of intimacy was ultimately insufficient for the task of fully conveying Evans's deep feelings for the people of this community, but when employed selectively, the aerial view provides a crucial sense of expansion. It suggests in visual terms—by taking a step up and back from the subject—a broader conceptual consideration of the way this land has sustained the people who have lived there, often for generations. By alternating between portraiture, traditional terrestrial landscapes, and the occasional aerial view in Matfield Green, Evans crafts a richer understanding of place: one that is both personal and integrally connected to her broader human concerns for the way we live on and with the land.

For her ongoing project in North Dakota, Evans has made several visits to the northwestern part of the state to photograph the effects of fracking operations by the oil industry. Here, she employs the aerial view as she did in her work at Joliet Arsenal: as a means of orienting herself to a landscape with which she was at first unfamiliar. As in her work in Matfield Green, Evans has integrated portraiture with landscape views, realizing, as the project progressed, that virtually everyone in the area was affected by the radical and troubling transformation of the land.

Evans's aerial views in this series are more deeply charged and, by her own admission, more pointedly political than any of her earlier aerial projects. They unabashedly call attention to brutal excoriations the oil industry has wrought on the land in its quest for profit. In one view, for example, the laying of a new oil pipeline near White Earth, North Dakota, appears like a fresh laceration to the earth's undulating green skin [PL. 94]. In another image, Evans pictures a newly excavated oil waste dump, its murky pools sitting stagnant amid a skein of bulldozer tracks that attests to the manic pace at which the earth's surface is being transformed [PL. 93]. These views from above, when juxtaposed with portraits of the people who live in these towns (as well as those who have moved there to find work), craft a poignant and unsettling vision of a local landscape that has changed radically in a very short period. In many ways, the land has been sold out from underneath the people who live there by people who do not, and by corporations who seem not to care about the long-term environmental and psychic damage their actions may bring about. The oil industry has also, however, created jobs and a short-term economic boom that many residents have accepted, albeit largely out of desperation. These tensions between human beings and the land resonate deeply with Evans. She finds the situation incredibly troubling, and she sees her photographs for this project as serving a social documentary function, helping to bring the severity of the situation to greater public awareness.

In many ways, Evans's photographs of the oil boom in North Dakota are a culmination of her lifelong commitment to exploring the profound and complex connections between people and place. In the course of this journey, which has at its heart the prairie landscape in which she grew up, she has discovered our estrangement from the land, as well as our capacity to heal the wounds we have caused, at times through thoughtless acts, at times through naïveté. Such revelations derive in no small part from Evans's astute aerial imagination, as placed in the vital service of art. Through her aerial photographs, which spring from devoutly humane concerns, Evans has expanded not only her own understanding of the world she inhabits, but ours as well.

ENDNOTES

1 Conversation with the artist, April 2012.

2 Evans notes that her frame of reference for this concept comes from the ancient text *The Emerald Tablet of Hermes Trismegistus*. This brief text, which has been widely translated throughout the centuries, is composed of several sentences that ostensibly relate to the teachings of Hermes Trismegistus, a Hellenistic conception that was possibly based on the Greek god Hermes and the Egyptian god Thoth. Though the dates of its creation are not entirely certain, it is believed to have been first conceived ca. 650–830 AD.

3 The artist George Catlin, who traveled through the Great Plains region in the 1830s, commented on the seemingly endless nature of the prairie; it was like a "boundless ocean," a characteristic he found to be both "monotonous" and "painful." See Joni L. Kinsey, "Ending Up and Landing Out in the Prairie," *Iowa Review* 30:3 (Winter 2000/2001): 133. Evans has noted a deep admiration for Catlin's work.

4 Evans flew with Duane Gulker from 1990 to 1991. During this time she also began flying with Jonathan Baxt.

5 Terry Evans, preface to *The Inhabited Prairie* (Lawrence: University Press of Kansas, 1998), ix.

6 To photograph this subject, Evans enlisted the assistance of Major Jonathan Baxt.

7 Evans, preface to *The Inhabited Prairie*, x.

8 The feminist historian Donna Haraway notably has written about the metaphoric importance of "embodied vision," as opposed to what she describes as "a conquering gaze from nowhere" that equates to certain conceptions of the "God's-eye view." This kind of gaze, as Haraway writes, "mythically inscribes all marked bodies, and makes the unmarked category claim the power to see and not be seen, to represent while escaping representation." (Donna Haraway, "The Persistence of Vision," in Nicholas Mirzoeff, ed., *The Visual Culture Reader* [London: Routledge, 1998], 191.) Haraway's rhetoric is decidedly political and ought to be considered as historically situated (her essay "A Cyborg Manifesto: Science, Technology, and Socialist-Feminism in the Late Twentieth Century" was published in 1985, and her influential book *Simians, Cyborgs and Women: The Reinvention of Nature* was published in 1991). Though Evans's aerial photographs are not overtly feminist statements in the way Haraway might insist on, it is significant that Evans's humane perspective derives from the full intellectual and sensory realm of her creative experience, and not from a cooler, more detached manner of working.

9 Evans, preface to *The Inhabited Prairie*, x.

10 For an excellent discussion of the negative and utopian strains of perception as they have informed the history of aerial photographs, see Paula Amad, "From God's-Eye to Camera-Eye: Aerial Photography's Post-humanist and Neo-humanist Visions of the World," *History of Photography* 36:1 (February 2012): 66–86.

11 Brunelleschi is credited with having developed (or rediscovered) linear perspective around 1420. This manner of rendering the illusion of three-dimensional space on a two-dimensional surface had been known to the Greeks and Romans in ancient times, but lost during the Middle Ages.

12 For a thorough discussion of how these early bird's-eye views contributed to the development of a certain mythology about the Midwest as being the "heartland" of American agrarian virtue, see Jason Weems, "Barnstorming the Prairies: Flight, Aerial Views and the Idea of the Midwest, 1920–1940" (Ph.D. diss., Stanford University, 2003).

13 Rothstein, as well as his fellow FSA photographer John Vachon, was sent on assignment to Grundy County, Iowa, to document small-town and farm life there in September and October 1939, and again in April 1940. Though most of his views were made on the ground, a few were made from the air, including an image of Grundy Center blanketed by snow. See *Air view, Grundy Center, Iowa*, Library of Congress Prints and Photographs Online Catalog, call number LC-USF34-029422-D [P&P], http://www.loc.gov/pictures/item/fsa2000010753/PP/. For more information on the FSA's use of aerial photography, see Weems, "Barnstorming the Prairies," chap. 2, 77–136.

14 This "first" image no longer exists. The earliest surviving image by Nadar, an aerial view of Paris, dates to 1866. For a thorough discussion of Nadar's first flights with a camera, see Beaumont Newhall, *Airborne Camera: The World from the Air and Outer Space* (New York: Hastings House, 1969), 19–21. Newhall's text was the first to consider the history of aerial photography extensively. The book is a staple of Evans's personal library (see Evans's bibliography in this volume).

15 Quoted in Newhall, *Airborne Camera*, 24–26.

16 The negotiations did not, apparently, come to a concrete resolution, despite the emperor's offer to pay Nadar over 50,000 francs. See Denis Cosgrove and William L. Fox, *Photography and Flight* (London: Reaktion Books, 2010), 26.

17 The military also became incredibly efficient at amassing images: by 1944, according to one statistic, American pilots were capable of taking up to three million photographs each month. See Cosgrove and Fox, *Photography and Flight*, 55.

18 See Dianne Harris and D. Fairchild Ruggles, eds., *Sites Unseen: Landscape and Vision* (Pittsburgh: University of Pittsburgh Press, 2007), 99.

19 Archibald MacLeish, "A Reflection: Riders on the Earth Together, Brothers in Eternal Cold," *New York Times*, December 25, 1986, 1.

20 Oto Bihalji-Merin, introduction to Hanns Reich, *The World from Above* (New York: Hill and Wang, 1966), 5.

21 Nancy Newhall, *This Is the American Earth* (Boston: Little, Brown, 1992), 36–38.

22 This quote taken from Google Earth's Outreach web page: http://www.google.com/earth/outreach/tools/index. html (July 5, 2012).

23 Terry Evans, preface to *Disarming the Prairie* (Baltimore: Johns Hopkins University Press, 1998), vii.

24 See Tony Hiss's introductory essay "Turning Bullets into Birds," in Evans, *Disarming the Prairie*, 1.

25 Evans benefited tremendously from the knowledge and generosity of several individuals during the course of this project. Stan Rowe, an ecologist from British Columbia, suggested a helpful flight plan for one leg of her journey. Art d'Entremont served as a pilot for five days. Evans also visited the Canadian writer Sharon Butala, who lives in Saskatchewan and writes about prairie life in the southwest part of that province.

26 Conversation with the artist, June 2012.

27 Having viewed a selection of her landscape diptychs and triptychs, Szarkowski wrote to Evans in a letter dated June 17, 1996: "My humble suggestion is that you sell something and buy a panoramic camera." E-mail conversation with the artist, May 7, 2012.

28 Email conversation with the artist, May 7, 2012.

29 The project resulted in the book *Revealing Chicago: An Aerial Portrait* and an exhibition of photographs, the first to be held in Chicago's Millennium Park (which opened in 2005).

30 See Terry Evans and Charles Wheelan, *Revealing Chicago: An Aerial Portrait* (New York: Harry N. Abrams, 2005).

31 The CNA Center houses the CNA (Continental National American) Financial Corporation.

32 Conversation with the artist, June 2012.

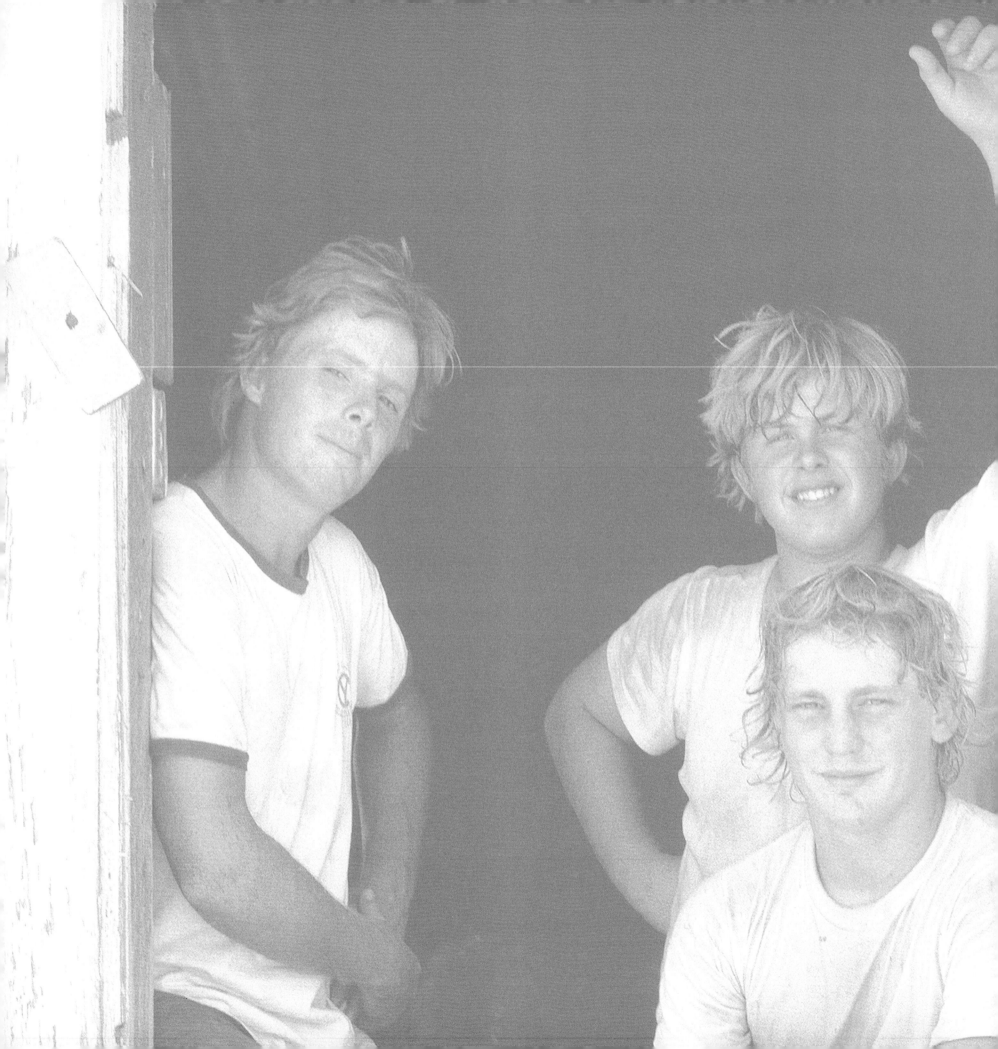

PLATES

Early Documentary

POVERTY IN KANSAS

Evans's first major photographic project, from 1971 to 1973,

documented the effects of poverty in Kansas. Working closely

with local antipoverty organizations, Evans made 35mm

black-and-white portraits of subjects living in Kansas City, Salina,

Lawrence, and Belleville, Kansas. Strongly influenced by the

1930s social documentary work of photographers such

as Dorothea Lange, Evans's images convey the dignity of her

subjects and the context of their environments.

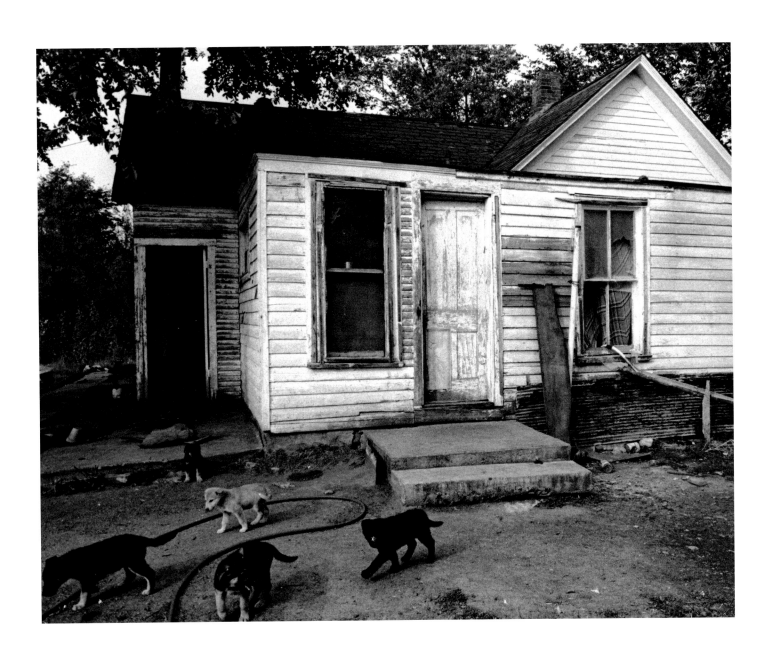

PLATE 3 *Kansas City, Kansas*, 1972.
Gelatin silver print. Gift of the artist, 2012.18.7.

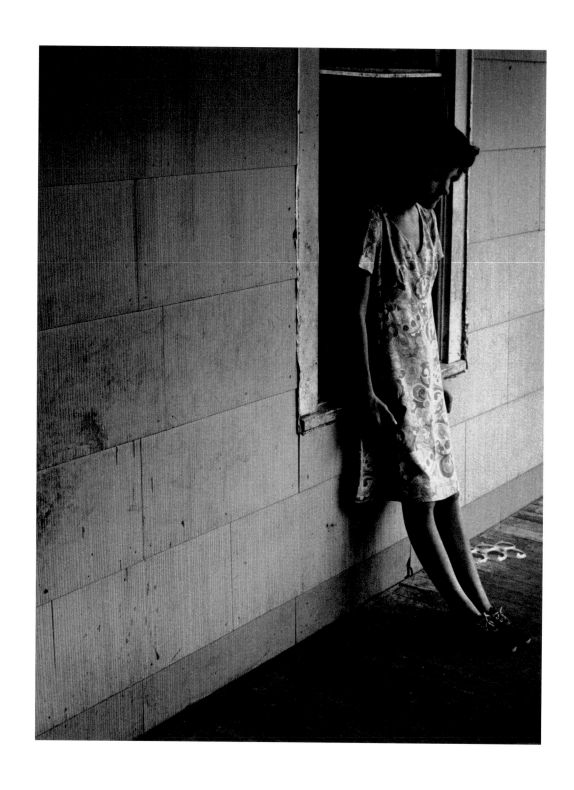

PLATE 4 *Girl who is blind with radio, Kansas City, Kansas, 1973.*
Gelatin silver print. Gift of the artist, 2012.18.6.

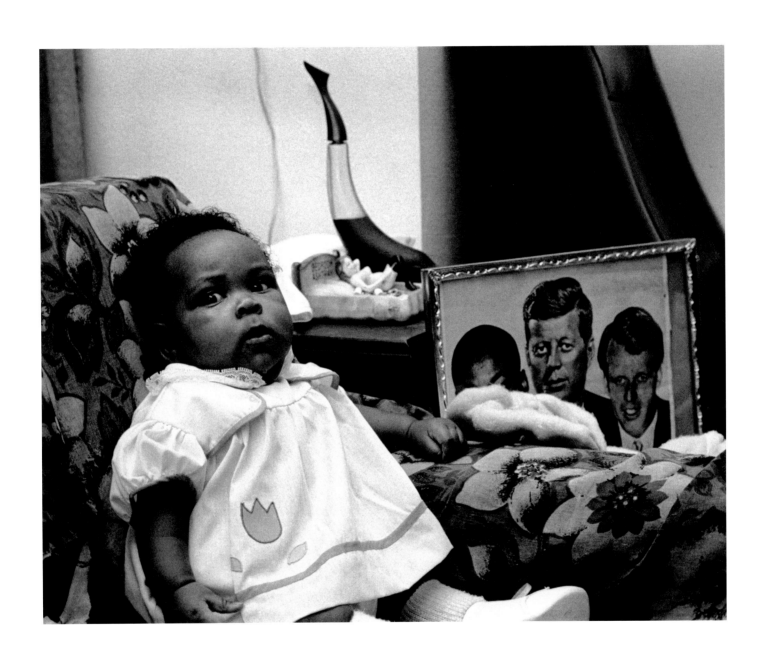

PLATE 5 *Baby, King, and Kennedys, Lawrence, Kansas, 1972-73.*
Gelatin silver print. Gift of the artist, 2012.18.1.

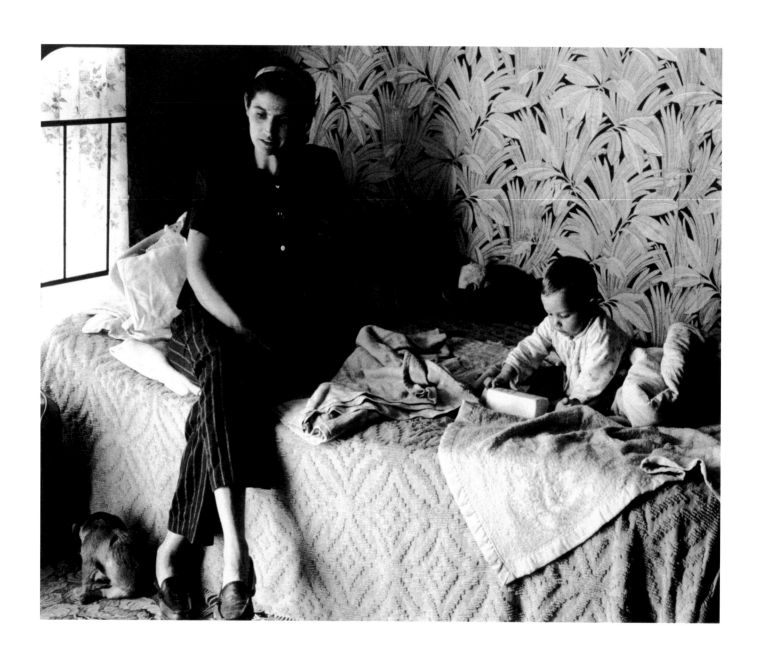

PLATE 6 *Belleville, Kansas,* 1973.
Gelatin silver print. Gift of the artist, 2012.18.2.

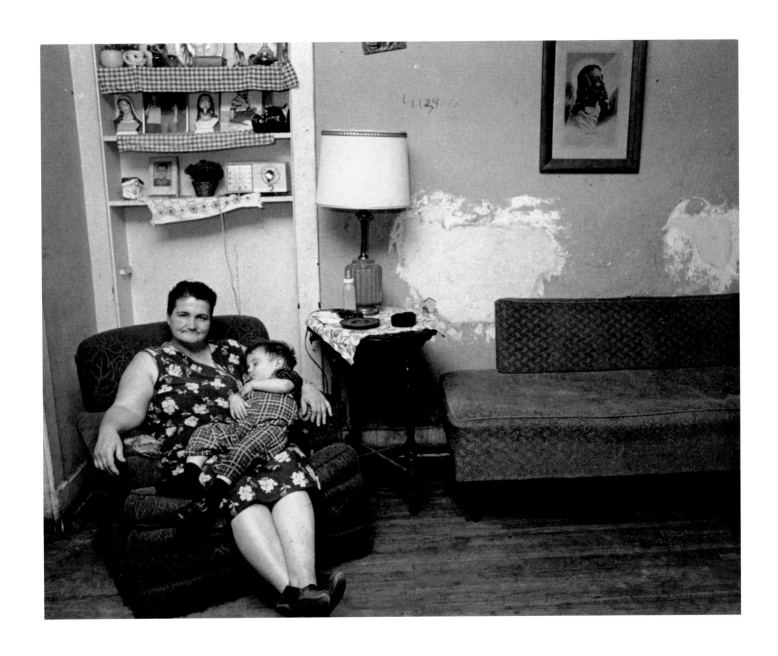

PLATE 7 *Kansas City, Kansas*, 1973.
Gelatin silver print. Gift of the artist, 2012.18.8.

KANSAS SURVEY

In the summer of 1974, Evans created a series of black-and-white

portraits for the Kansas Survey. This project, organized by

curator and photographer James Enyeart and funded by the

National Endowment for the Arts, sought to "create an

aesthetic survey" of the state. Evans worked in the town of

Abilene and around Saline County, Kansas, using a new camera:

a medium-format, 2¼-inch Hasselblad. The Kansas Survey

work of Evans, Enyeart, and Larry Schwarm was documented

in the catalogue *No Mountains in the Way* (1975).

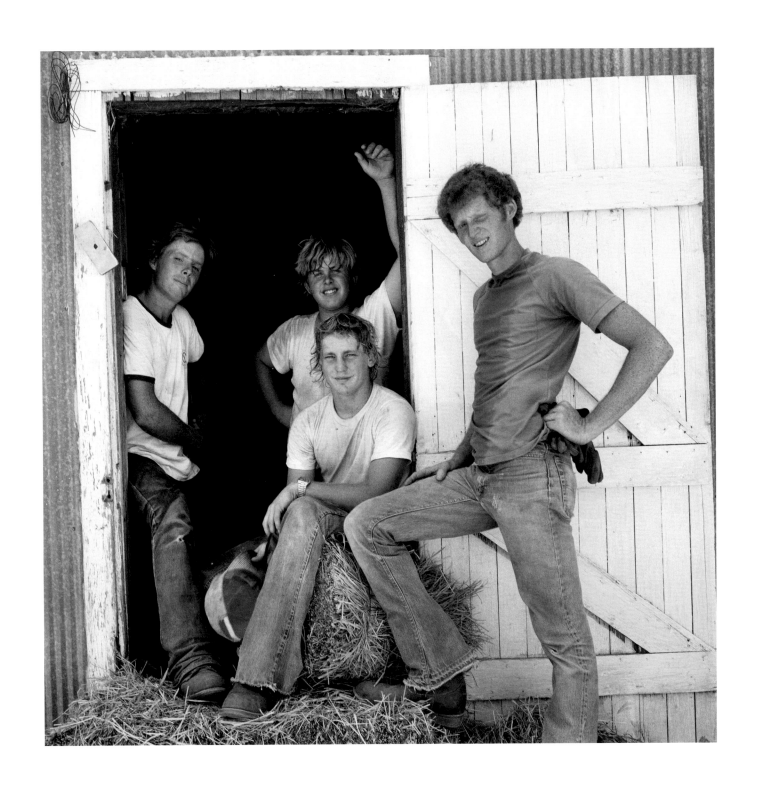

PLATE 8 *Evans farm, Bennington, Kansas, 1974.*
Inkjet print (printed 2012). Gift of the Hall Family Foundation, 2012.17.24.

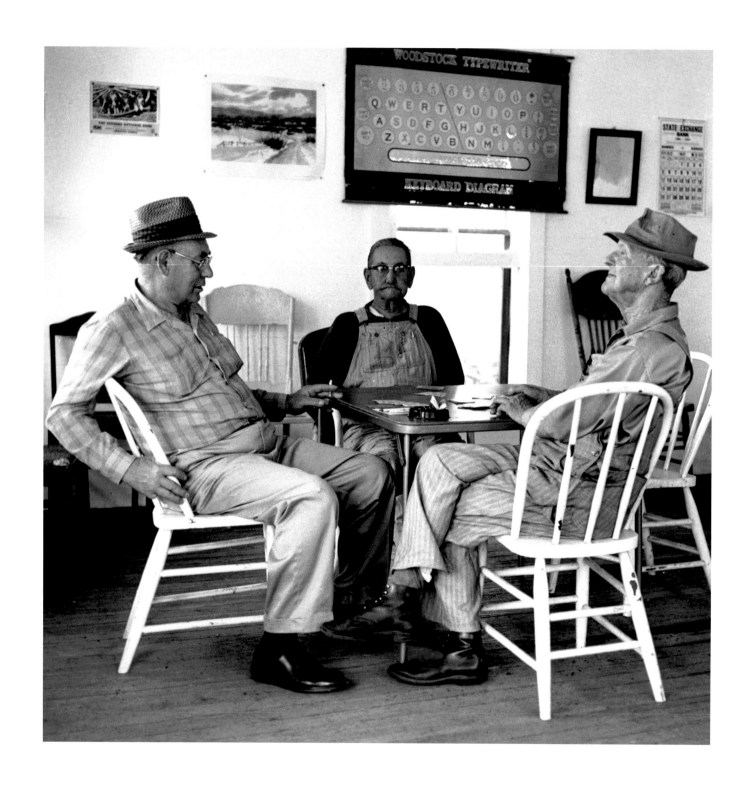

PLATE 9 *Burns, Kansas,* July 1974.
Gelatin silver print. Gift of the Hall Family Foundation, 2012.17.13

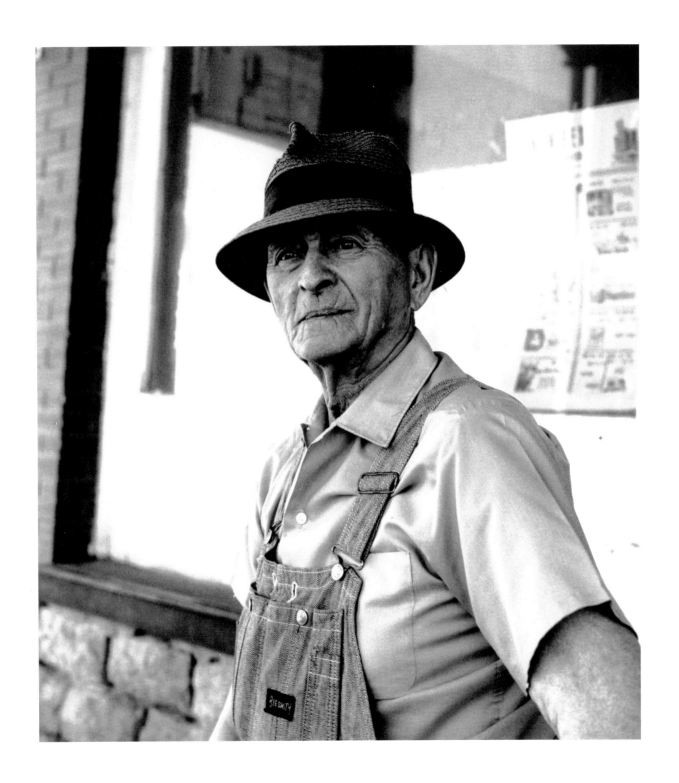

PLATE 10 *Green, Kansas,* July 1974.
Gelatin silver print. Gift of the Hall Family Foundation, 2012.17.37.

FAMILY

Beginning in the fall of 1974, with the birth of her second child,

Evans devoted two years to making personal images of her family.

Using both her 35mm and medium-format Hasselblad cameras,

she photographed her son David and daughter Corey in various

states of activity. These domestic pictures are candid and

spontaneous—a distinct departure from the more formal

approach that characterized her earlier photographs of strangers.

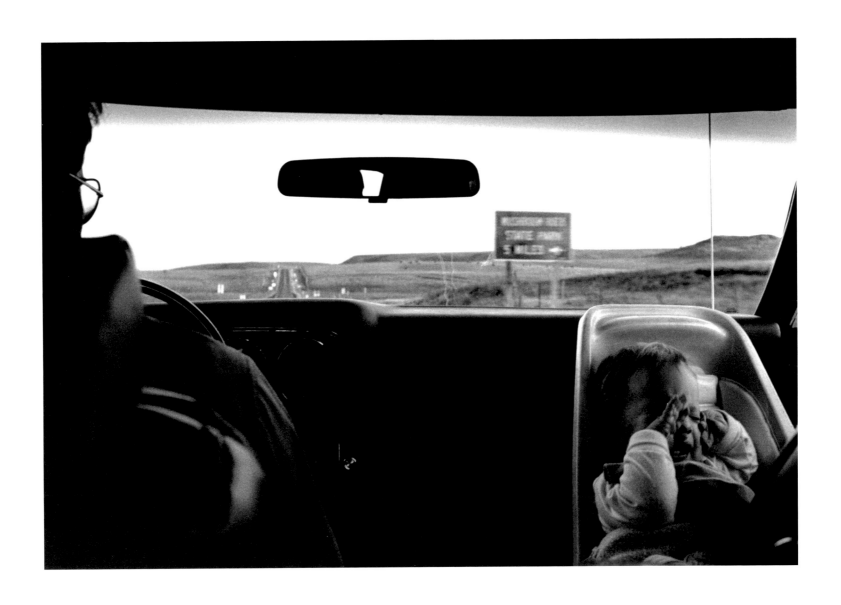

PLATE 11 *Corey tired,* 1975.
Gelatin silver print. Gift of the artist, 2012.18.3.

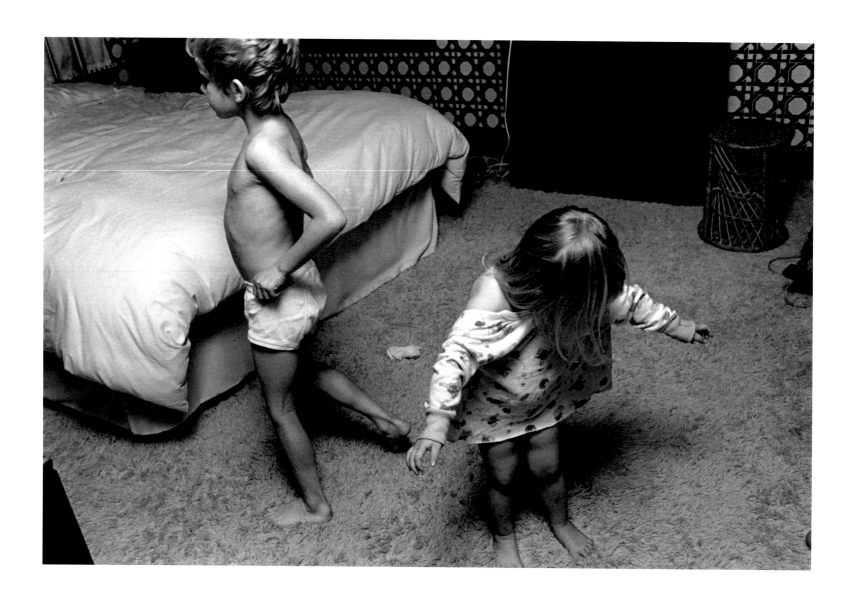

PLATE 12 *David and Corey*, 1976.
Gelatin silver print. Gift of the artist, 2012.18.4.

PLATE 13 *Tom, David, and Kristy,* 1975.
Gelatin silver print. Collection of the artist.

KANSAS ALBUM AND RELATED PORTRAITS

In the Bicentennial year of 1976, Evans organized the Kansas Album

project with the support of the Kansas Bankers Association. A total

of nine photographers were involved in this ambitious endeavor

to record the texture of contemporary life in Kansas. Working between

June and October, they recorded a wide variety of subjects. Evans's

black-and-white portraits were made in and around her hometown of

Salina, Kansas. These portraits mark a notable shift in her documentary

practice, suggesting a newfound intimacy and confrontational edge.

Evans worked steadily in this vein until 1978, when her primary focus

shifted to the landscape.

PLATE 14 *The Reverend Louis Dale, Salina, Kansas*, October 1976.
Gelatin silver print. Gift of the Hall Family Foundation, 2012.17.62.

PLATE 15 *Jim Lambert, Salina, Kansas*, September 1977.
Gelatin silver print. Gift of the Hall Family Foundation, 2012.17.44.

PLATE 16 *Jim Hawley, Salina, Kansas,* October 1976.
Gelatin silver print. Gift of the Hall Family Foundation, 2012.17.43.

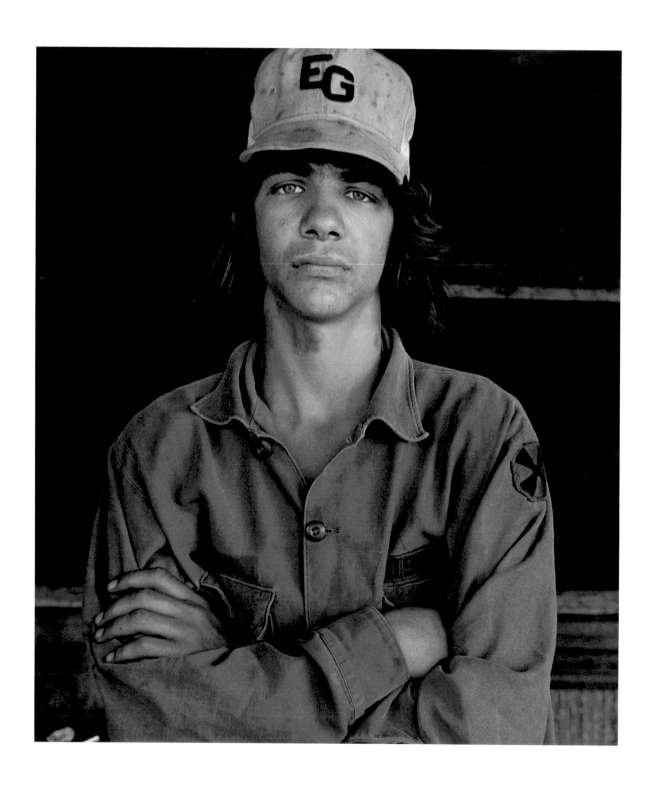

PLATE 17 *Frank Creach, Salina, Kansas,* June 1977.
Gelatin silver print. Gift of the Hall Family Foundation, 2012.17.35.

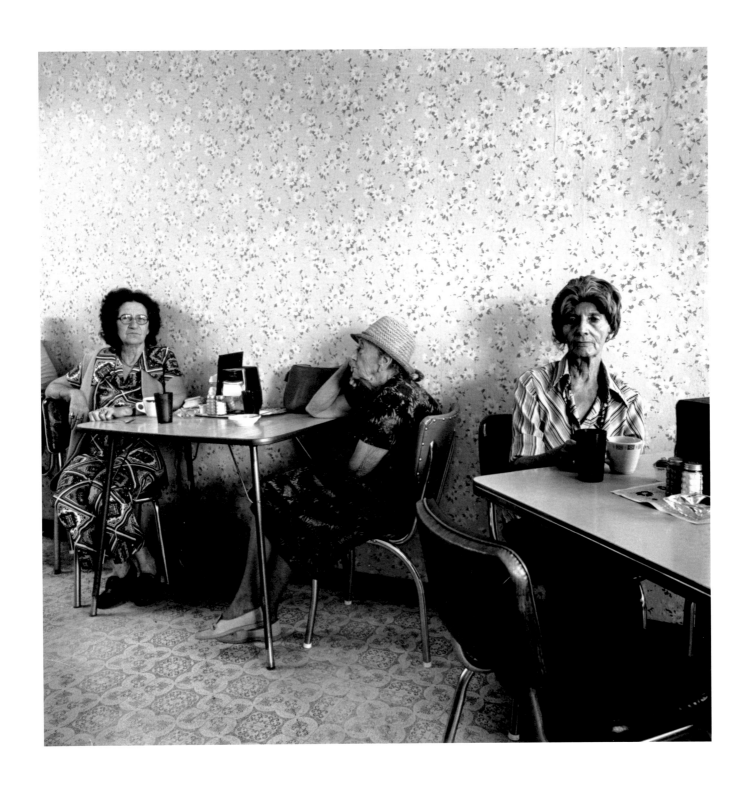

PLATE 18 *Ellsworth Café, Ellsworth, Kansas*, 1981.
Gelatin silver print. Gift of the artist, 2012.18.5.

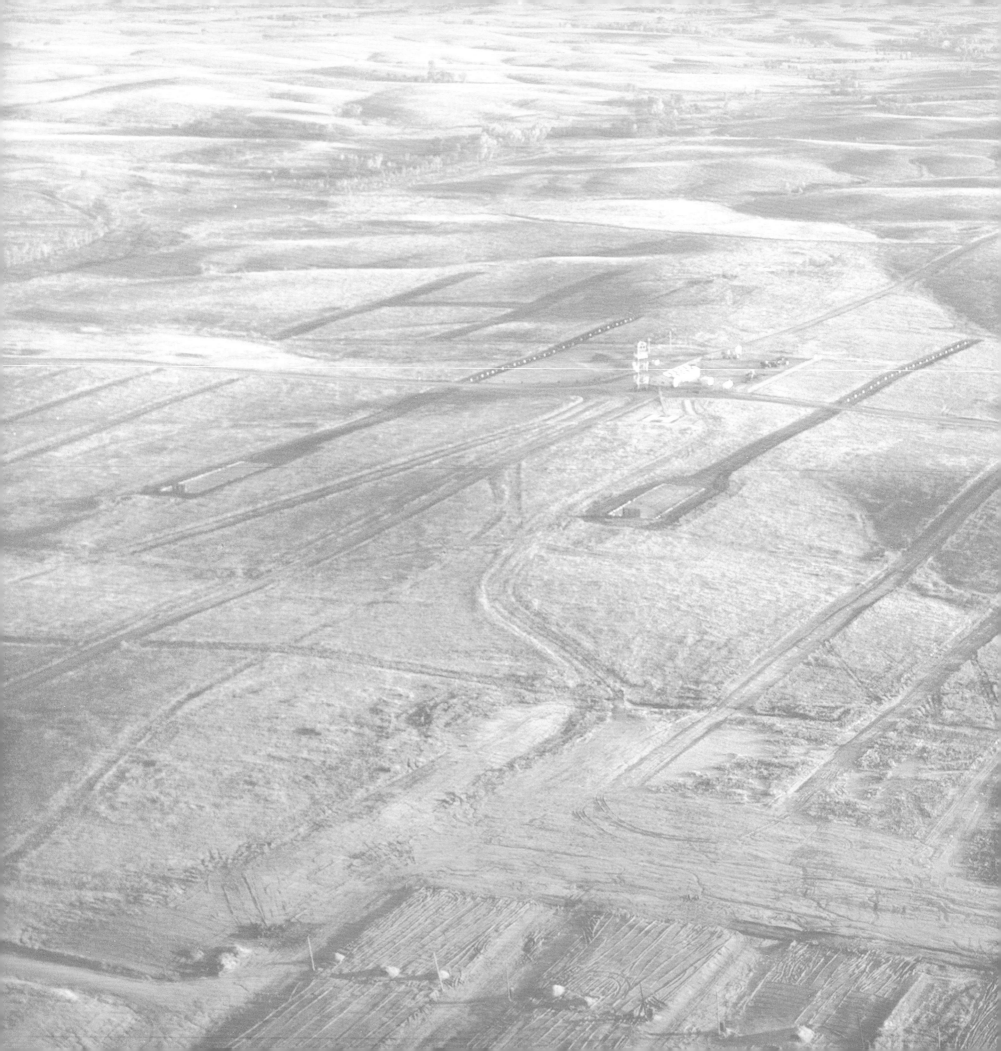

The Prairie

PRAIRIE IMAGES OF GROUND AND SKY

In the spring of 1978, Evans's artistic style shifted dramatically when she discovered the subject of the Kansas prairie. While she never gave up portrait work, this began her career as a landscape photographer. Her first photographs were black and white views of native prairie grasses, taken at waist height, looking straight down at the ground. In the course of a year, she made over 4000 such photographs, all with the soft, even light of overcast skies.

In the spring of 1979, she began to make color photographs of the prairie. With this aesthetic shift, she also looked out to the seemingly endless horizon and up to the region's mercurial skies. The result is a dramatically wider embrace of the sensory experience of the landscape.

In 1980, she made her first aerial photographs—an approach that would become central to all her subsequent work. All her early landscape images depicted the virgin prairie: land undisturbed by human intervention.

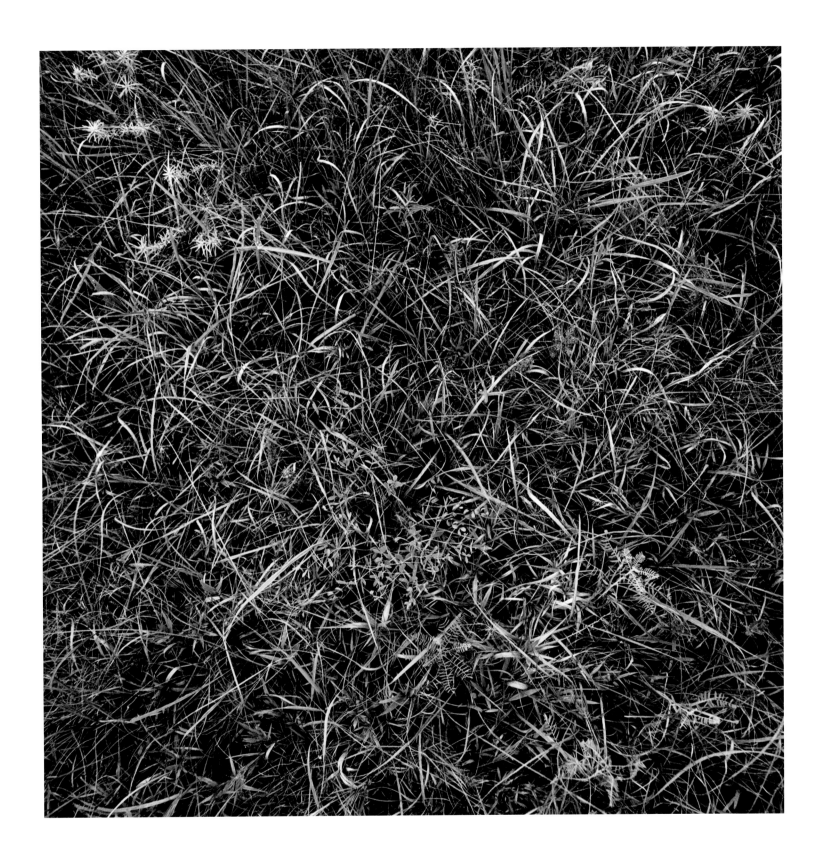

PLATE 19 *Fent's Prairie,* October 2, 1978.
Gelatin silver print. Gift of the Hall Family Foundation, 2009.27.2.

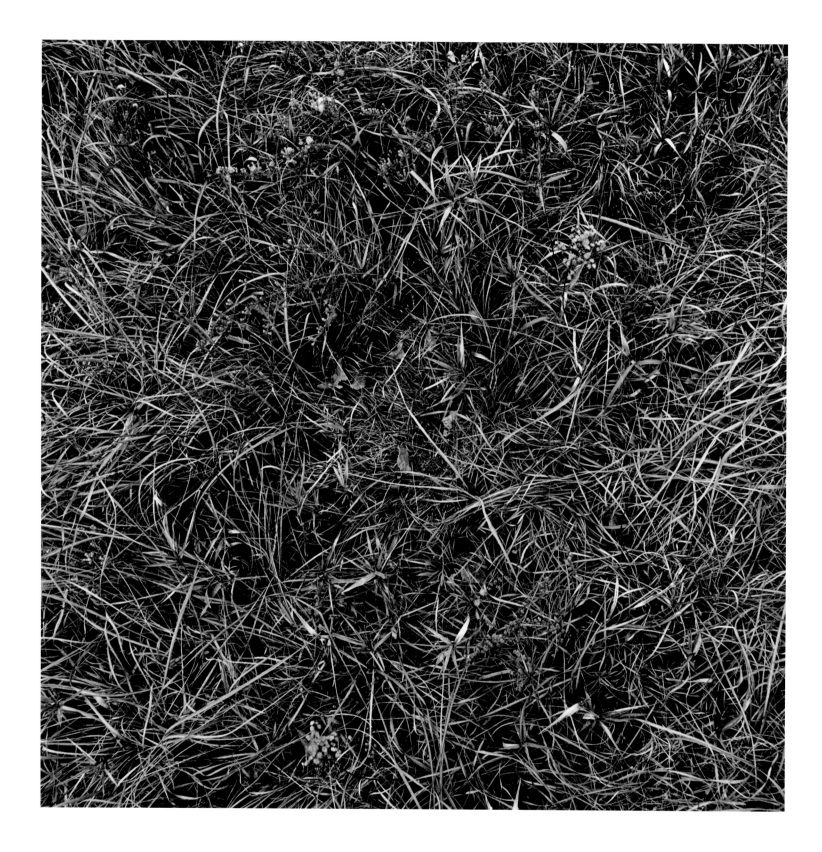

PLATE 20 *Fent's Prairie,* November 10, 1978.
Gelatin silver print. Gift of the Hall Family Foundation, 2009.27.3.

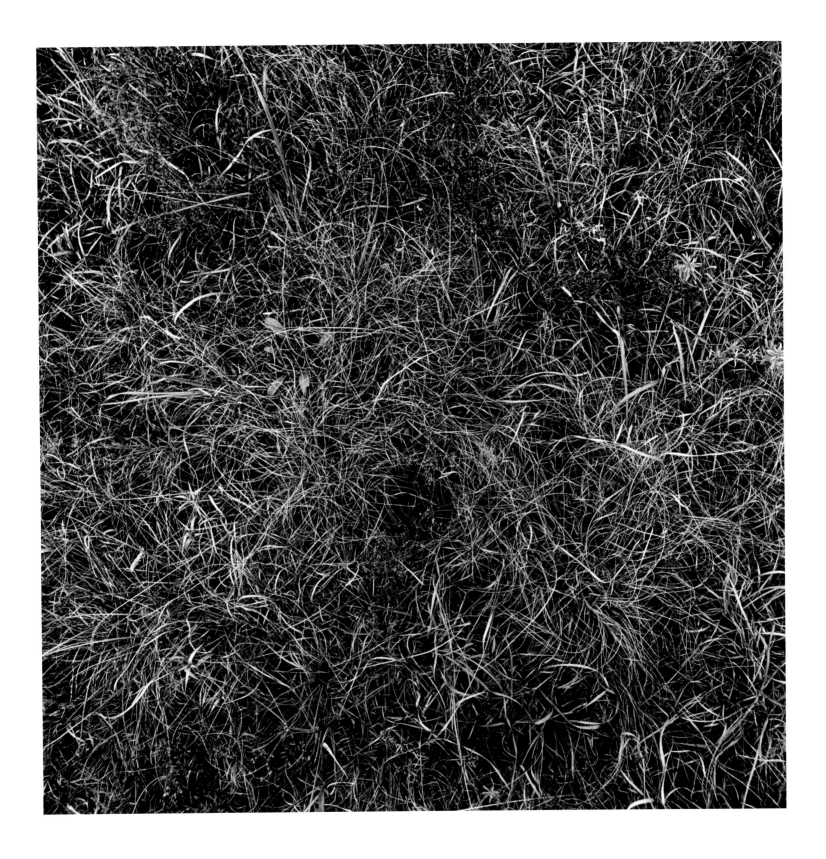

PLATE 21 *Fent's Prairie*, October 11, 1978.
Gelatin silver print. Gift of the Hall Family Foundation, 2009.27.4.

85

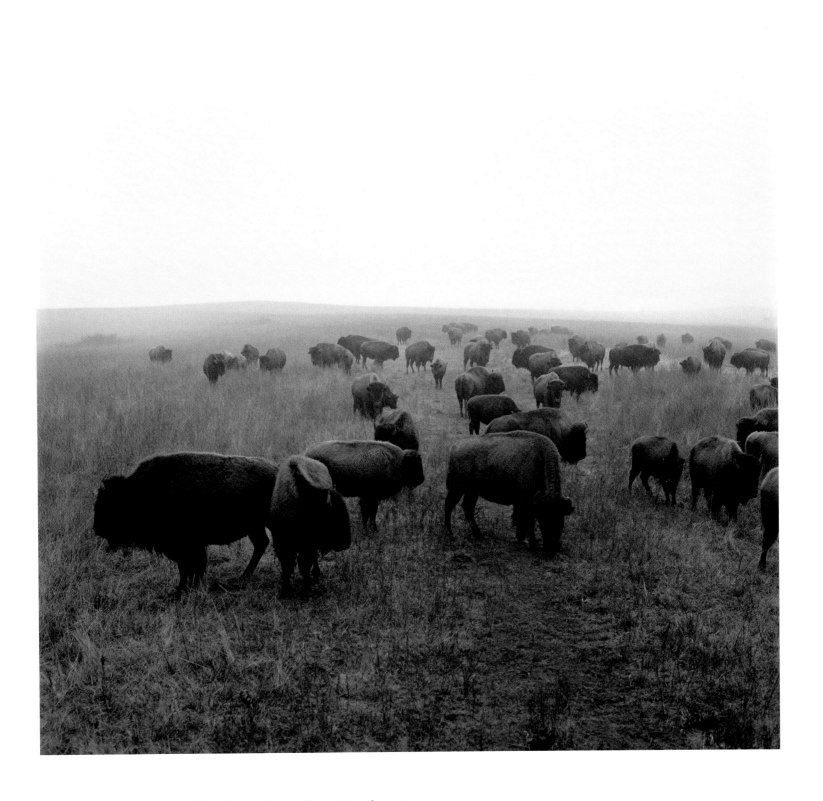

PLATE 22 *Bison at Maxwell Game Preserve, Roxbury, Kansas,* December 1981.
Inkjet print (printed 2012). Gift of the Hall Family Foundation, 2012.17.12.

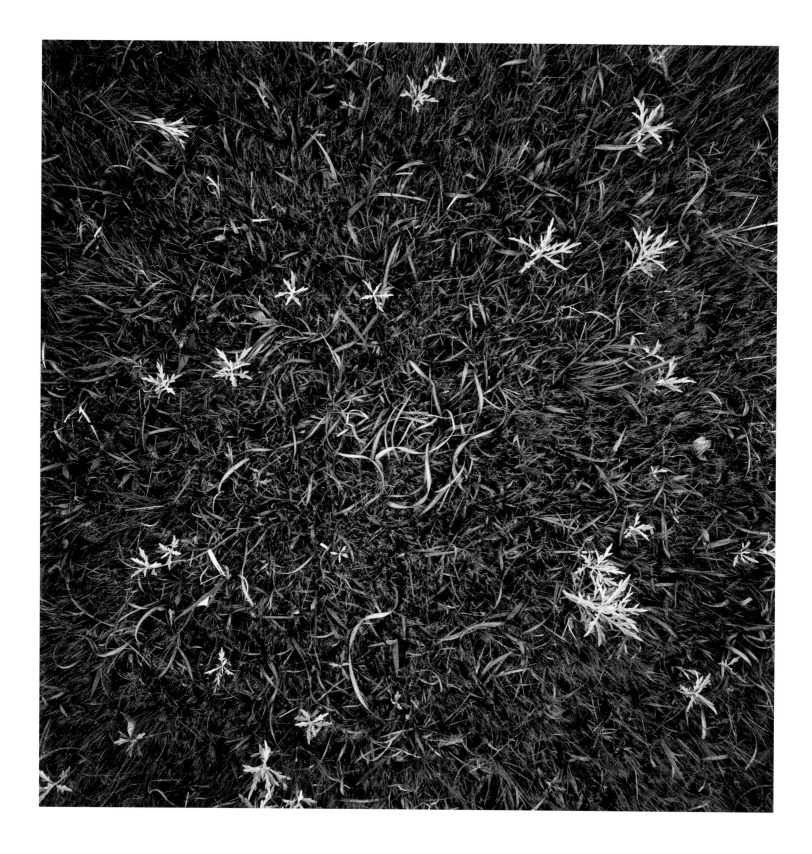

PLATE 23 *Sage, Scribner's panic grass, and other native grasses, Fent's Prairie,* May 1979.
Inkjet print (printed 2012). Gift of the Hall Family Foundation, 2012.17.66.

PLATE 24 *Fairy ring of mixed grasses and brome, with daisy fleabane blooming outside the ring, Fent's Prairie*, June 1979.
Chromogenic print (printed 1990s). Gift of the Hall Family Foundation, 2012.17.26.

PLATE 25 *Sky over Shawnee County, Kansas,* September 1979.
Inkjet print (printed 2012). Gift of the Hall Family Foundation, 2012.17.68.

PLATE 26 *Lake Melvern, Osage County, Kansas,* April 1981.
Inkjet print (printed 2012). Gift of the Hall Family Foundation, 2012.17.48.

PLATE 27 *Konza Prairie, Geary County, Kansas,* June 1982.
Chromogenic print (printed 1990s). Gift of the Hall Family Foundation, 2012.17.46.

THE INHABITED PRAIRIE

By 1985, Evans felt she had photographed the undisturbed prairie to "the limits" of her vision. After a brief return to portraiture, she decided in 1989 to focus on the inhabited prairie, realizing that the human-altered landscape represented a critical aspect of her larger subject. Beginning with color, she switched to black and white in order to emphasize the formal qualities—the shapes and patterns—of what she saw. Evans worked on the series from 1989 to 1992. Typically, she flew with pilots within a twenty-five-mile radius of her home in Salina, Kansas, photographing at a relatively low altitude of 700 to 1,000 feet. Her views of agricultural, militarized, and industrialized landscapes speak to a complex overlay of natural and human histories.

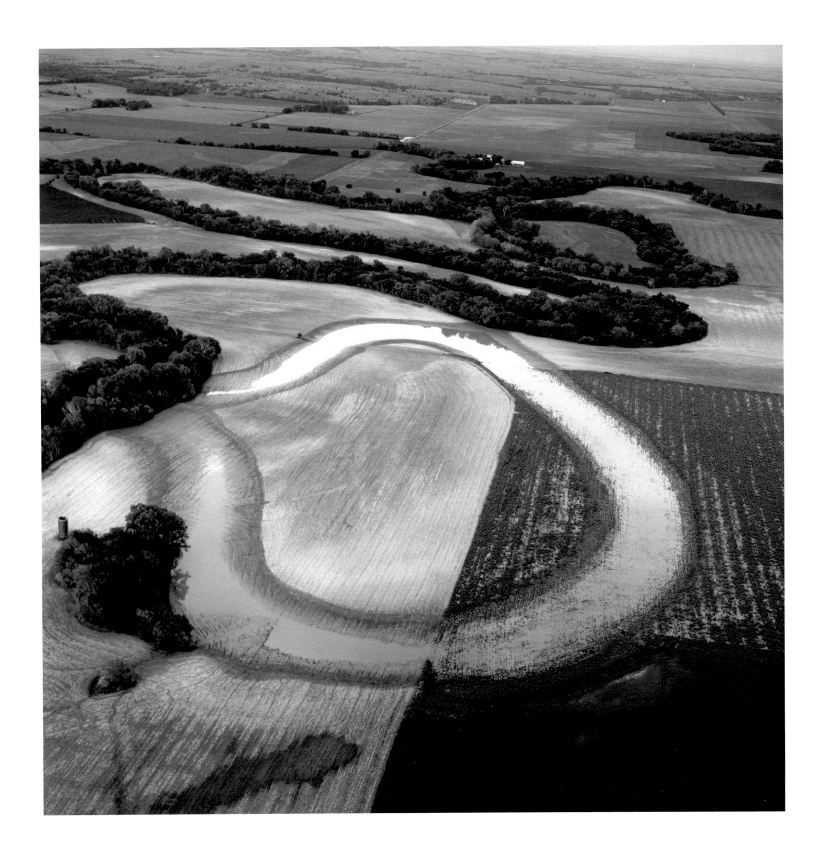

PLATE 28 *Solomon River oxbow, Ottawa County, Kansas*, August 2, 1990.
Gelatin silver print. Gift of the Hall Family Foundation, 2009.27.5.

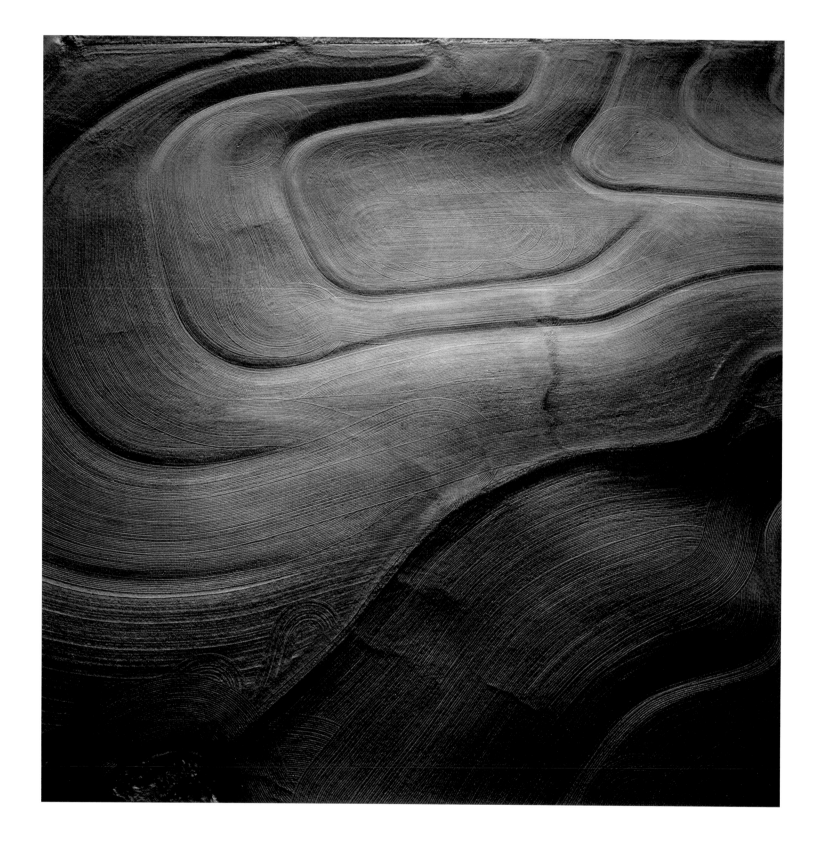

PLATE 29 *Terraced plowing, Saline County, Kansas,* September 1990.
Chromogenic print. Gift of the Hall Family Foundation, 2012.17.73.

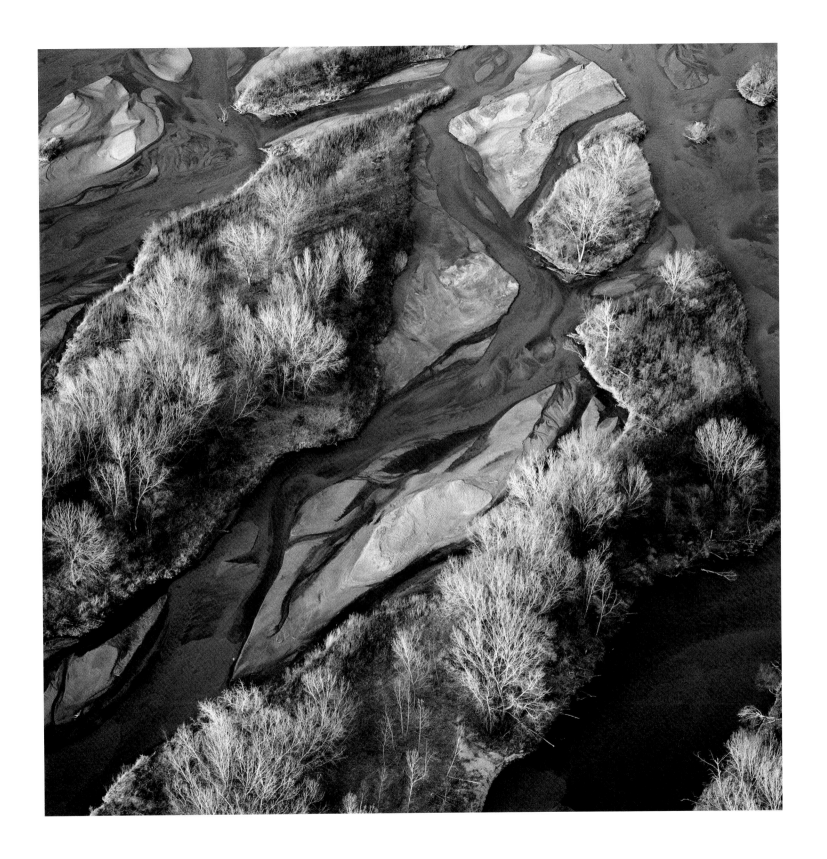

PLATE 30 *Platte River, Nebraska*, 1990.
Inkjet print (printed 2012). Gift of the Hall Family Foundation, 2012.17.57.

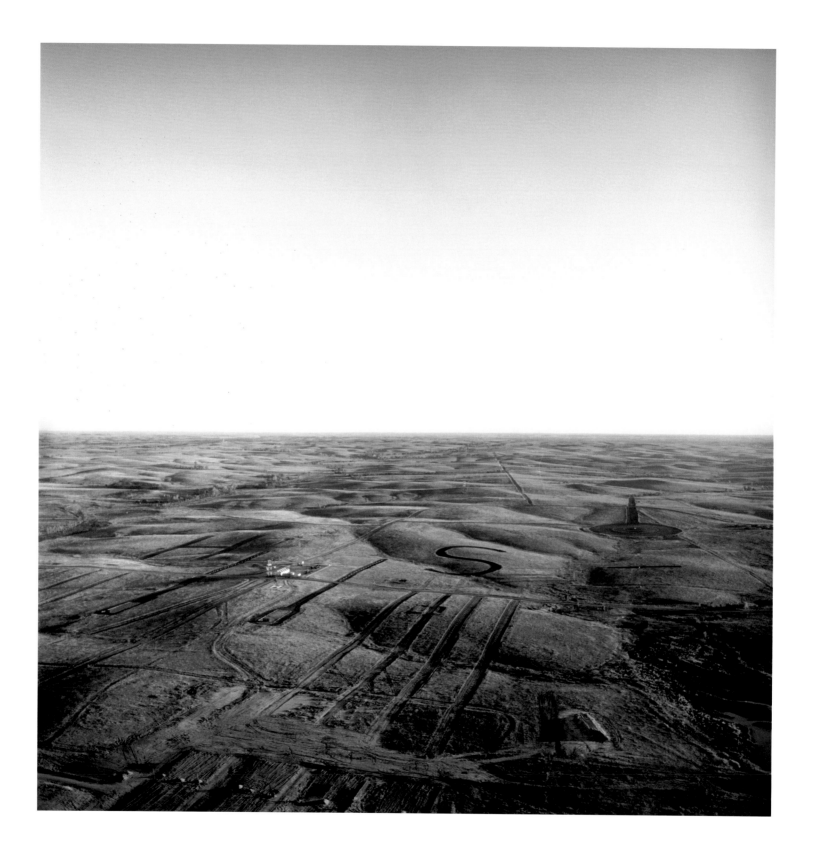

PLATE 31 *Smoky Hill Weapons Range, Saline County, Kansas*, October 22, 1990.
Gelatin silver print. Gift of the Hall Family Foundation, 2009.27.6.

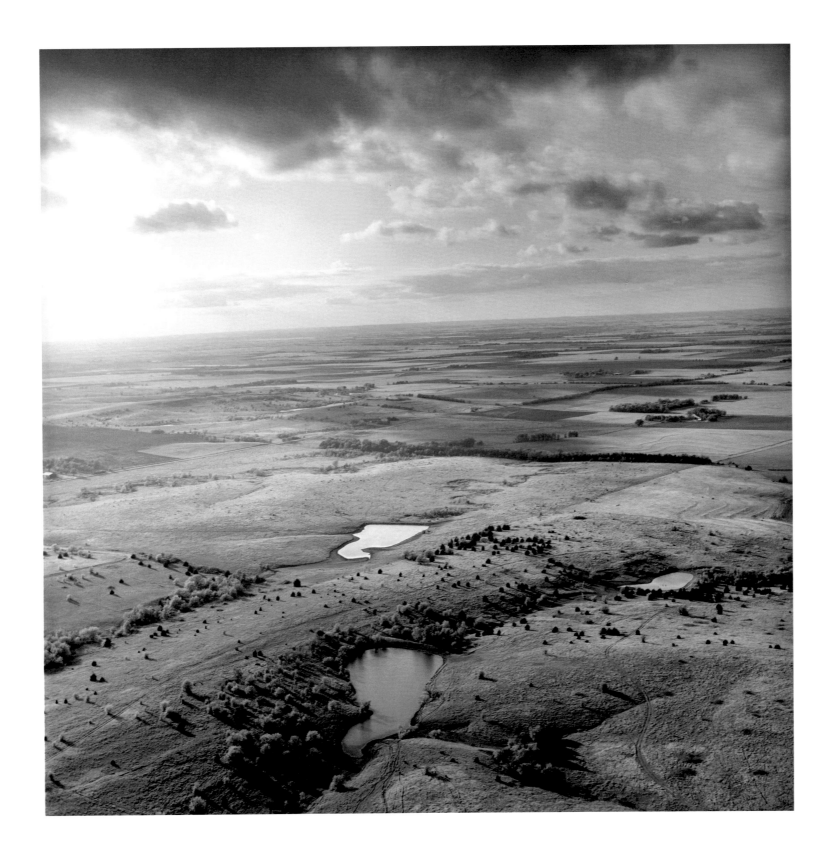

PLATE 32 *Ponds and sky, western Saline County, Kansas*, May 8, 1991.
Gelatin silver print. Gift of the artist, 2009.26.

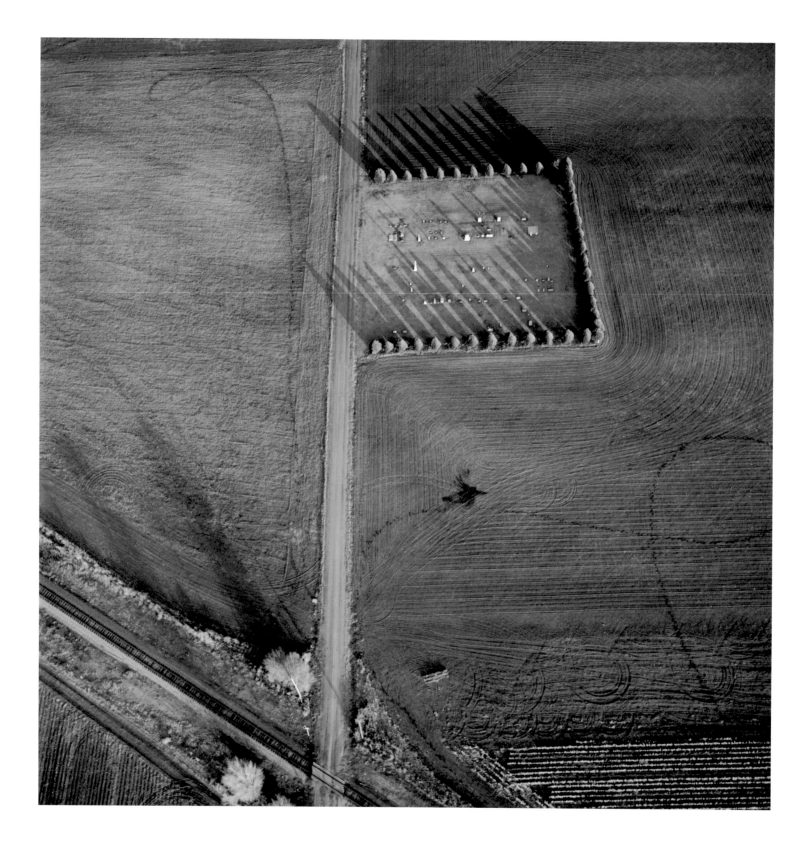

PLATE 33 *Assaria Cemetery, Saline County, Kansas,* January 20, 1992.
Gelatin silver print. Gift of the Hall Family Foundation, 2012.17.7.

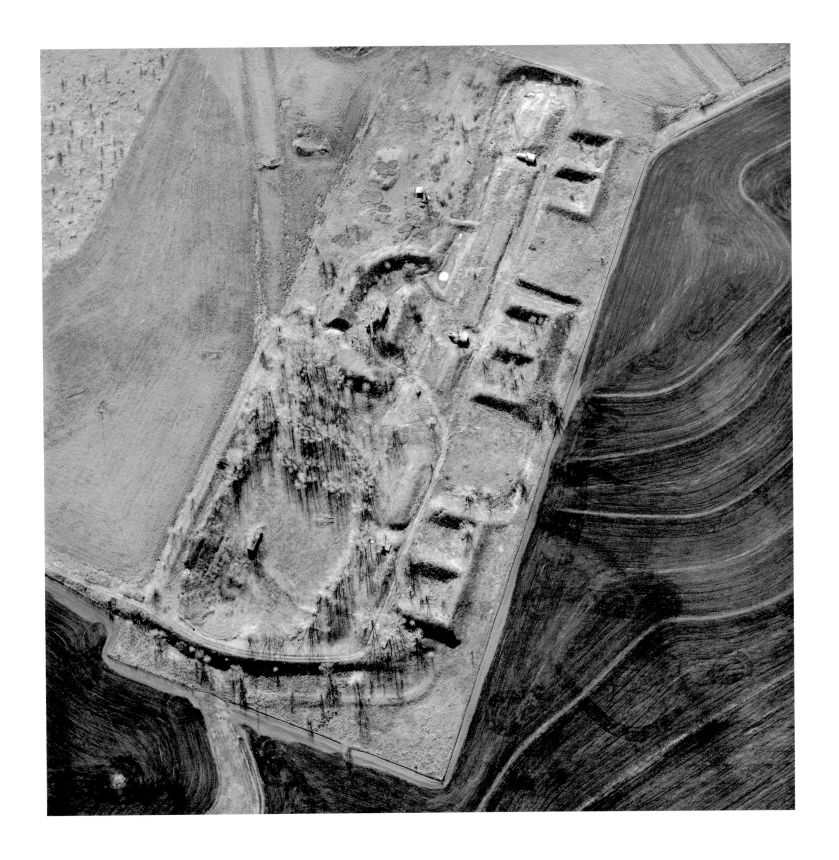

PLATE 34 *Abandoned missile launching pad, Saline County, Kansas*, March 23, 1991.
Gelatin silver print. Gift of the Hall Family Foundation, 2012.17.5.

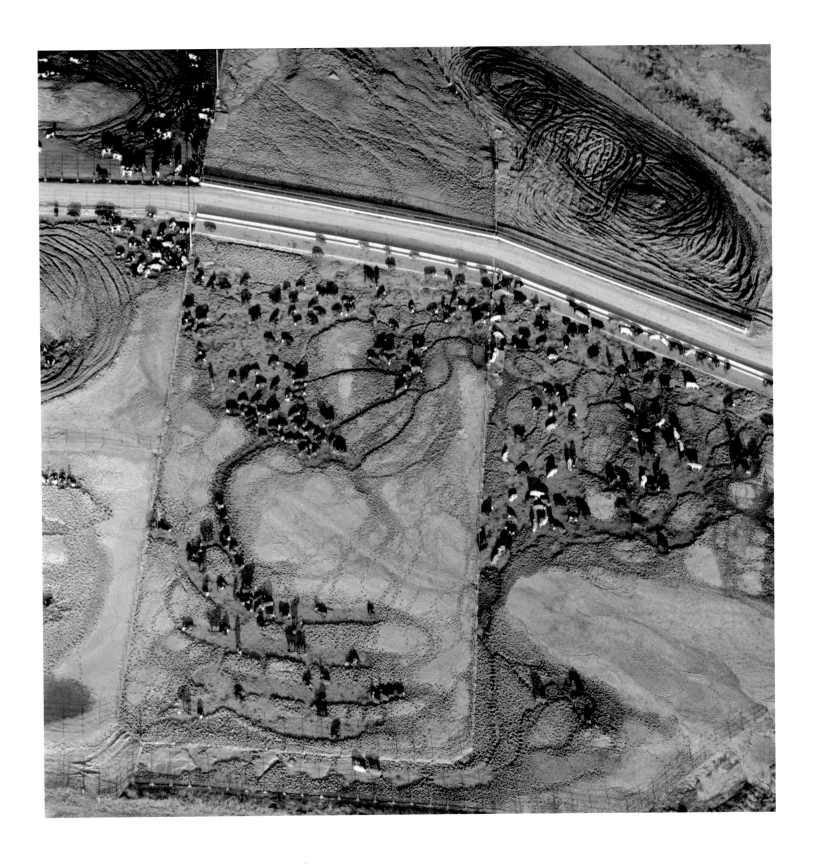

PLATE 35 *Cattle feedlot, Saline County, Kansas,* April 24, 1993.
Gelatin silver print. Gift of the Hall Family Foundation, 2012.17.16.

DISARMING THE PRAIRIE

Between 1995 and 1997, Evans photographed the Joliet Army Arsenal, an abandoned munitions manufacturing site forty miles southwest of Chicago. Scarred by industrial contamination, this land was being transferred to the U.S. Forest Service to create the Midewin National Tallgrass Prairie, the nation's first national prairie park. Evans was fascinated by this process of rehabilitation and the site's complex layers of history—abandoned military buildings, a Civil-War era fence, an Indian burial ground.

For this project, she made both aerial views and more traditional landscapes on the ground.

PLATE 36 *Furnace room (sink), east side, former Joliet Arsenal, Illinois, October 10, 1996.*
Inkjet print (printed 2012). Gift of the Hall Family Foundation, 2012.17.36.

PLATE 37 *Cow and horse grazing at the Plenemuk burial mound site, former Joliet Arsenal, Illinois,* January 1, 1997.
Chromogenic print. Gift of the Hall Family Foundation, 2012.17.20.

PLATE 38 *Railroad tracks next to Drummond Prairie, former Joliet Arsenal, Illinois*, November 25, 1996.
Inkjet print (printed 2012). Gift of the Hall Family Foundation, 2012.17.60.

PLATE 39 *Fieldstone fence, labor attributed to Confederate prisoners of war, 1861-1865, former Joliet Arsenal, Illinois, February 1996.*
Inkjet print (printed 2012). Gift of the Hall Family Foundation, 2012.17.34.

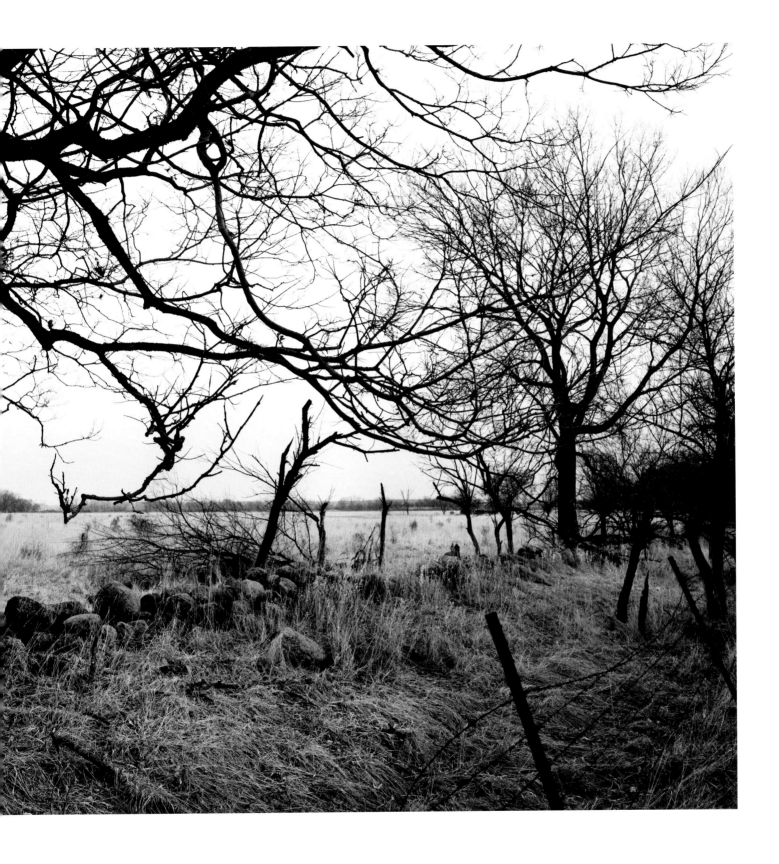

CANADA TO TEXAS

In 1996, Evans received a John Simon Guggenheim Memorial
Fellowship to create an aerial photographic survey of the great
North American mixed-grass prairie, from central Saskatchewan
in Canada to central Texas. Photographing entirely from the air,
and in color, Evans worked systematically on the project from
1996 to 1999. The resulting body of work covers a region nearly
2000 by 500 miles in size, a dramatic expansion of the idea that
began with her earliest, extremely intimate, prairie photographs.

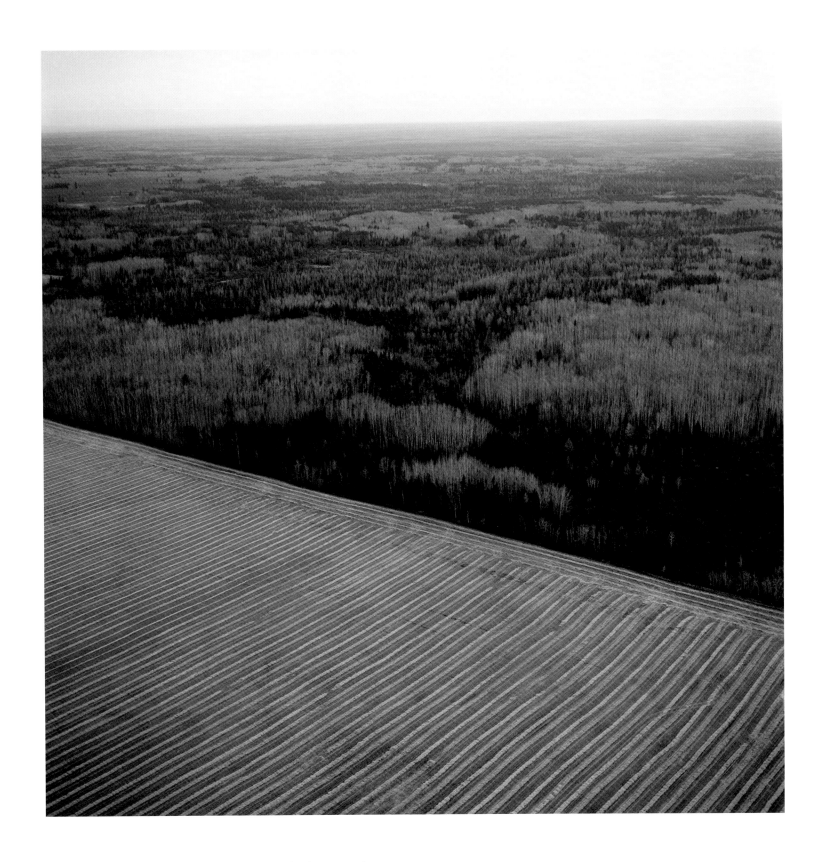

PLATE 40 *Where the prairie meets the forest, Saskatchewan*, October 24, 1996.
Inkjet print (printed 2012). Gift of the Hall Family Foundation, 2012.17.81.

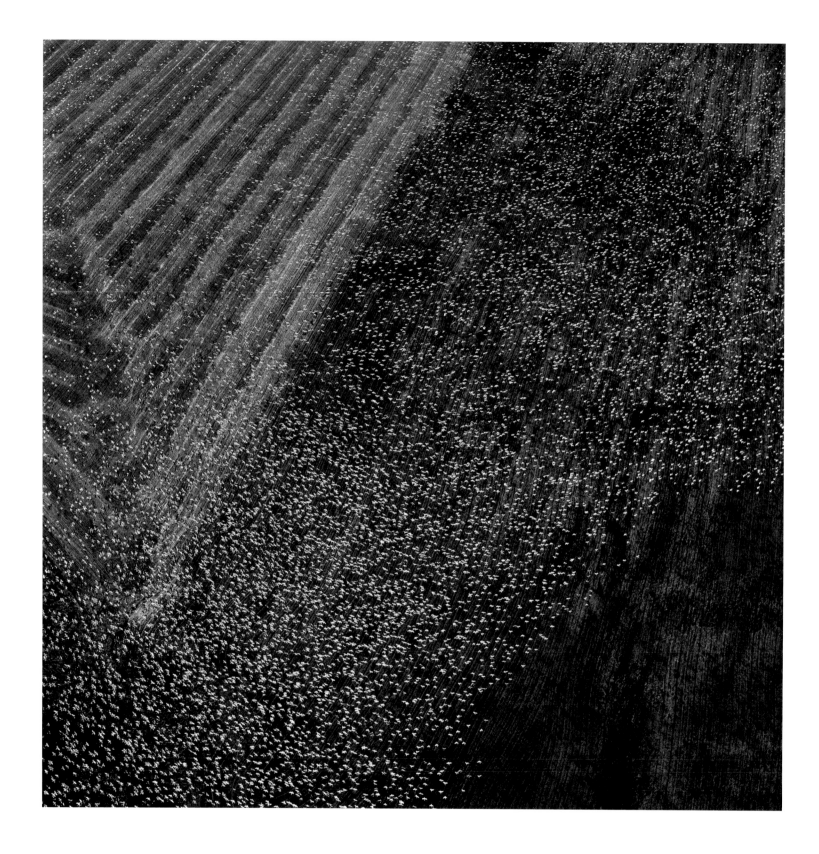

PLATE 41 *Snow geese, south of Regina, Saskatchewan,* October 21, 1996.
Inkjet print (printed 2012). Gift of the Hall Family Foundation, 2012.17.71.

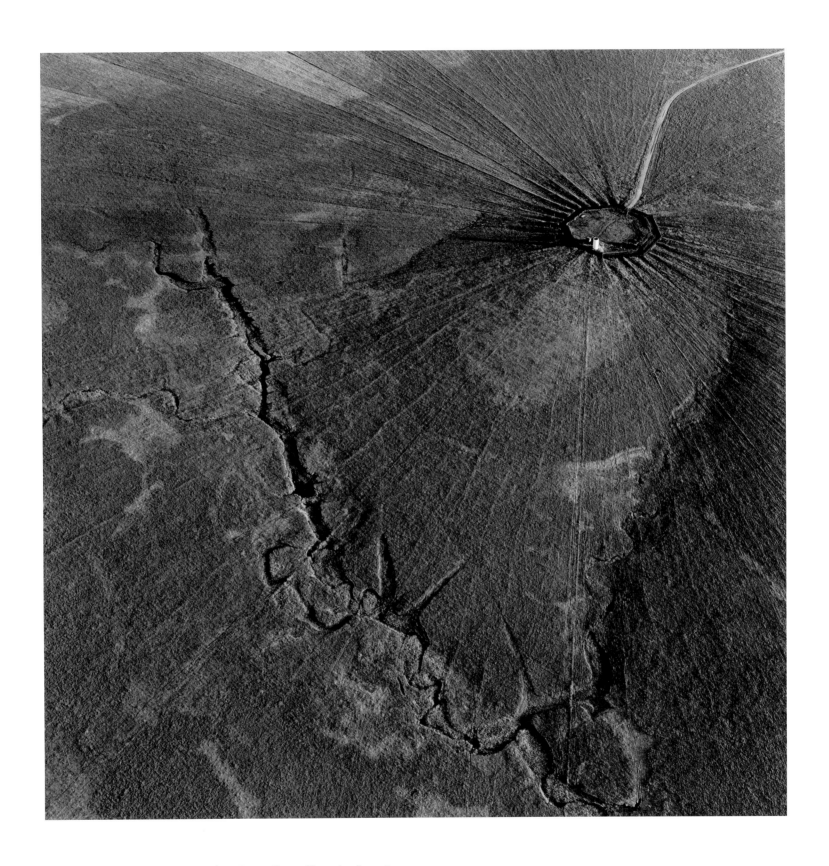

PLATE 42 *Rotational grazing, Chase County, Kansas*, November 8, 1996.
Chromogenic print (printed 1999). Gift of the Hall Family Foundation, 2012.17.64.

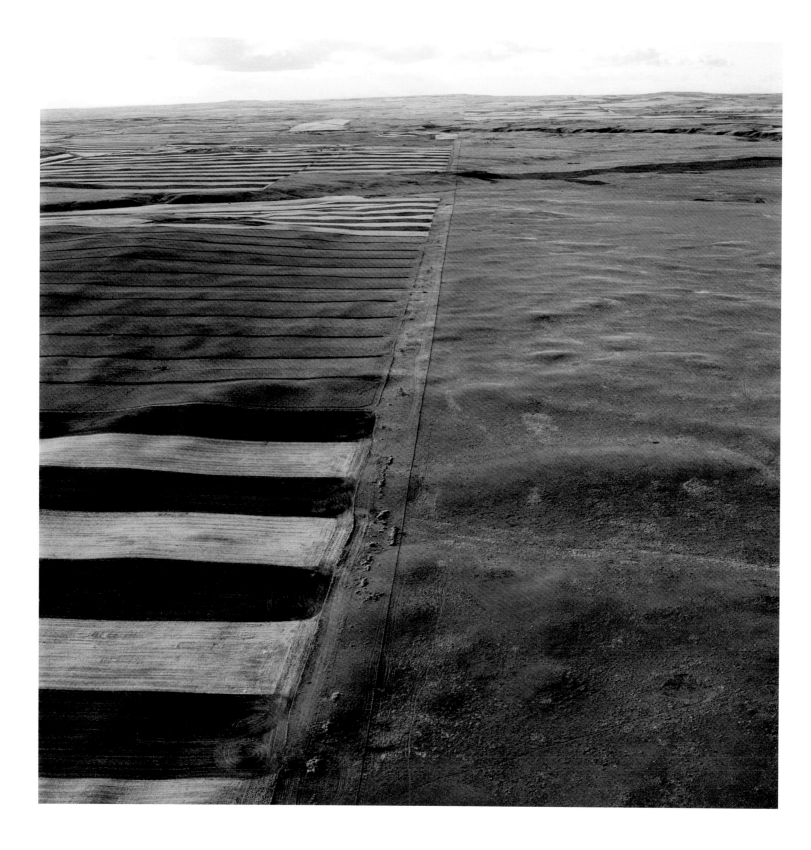

PLATE 43 *US-Canada border, Montana/Alberta*, October 22, 1996.
Inkjet print (printed 2012). Gift of the Hall Family Foundation, 2012.17.79.

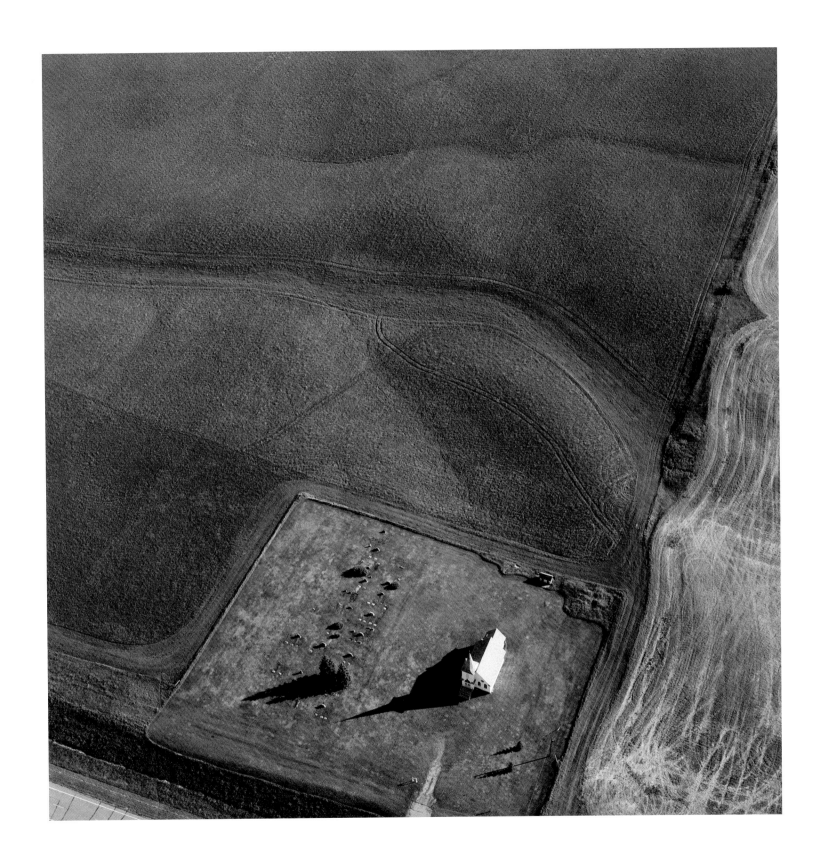

PLATE 44 *East of Crosby, North Dakota*, October 15, 1997.
Inkjet print (printed 2012). Gift of the Hall Family Foundation, 2012.17.22

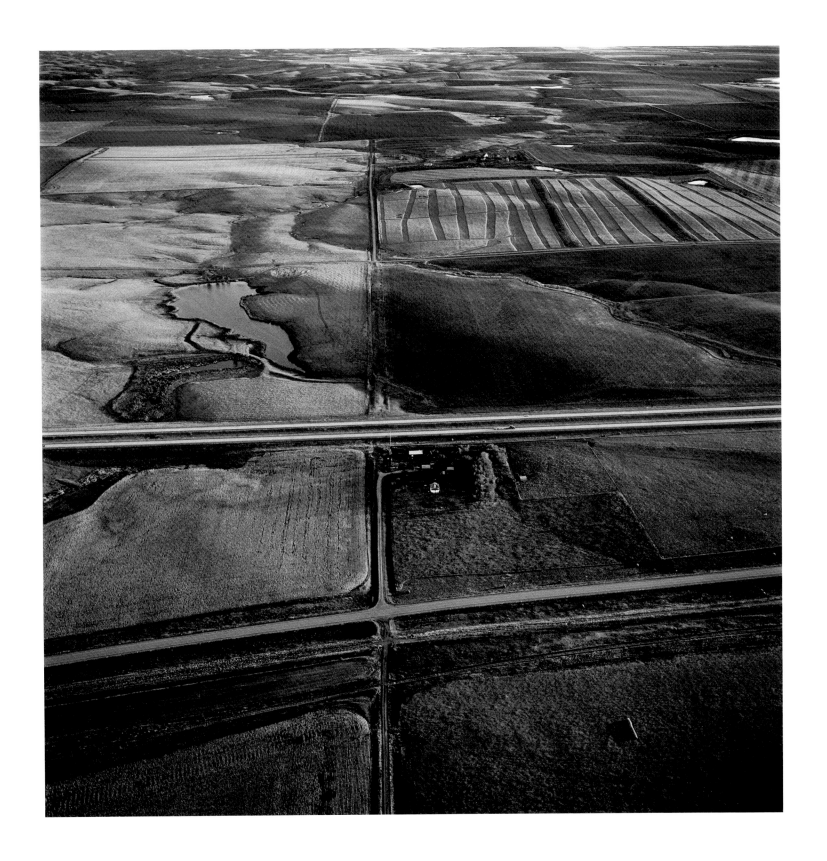

PLATE 45 *West of Bismarck, North Dakota*, October 15, 1997.
Inkjet print (printed 2012). Gift of the Hall Family Foundation, 2012.17.80.

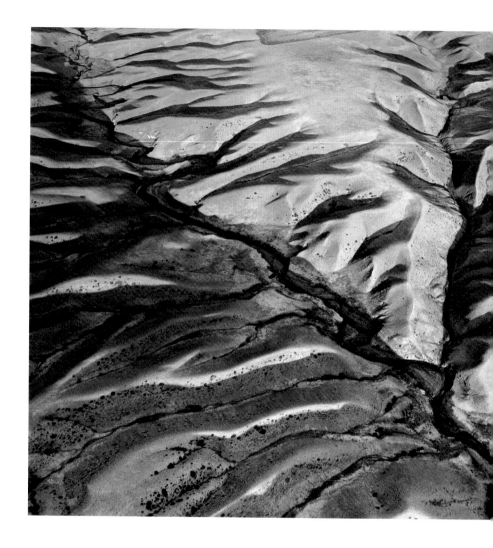

PLATE 46 *East of Great Falls, Montana,* September 28, 1999.
Inkjet print (printed 2012). Gift of the Hall Family Foundation, 2012.17.23.

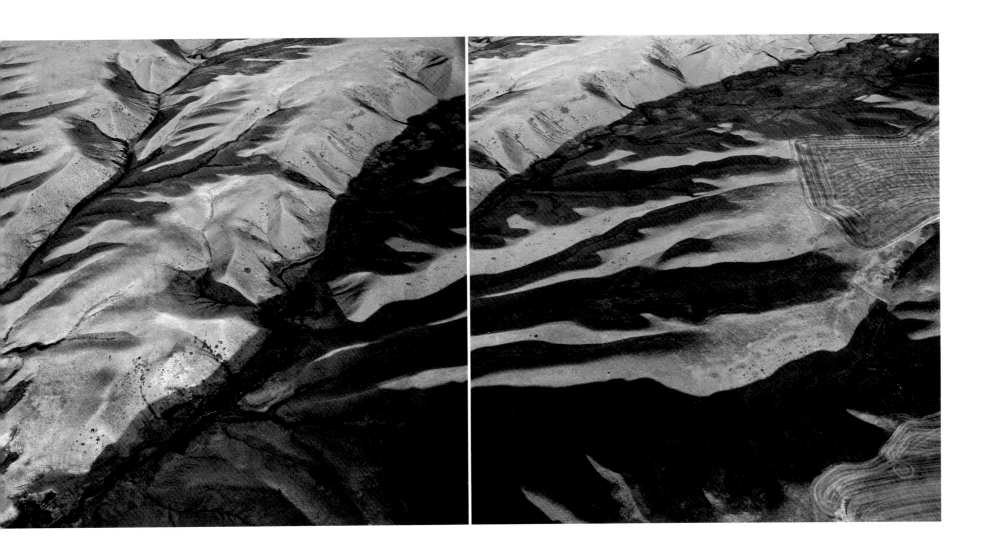

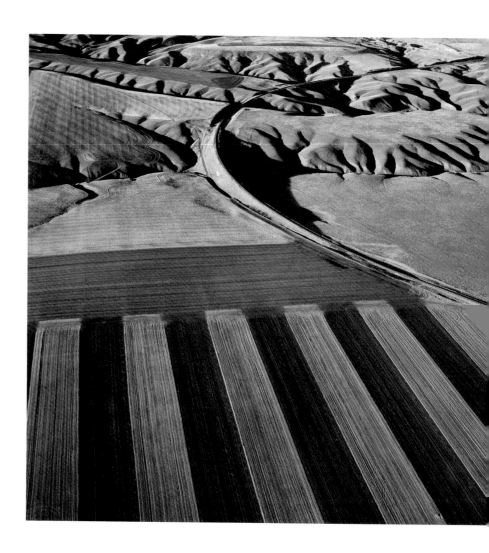

PLATE 47 *North of Great Falls, Montana*, September 28, 1999.
Inkjet print (printed 2012). Gift of the Hall Family Foundation, 2012.17.53.

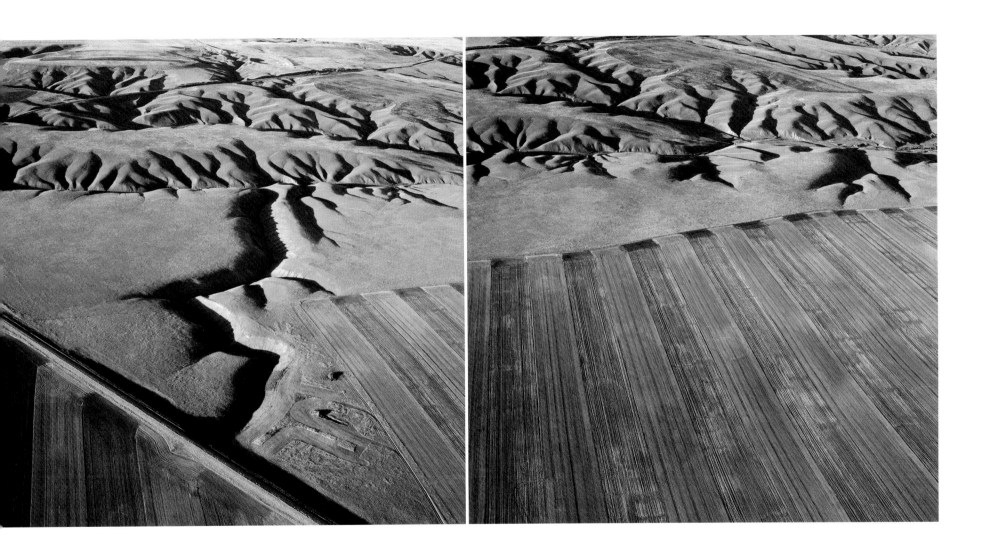

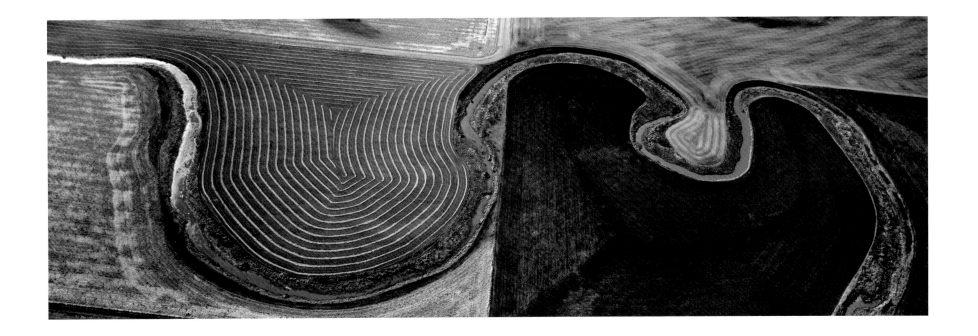

PLATE 48 *River, south of Regina, Saskatchewan*, October 21, 1996.
Inkjet print (printed 2012). Gift of the Hall Family Foundation, 2012.17.63.

PRAIRIE SPECIMENS

While engaged with several other projects, Evans began to

photograph plant and animal specimens native to the prairie.

Her first photographs, in 1997, were inspired by a book

of century-old botanical specimens found in Matfield Green.

She continued to explore and expand on this idea through

2002, using a 4 x 5-inch view camera to photograph the

collections of the Field Museum of Natural History, Chicago.

Evans worked entirely in color for this series, and printed

at a scale that rendered the subjects near life size.

PLATE 49 *Anton Olsen's Flora of Kansas, green milkweed, May 25, 1886, 1999.*
Inkjet print. Gift of Hallmark Cards, Inc., 2005.27.4054.

PLATE 50 *Field Museum, helianthus, Ravenswood, Chicago, Illinois, 1905, 2000.*
Inkjet (Iris) print. Gift of Hallmark Cards, Inc., 2005.27.2638.

PLATE 51 *Field Museum, oak leaves, Riverside, Chicago, Illinois, 1892,* 2002.
Inkjet (Iris) print. Gift of the Hall Family Foundation, 2012.17.32.

PLATE 52 *Field Museum, two carp, 1958, 2001.*
Inkjet (Iris) print. Gift of the Hall Family Foundation, 2012.17.33.

PLATE 53 *Field Museum, bullsnakes, various dates and locations, 2001.*
Inkjet print (printed 2012). Gift of the Hall Family Foundation, 2012.17.29.

PLATE 54 *Field Museum, drawer of eastern meadowlarks, various dates and locations, 2001.*
Inkjet print. Gift of the Hall Family Foundation, 2010.14.7.

PLATE 55 *Field Museum, drawer of northern cardinals, various dates and locations, 2001.*
Inkjet print. Gift of the Hall Family Foundation, 2010.14.6.

PLATE 56 *Field Museum, jackrabbit, Texas, 1891, 2000.*
Inkjet (Iris) print. Gift of the Hall Family Foundation, 2012.17.31.

PLATE 57 *Field Museum, Eskimo curlew, Kansas, 1837*, 2001.
Inkjet (Iris) print. Gift of the Hall Family Foundation, 2012.17.30.

PLATE 58 *Field Museum, Trumpeter swan, North Dakota, 1891, 2001.*
Inkjet (Iris) print. Collection of Elizabeth and Marc Wilson, Platte County, Missouri.

PRAIRIE SCROLLS

In 2007, Evans revisited some of her earliest photographs (1978–79) of the prairie. Inspired by Japanese scrolls, she used new digital technology to scan and stitch individual negatives into a single, elongated horizontal image. Evans views these works as entirely new conceptions that "required almost thirty years to become fully realized."

PLATE 59 *Fent's Prairie with dog,* 1978 and 2007.
Inkjet print (printed 2012). Gift of the Hall Family Foundation, 2012.17.28.

Matfield Green

MATFIELD GREEN

Evans first visited the tiny town of Matfield Green, located

approximately sixty miles northeast of Wichita in the Flint Hills of

Chase County, Kansas, in 1990. Introduced to it by Wes Jackson,

who had established a research branch of the Land Institute there

that year, Evans immediately began to photograph. Her first

pictures focussed on the town's abandoned houses, but she soon

began making portraits of the town's residents, most of whom

became close friends. Evans returned to Matfield Green repeatedly

through 1998 and again from 2008 to 2010. The resulting body

of work, in both color and black and white, is an in-depth study of

the people, structures, and environmental context of this small

but enduring community. Concepts of personal history, loss, and

the passage of time are central to this series.

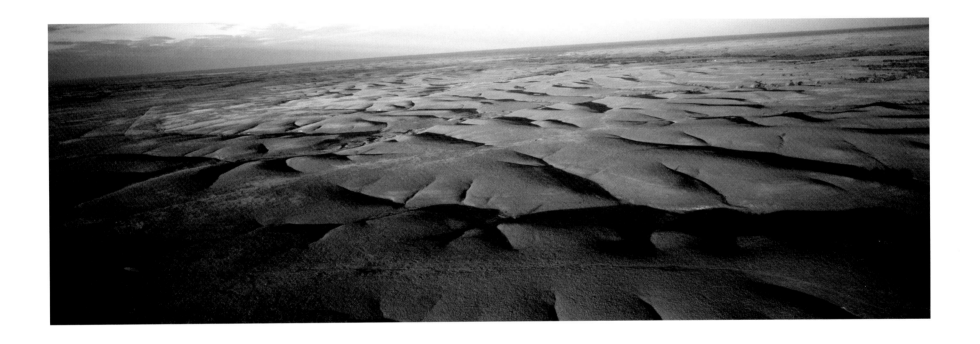

PLATE 60 *Prairie, Chase County, Kansas,* November 1996.
Inkjet print. Gift of the Hall Family Foundation, 2012.17.58.

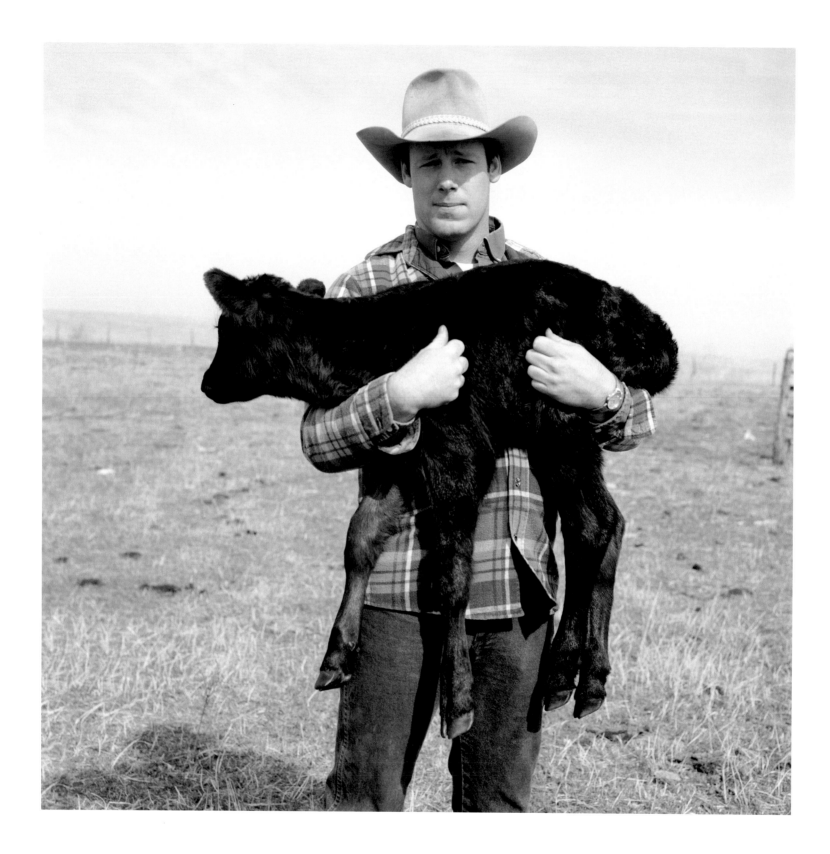

142 PLATE 61 *Carl with twin calf, Matfield Green, Kansas,* 1993.
Inkjet print (printed 2012). Gift of the Hall Family Foundation, 2012.17.15.

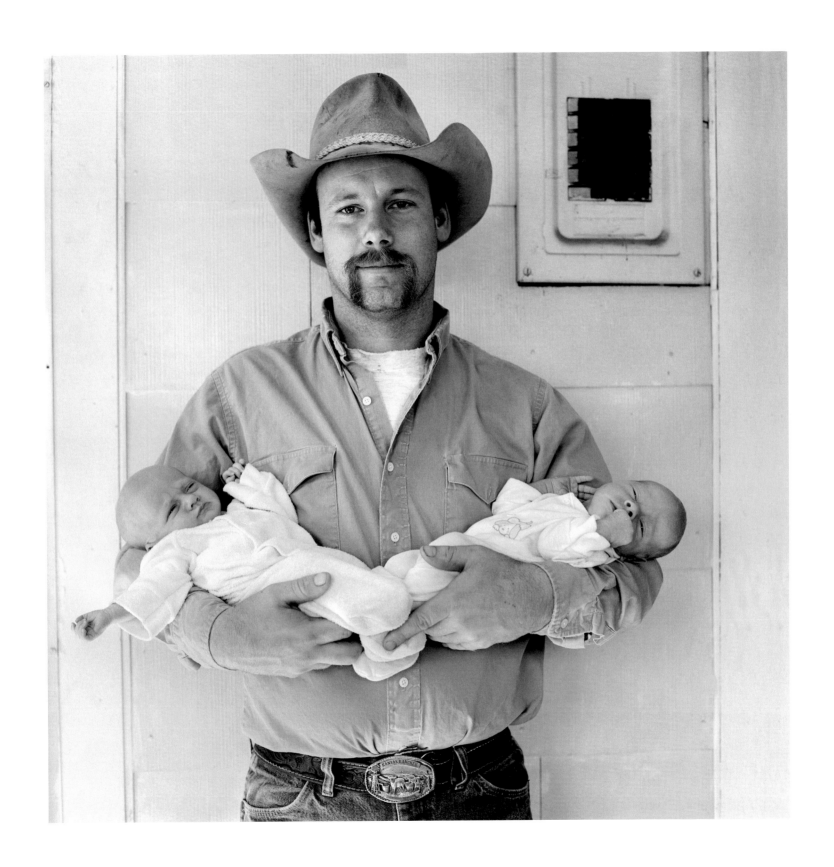

PLATE 62 *Carl with his twins, Shelby and Colter, Matfield Green, Kansas,* 1994.
Inkjet print (printed 2012). Gift of the Hall Family Foundation, 2012.17.14.

PLATE 63 *Bed, Matfield Green, Kansas*, 1991.
Inkjet print. Gift of the Hall Family Foundation, 2012.17.11.

PLATE 64 *The Lawrence's house, Matfield Green, Kansas*, January 1995.
Inkjet print. Gift of the Hall Family Foundation, 2012.17.49.

PLATE 65 *Spring prairie burning, Chase County, Kansas,* April 1994.
Inkjet print. Gift of the Hall Family Foundation, 2012.17.72.

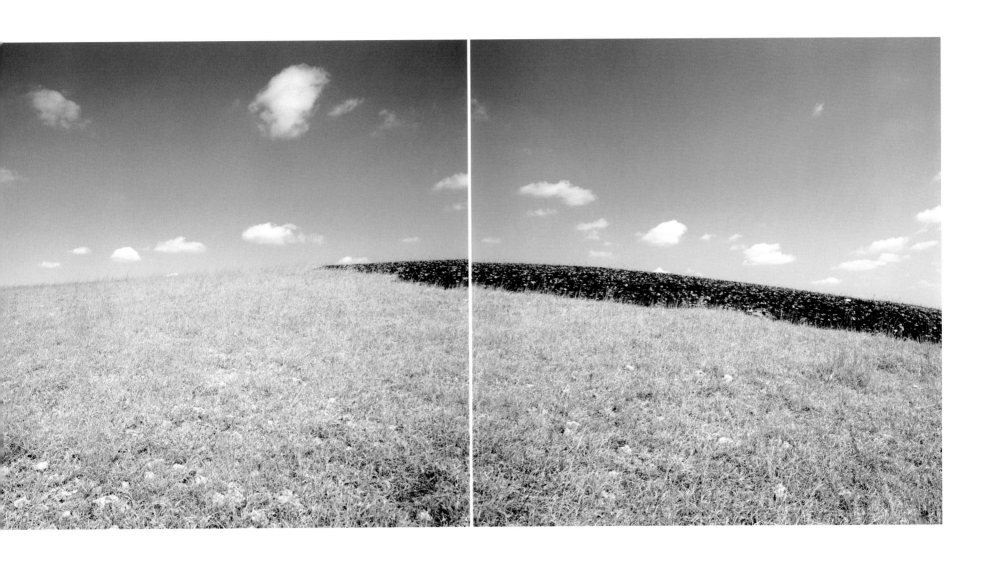

PLATE 66 *Interstate 35 intersecting the Flint Hills, Kansas*, April 1994.
Inkjet print (printed 2012). Gift of the Hall Family Foundation, 2012.17.41.

PLATE 67 *Ray with divining rods, Matfield Green, Kansas,* June 1997.
Inkjet print. Gift of the Hall Family Foundation, 2012.17.61.

PLATE 68 *Toots Conley, Matfield Green, Kansas,* May 2009.
Inkjet print. Gift of the Hall Family Foundation, 2012.17.74.

PLATE 69 *Toots, south of Matfield Green, Kansas,* January 2009.
Inkjet print. Gift of the Hall Family Foundation, 2012.17.75.

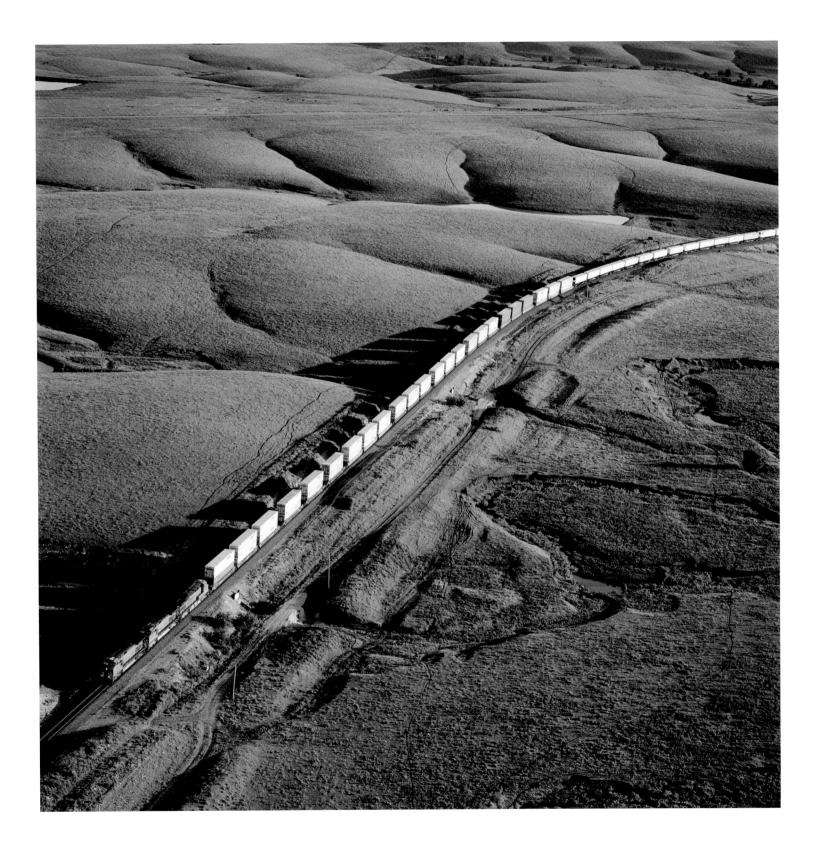

PLATE 70 *Train north of Matfield Green, Chase County, Kansas,* July 2009.
Inkjet print. Gift of the Hall Family Foundation, 2012.17.76.

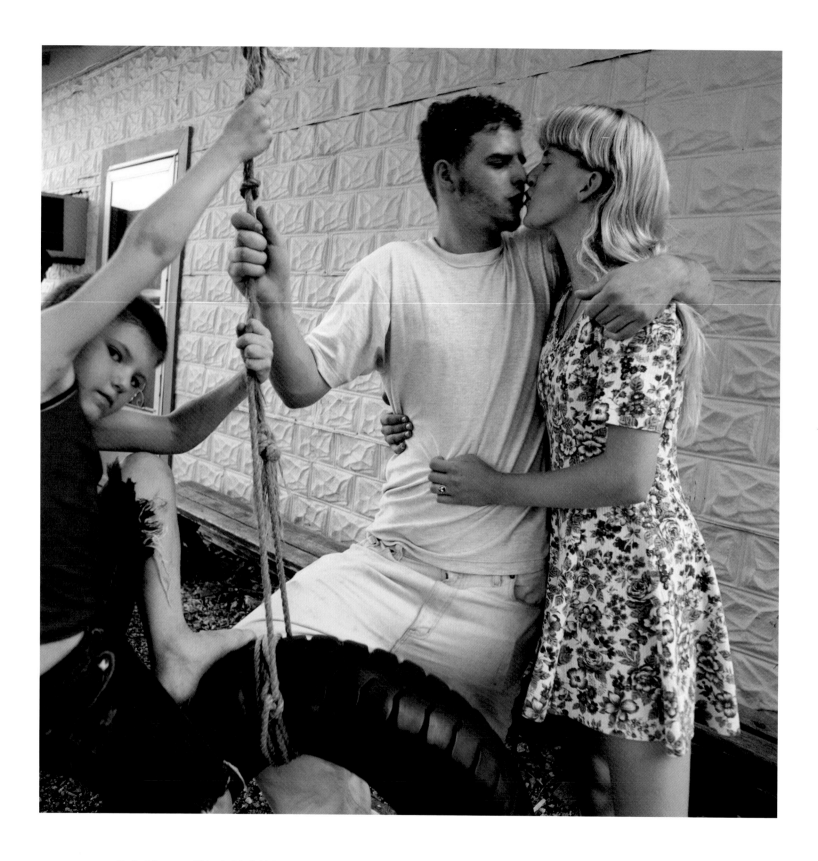

PLATE 71 *Becky Johnson and friends, Matfield Green, Kansas,* 1997.
Inkjet print. Gift of the Hall Family Foundation, 2012.17.10.

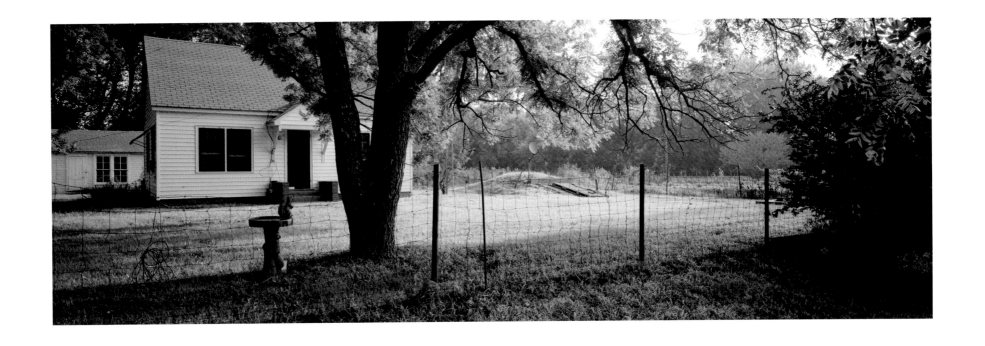

PLATE 72 *Evie Mae's house, Matfield Green, Kansas,* 1996.
Inkjet print. Gift of the Hall Family Foundation, 2012.17.25.

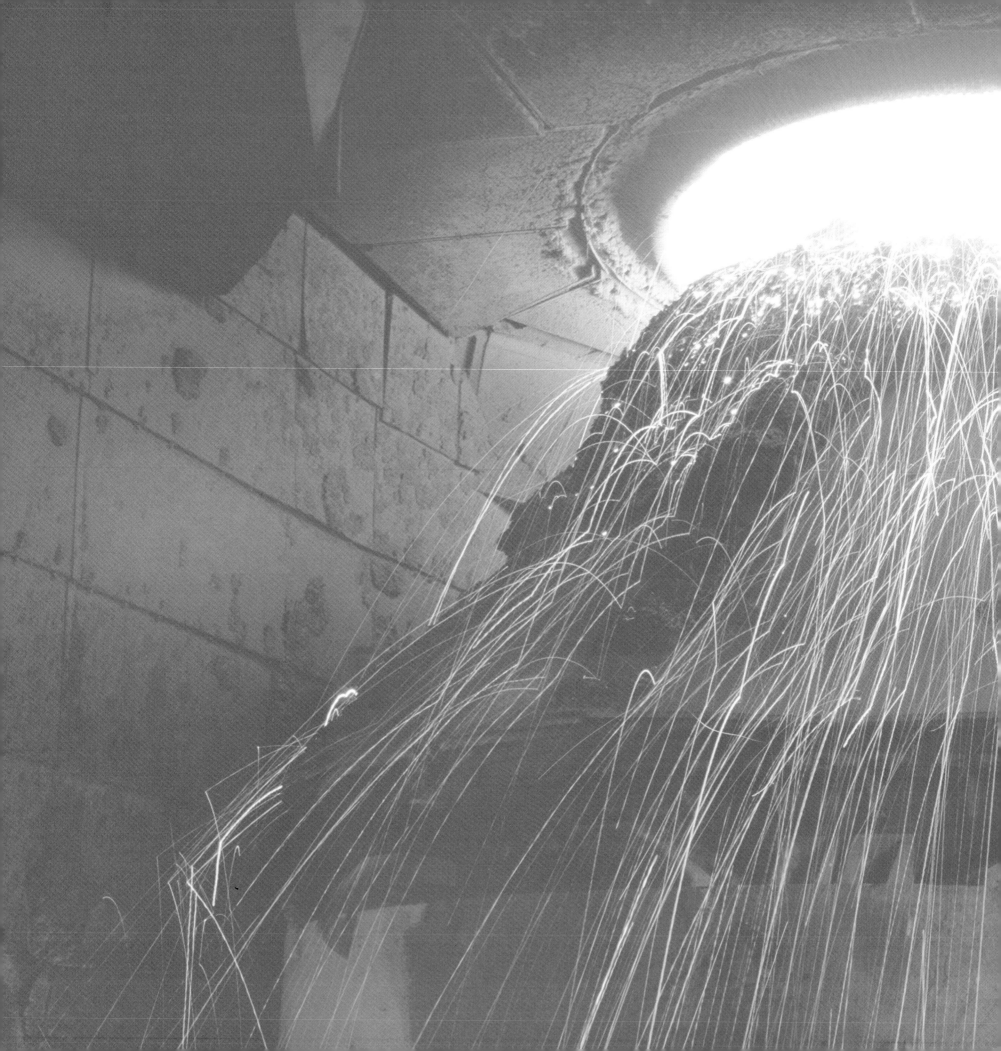

Beyond the Prairie

REVEALING CHICAGO

STEEL WORK

GREENLAND

Evans visited Iowa in April 2002 to lecture at the Cedar Rapids

Art Museum. While there, she went for a ride in a hot air

balloon, floating at low altitude over the outskirts of the city.

While not part of a specific series, this image prompted Evans to

consider the photographic possibilities of a larger urban and

suburban subject: Chicago.

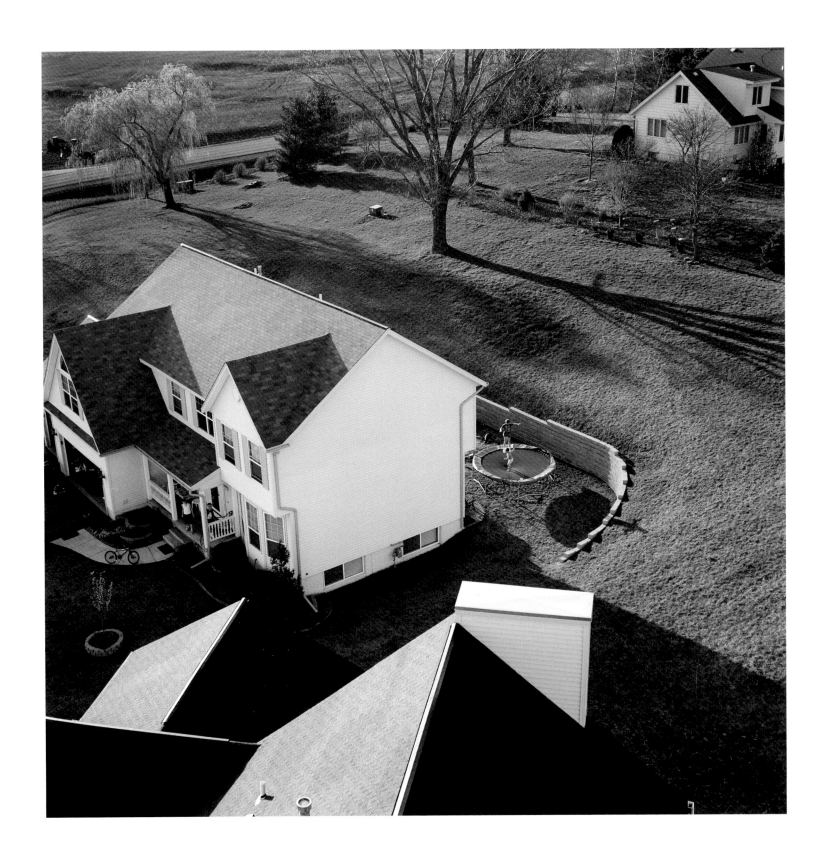

PLATE 73 *Trampoline, Cedar Rapids, Iowa*, April 17, 2002.
Chromogenic print. Gift of the Hall Family Foundation, 2012.17.77.

REVEALING CHICAGO

From 2003 to 2005, Evans conducted an extensive aerial survey
of the Chicago metropolitan region, supported by the Chicago
Department of Cultural Affairs, Openlands, and other
organizations. For this project, conducted in partnership with
Gerald Adelmann of Openlands, Evans worked exclusively
in color and made forty-six flights in helicopters, hot air balloons,
and small airplanes. Revealing Chicago culminated in a major
publication and an exhibition of photographs coinciding with the
opening of the city's new Millennium Park, in 2005.

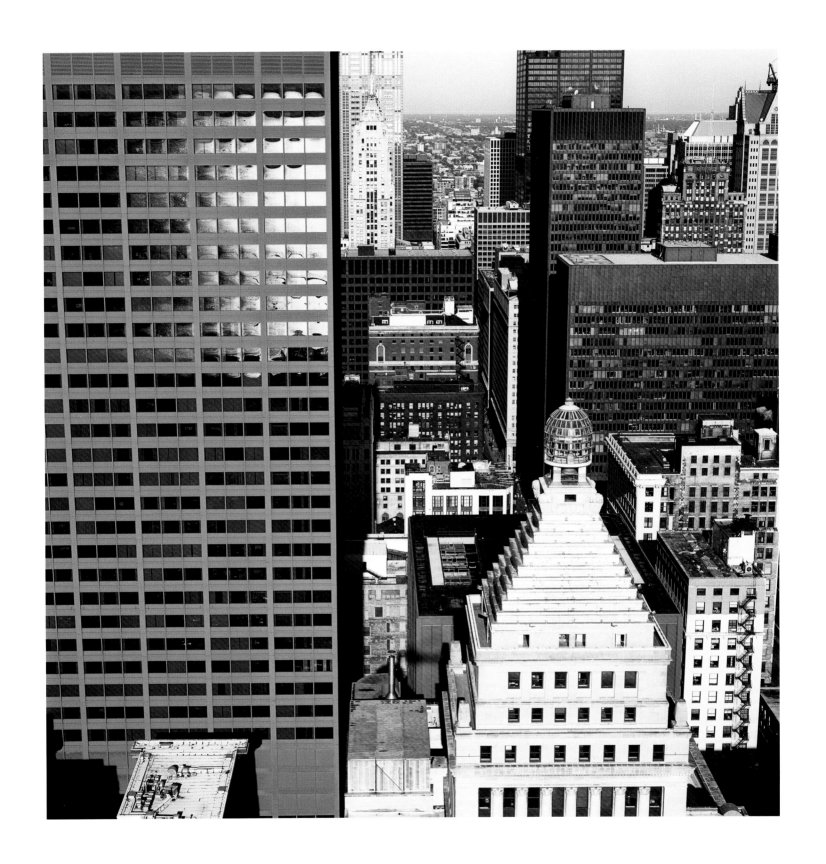

PLATE 74 *CNA building, downtown Chicago,* April 27, 2004.
Inkjet print (printed 2012). Gift of the Hall Family Foundation, 2012.17.17.

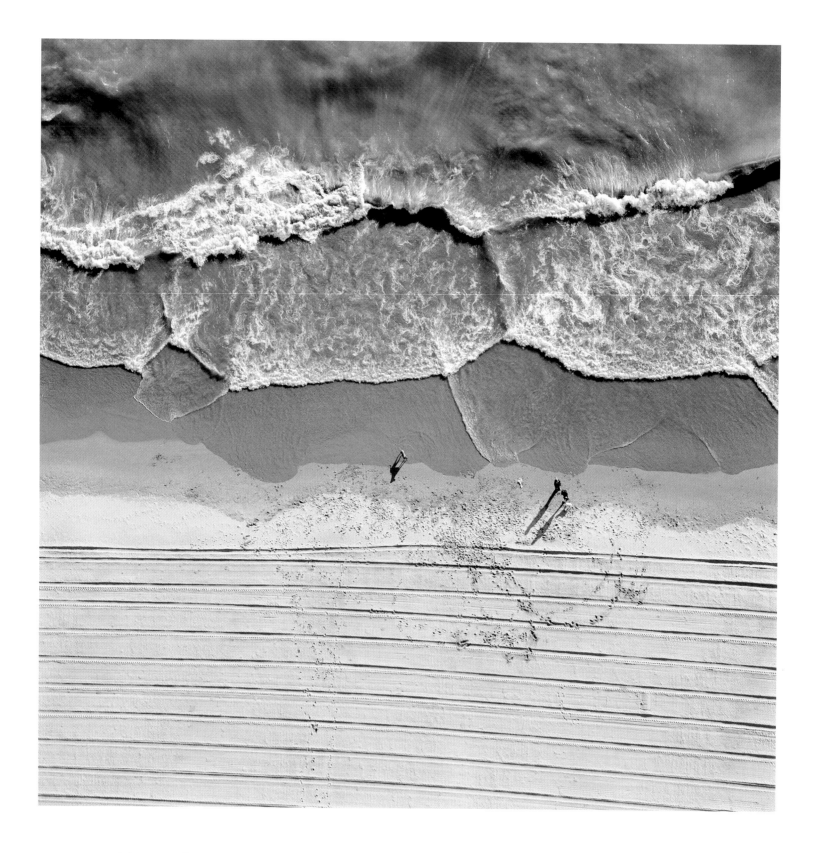

PLATE 75 *Oak Street Beach, Chicago*, April 27, 2004.
Inkjet print (printed 2012). Gift of the Hall Family Foundation, 2012.17.54.

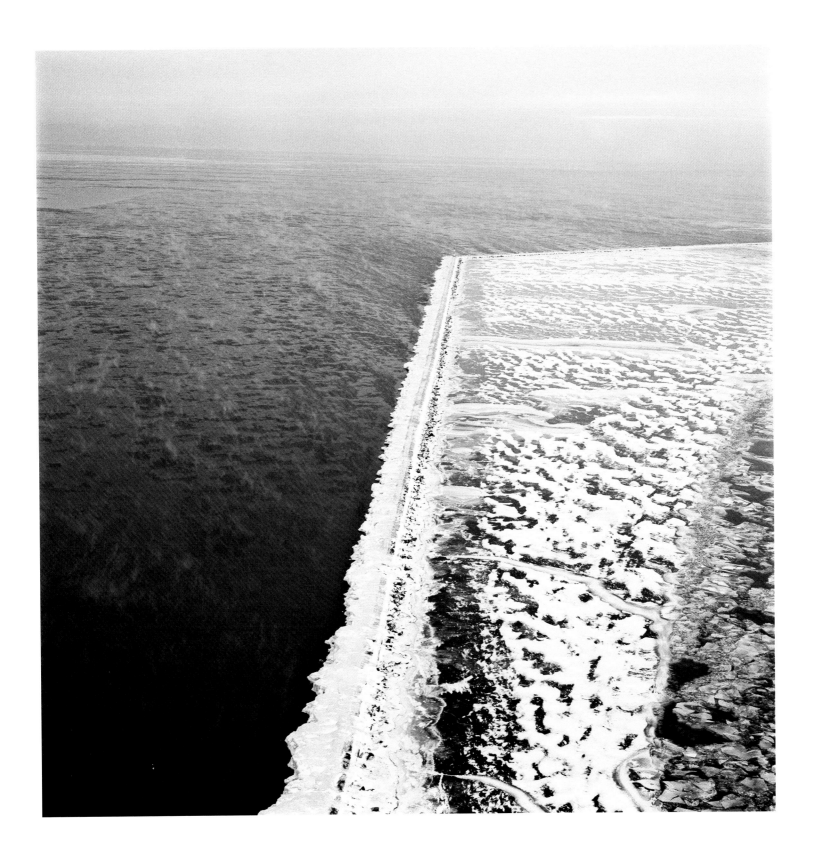

PLATE 76 *Jetty, lakefront near downtown Chicago,* January 29, 2004.
Inkjet print (printed 2012). Gift of the Hall Family Foundation, 2012.17.42.

PLATE 77 *Backyard pools, Frankfort Square, Will County,* September 17, 2003.
Inkjet print (printed 2012). Gift of the Hall Family Foundation, 2012.17.8.

PLATE 78 *Farm in the backyard, near border of Will and Cook Counties*, September 17, 2003.
Inkjet print (printed 2012). Gift of the Hall Family Foundation, 2012.17.27.

PLATE 79 *Rail, roads, and water, under the skyway, Calumet Harbor, Chicago,* May 12, 2003.
Inkjet print (printed 2012). Gift of the Hall Family Foundation, 2012.17.59.

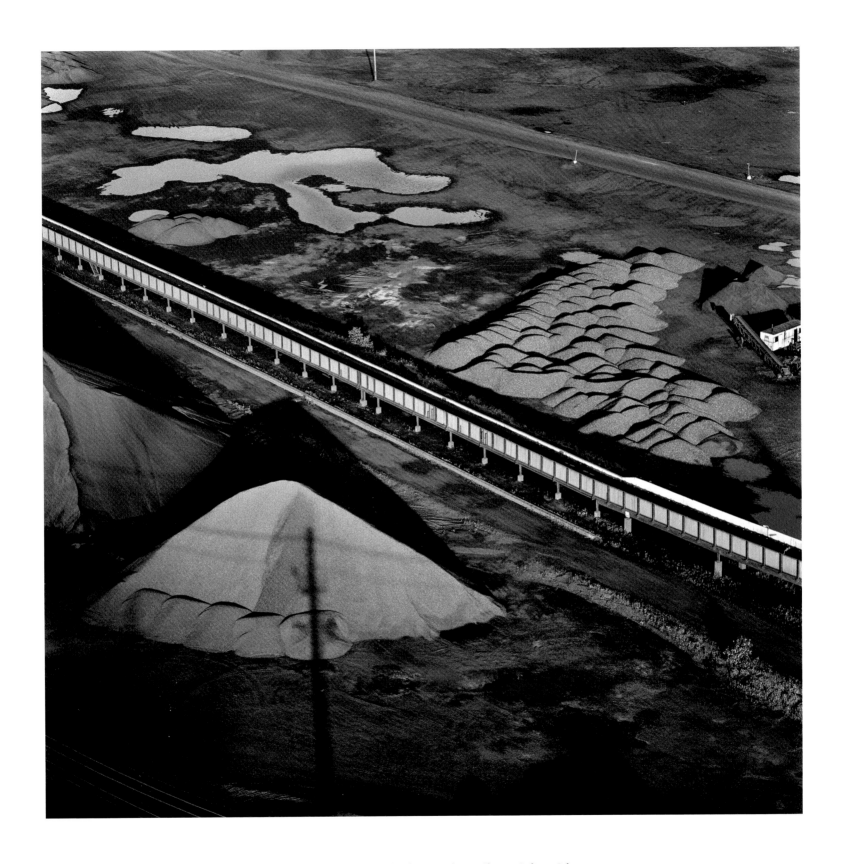

PLATE 80 *Inputs, conveyor and material storage area, Ispat Inland, Inc. (steel company), East Chicago, Indiana*, July 30, 2003.
Inkjet print (printed 2012). Gift of the Hall Family Foundation, 2012.17.40.

STEEL WORK

While working on her Revealing Chicago aerial survey, Evans became

intrigued by both the reality and the symbolism of steel production.

Between 2005 and 2009, she made more than thirty visits to steel mills

at Indiana Harbor and Burns Harbor, Indiana; Cleveland, Ohio; and

Coatesville, Pennsylvania. Most of these color photographs are interior

views emphasizing the vast scale of mill machinery and the sublime

power of the steel-making process. These pictures maintain an

important conceptual connection to the prairie by emphasizing the

industry's extractive nature: the raw materials are derived from mining

the Midwest landscape. Following this idea, from 2007 through 2009,

Evans made aerial photographs of open-faced iron ore mines, limestone

quarries, and coal mines in the region of Virginia, Minnesota.

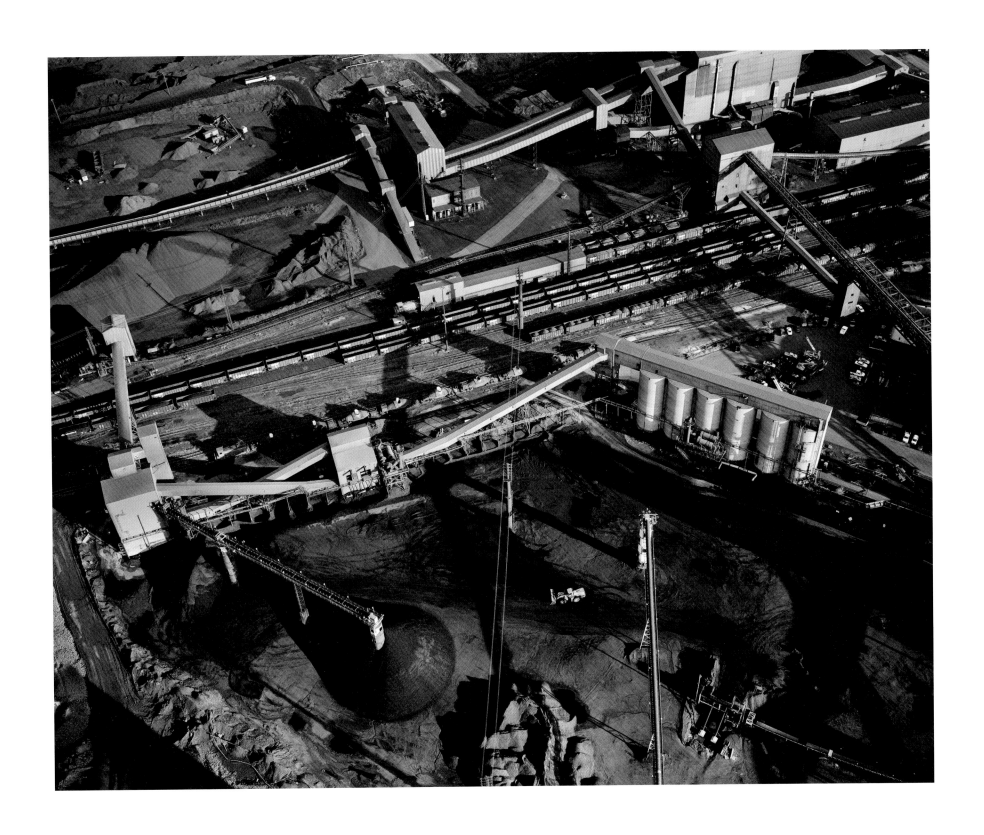

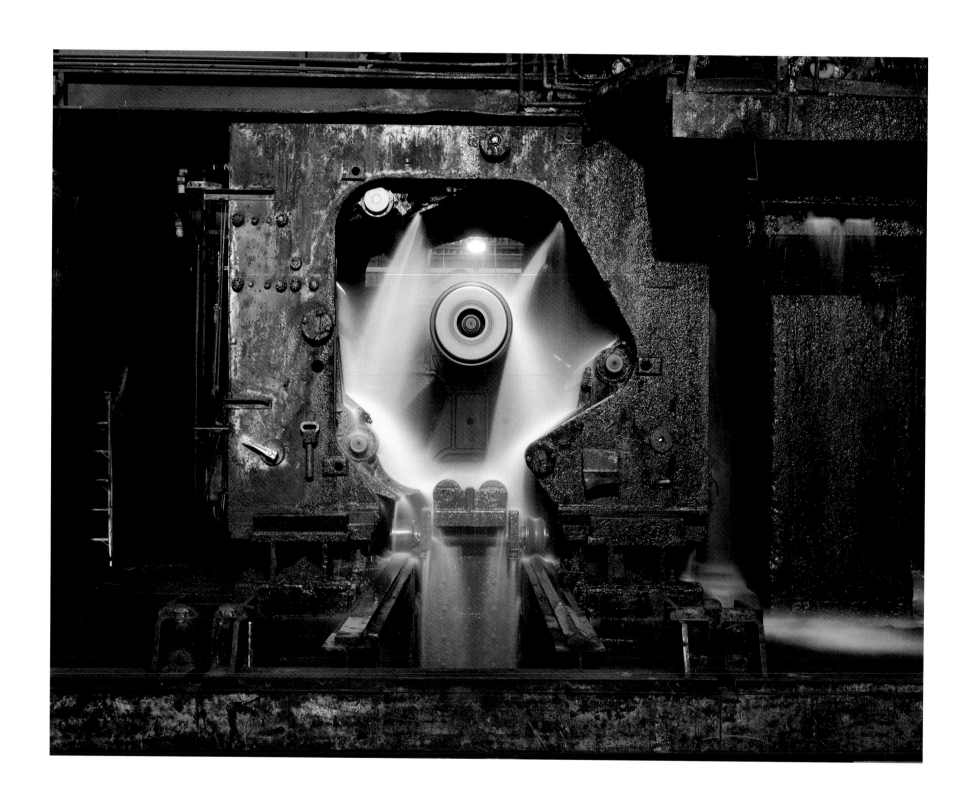

PLATE 82 *Acid rinse, Cleveland,* July 12, 2006.
Inkjet print (printed 2012). Gift of the Hall Family Foundation, 2012.17.6.

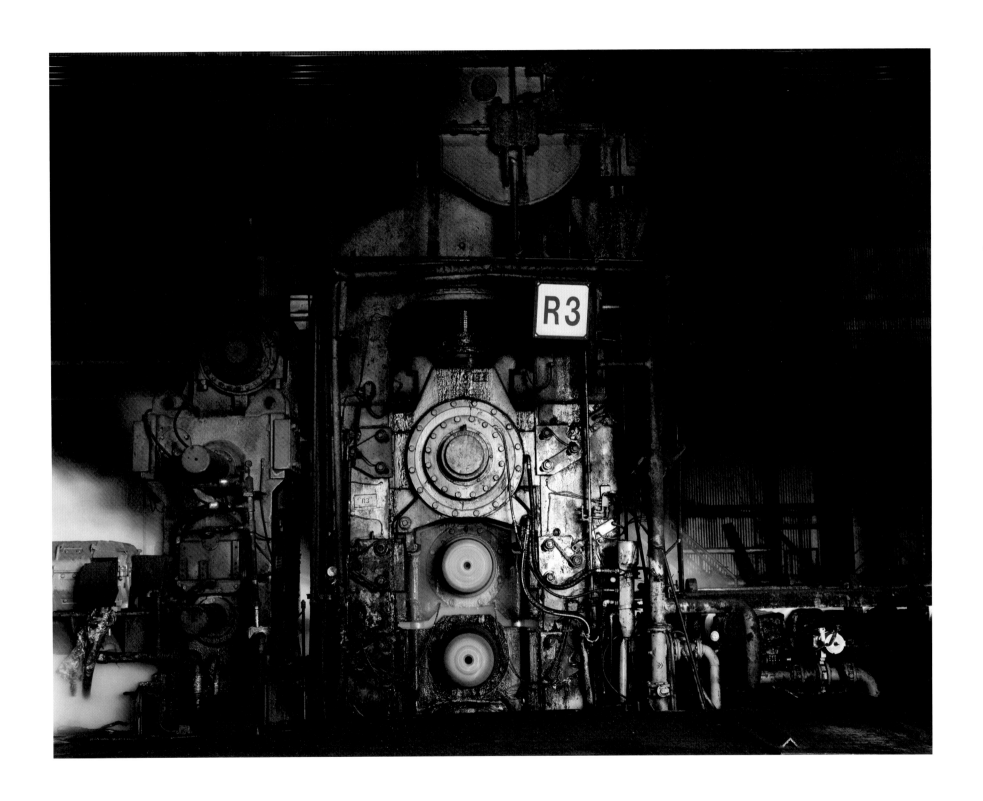

PLATE 83 *Roughing mill, Indiana Harbor*, March 3, 2006.
Inkjet print (printed 2012). Gift of the Hall Family Foundation, 2012.17.65.

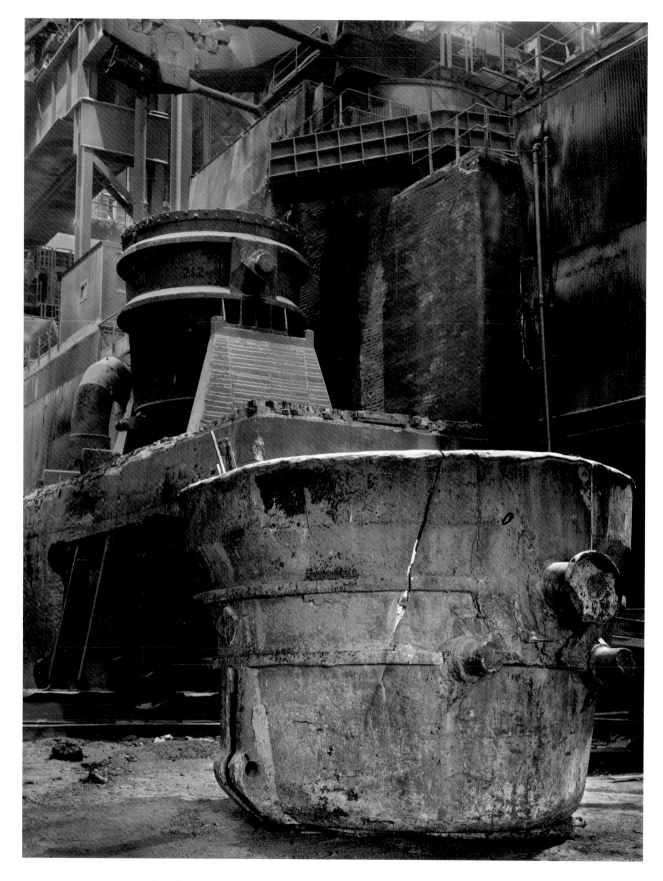

PLATE 84 *Cracked ladle, Indiana Harbor,* March 9, 2006.
Inkjet print. Purchase: acquired through the generosity of the Photography Society, 2008.66.

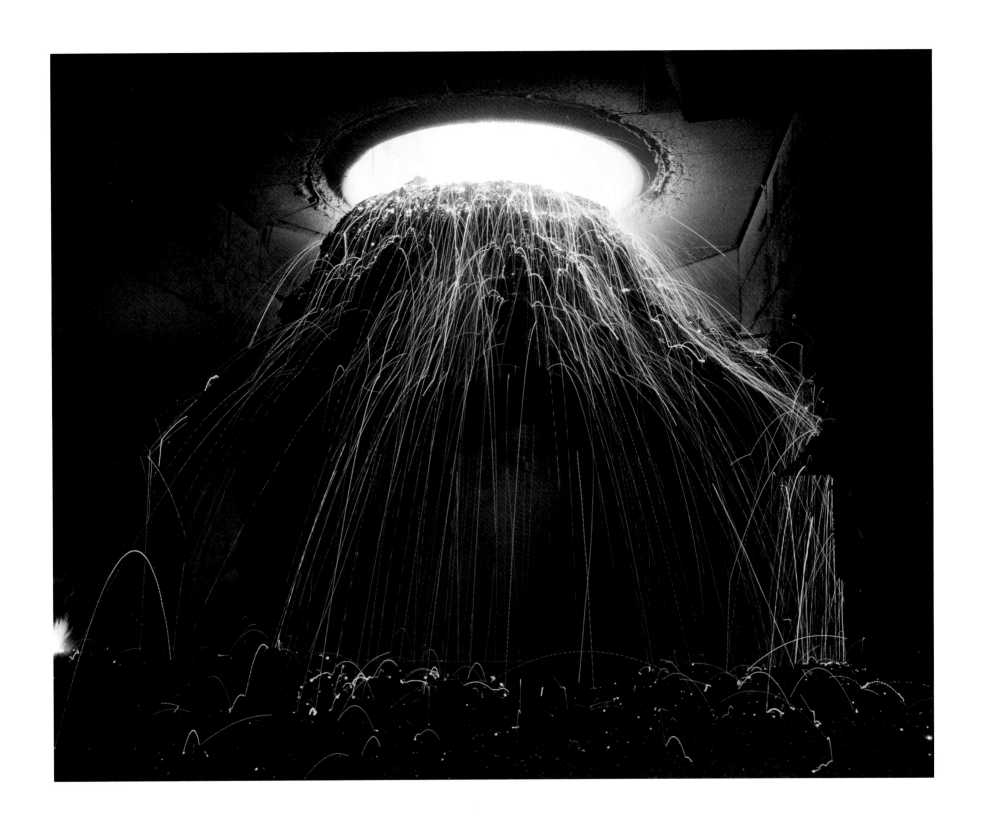

PLATE 85 *Slag processing, Indiana Harbor,* August 31, 2006.
Inkjet print (printed 2012). Gift of the Hall Family Foundation, 2012.17.69.

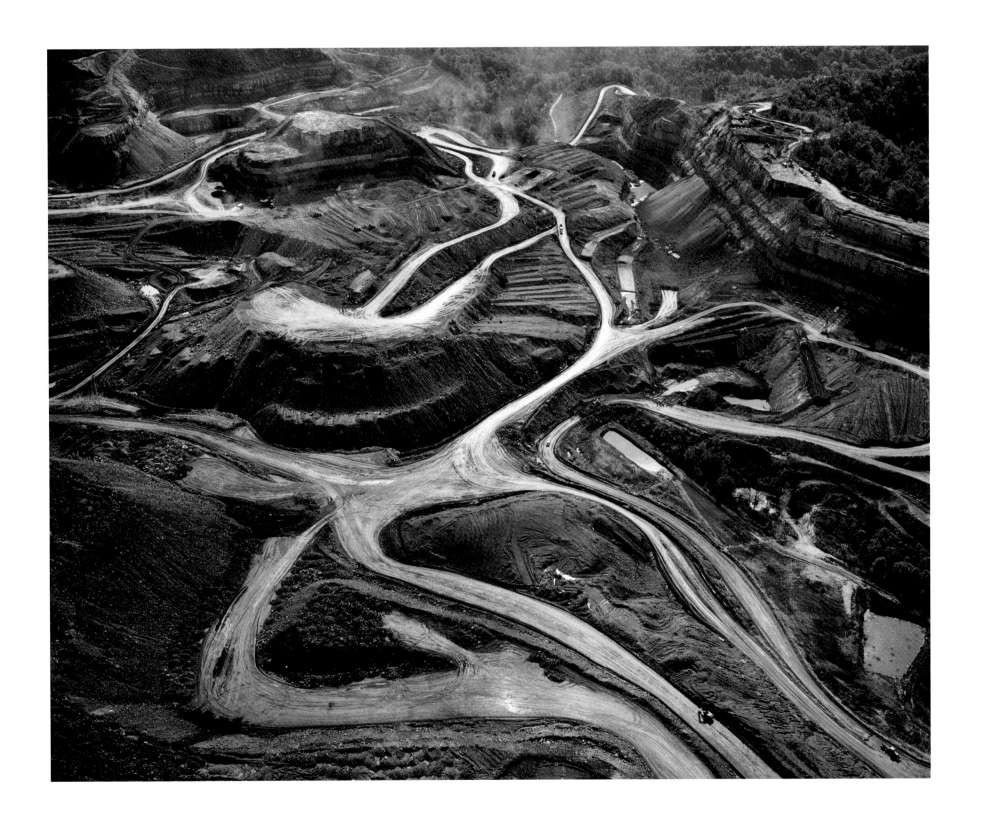

PLATE 86 *Mountaintop removal coal mining in eastern Kentucky,* October 22, 2009.
Inkjet print (printed 2012). Gift of the Hall Family Foundation, 2012.17.52.

GREENLAND

In June 2008, Evans was commissioned by the Spencer Museum

of Art at the University of Kansas, Lawrence, to photograph

the effects of global climate change in Greenland. The project,

a collaboration with the University's Center for the Remote

Sensing of Ice Sheets (CReSIS), required her to travel to

Ilulissat, Greenland to photograph icebergs and the Jakobshavn

Glacier, among other subjects. The project was extremely

challenging. The terrain, devoid of any familiar human traces,

confused Evans's sense of scale—a situation that she found both

disorienting and exciting.

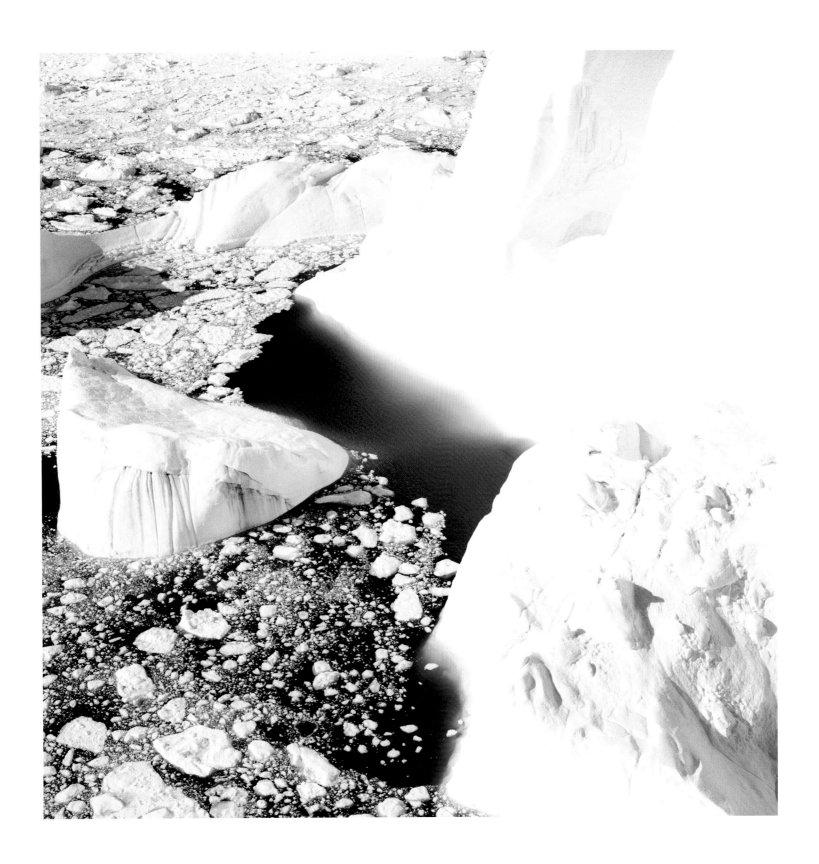

PLATE 87 *Ice fjord leading to Jakobshavn Glacier*, June 26, 2008, morning.
Inkjet print (printed 2012). Gift of the Hall Family Foundation, 2012.17.39.

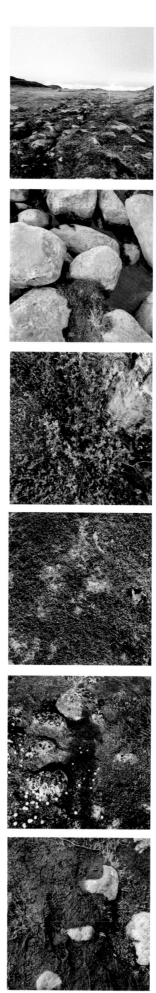

PLATE 88 *Path to the ice fjord leading to the mouth of Jakobshavn Glacier,* June 26, 2008, morning. Inkjet print. Collection of the artist.

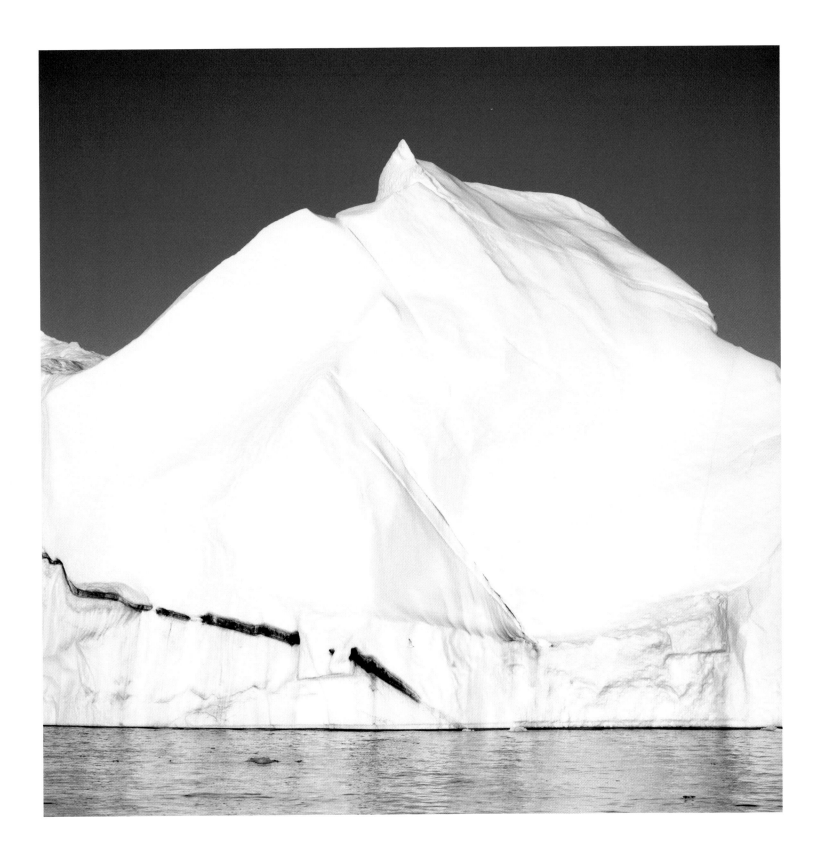

PLATE 89 *Disko Bay iceberg with bird*, June 27, 2008, around midnight.
Inkjet print (printed 2012). Gift of the Hall Family Foundation, 2012.17.21.

North Dakota Oil Boom

NORTH DAKOTA OIL BOOM

In 2011, Evans began a project with writer Elizabeth Farnsworth exploring the oil boom in the White Earth Valley near Williston, North Dakota. Working with both film and (for the first time) digital cameras, Evans records the environmental and human impact of the aggressive drilling operations in the region. Unlike previous projects, in which Evans took a more neutral stance, her North Dakota work reveals a more pointedly political viewpoint.

PLATE 90 *Preparation for fracking, south of Stanley, North Dakota*, May 24, 2012.
Inkjet print. Promised gift of Ralph and Nancy Segall, 116.2012.3.

PLATE 91 *Looking south from Highway 2, near White Earth, North Dakota*, October 15, 2011.
Inkjet print (printed 2012). Gift of the Hall Family Foundation, 2012.17.51.

PLATE 92 *House and oil pad on Jorgenson land, north of Tioga, North Dakota*, October 15, 2011.
Inkjet print (printed 2012). Gift of the Hall Family Foundation, 2012.17.38.

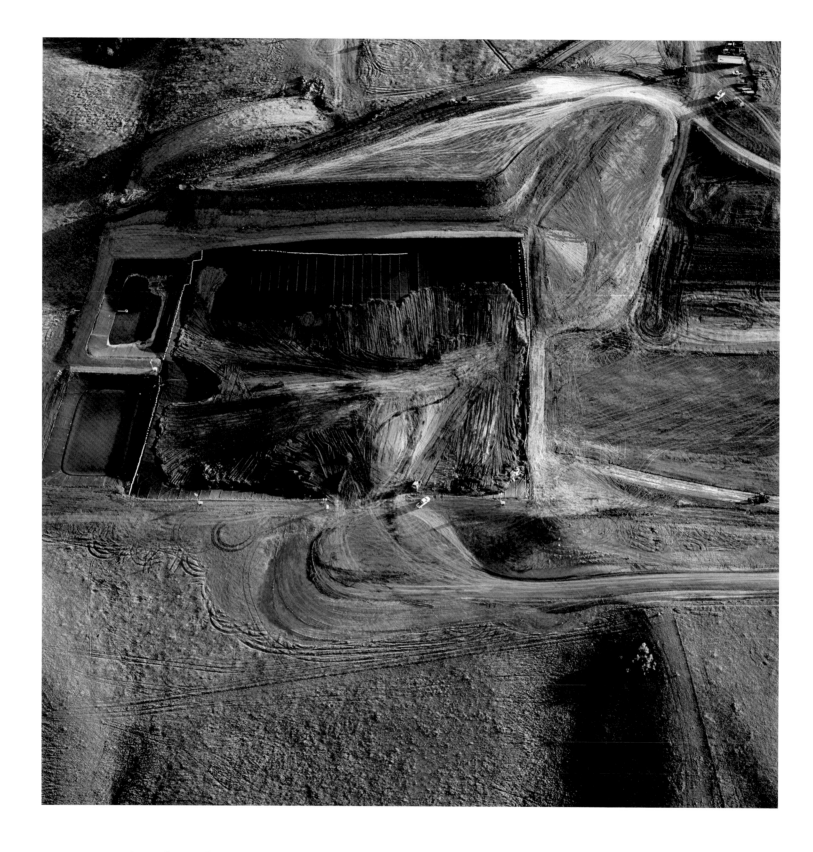

PLATE 93 *Oil waste dump, Williams County, North Dakota*, October 16, 2011.
Inkjet print (printed 2012). Gift of the Hall Family Foundation, 2012.17.47.

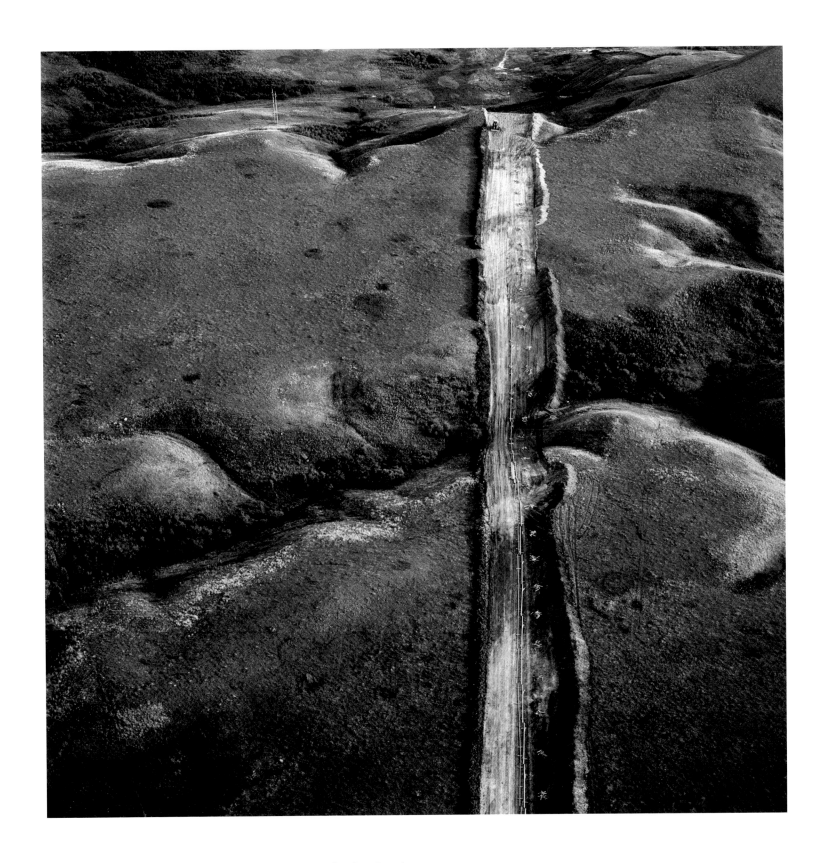

PLATE 94 *Oil pipeline right of way, Mountrail County, North Dakota,* June 6, 2011.
Inkjet print (printed 2012). Gift of the Hall Family Foundation, 2012.17.55.

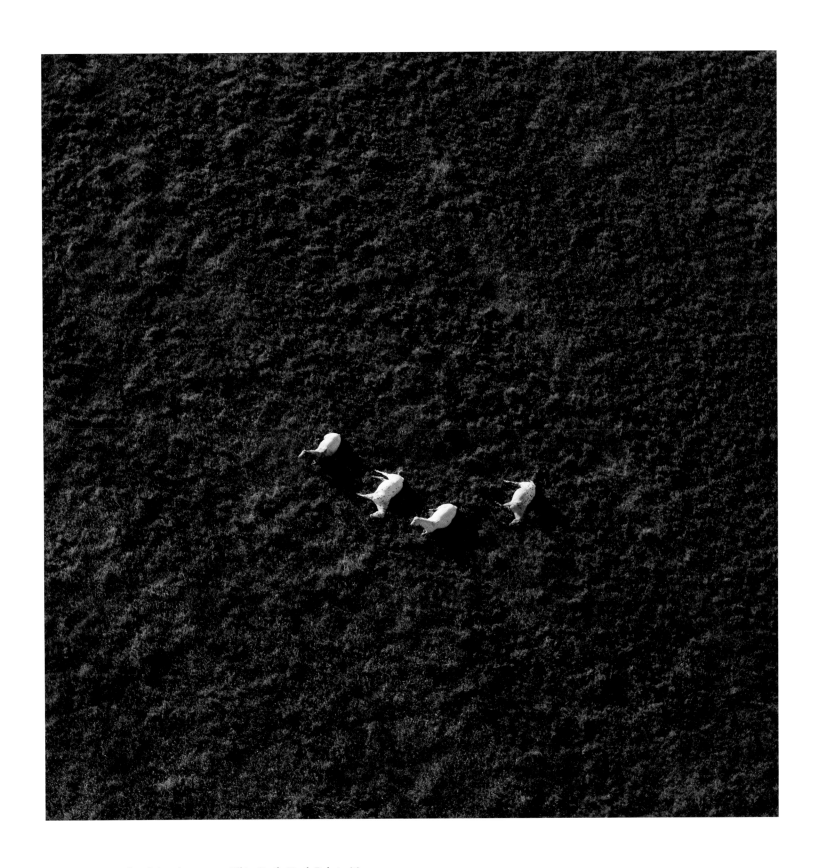

PLATE 95 *Scott's Appaloosas, near White Earth, North Dakota*, May 23, 2012.
Inkjet print. Promised gift of Ralph and Nancy Segall, 116.2012.4.

PLATE 96 *Kevin Davis' porch, near White Earth, North Dakota*, June 6, 2011.
Inkjet print (printed 2012). Gift of the Hall Family Foundation, 2012.17.45.

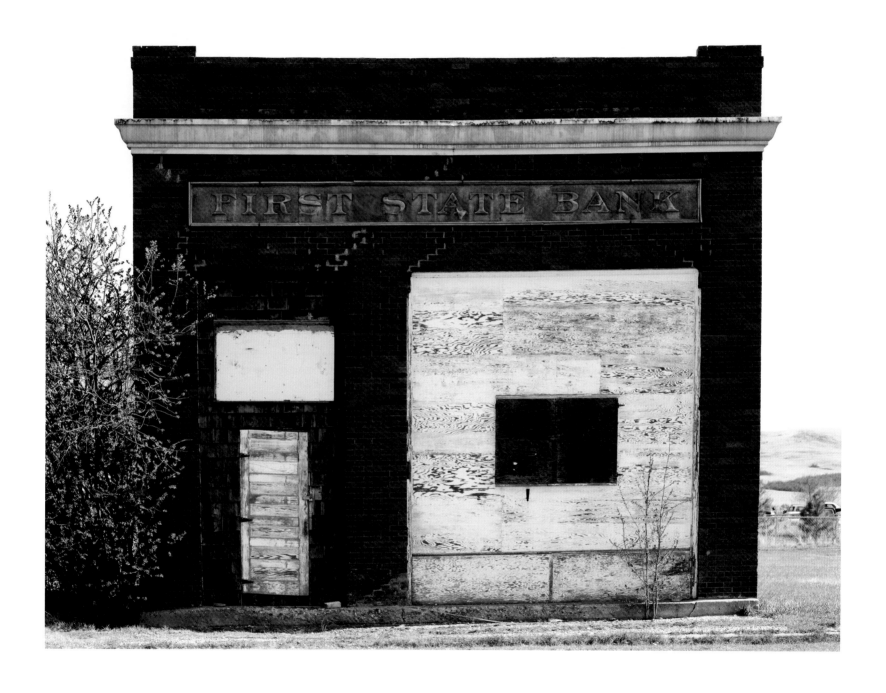

PLATE 97 *Bank from an earlier boom, White Earth, North Dakota*, April 22, 2012.
Inkjet print. Gift of the Hall Family Foundation, 2012.17.9.

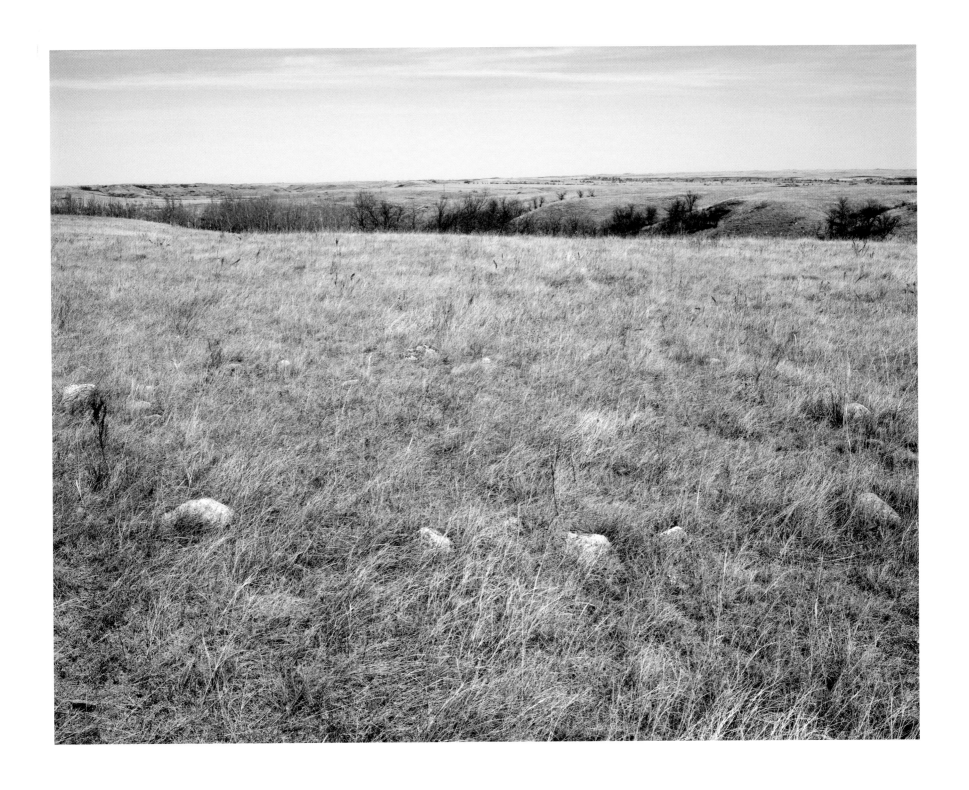

PLATE 98 *Paleo-indian ceremonial stones, above White Earth, North Dakota, April 22, 2012.*
Inkjet print. Gift of the Hall Family Foundation, 2012.17.56.

193

PLATE 99 *Edyth S. Pladson, Wildrose, North Dakota,*
three oil wells on family farm, age 94, May 24, 2012.
Inkjet print. Promised gift of Jeanne and Richard S. Press, 115.2012.3.

PLATE 100 *Nelson Bird Bear, retired coal miner, has both lease and surface*
rights, lives on Berthold Reservation at Mandaree, age 66, May 26, 2012.
Inkjet print. Promised gift of Jeanne and Richard S. Press, 115.2012.5.

PLATE 101 *Harley Bingenheimer, pipe wrangler on oil rig, Evanston,*
Wyoming, has worked 15 years on a rig, age 42, May 25, 2012.
Inkjet print. Promised gift of Jeanne and Richard S. Press, 115.2012.4.

PLATE 102 *Scott Davis, White Earth, Angus beef rancher, oil pad built*
on his virgin prairie, does not own mineral rights, age 57, May 22, 2012.
Inkjet print. Promised gift of Jeanne and Richard S. Press, 115.2012.8.

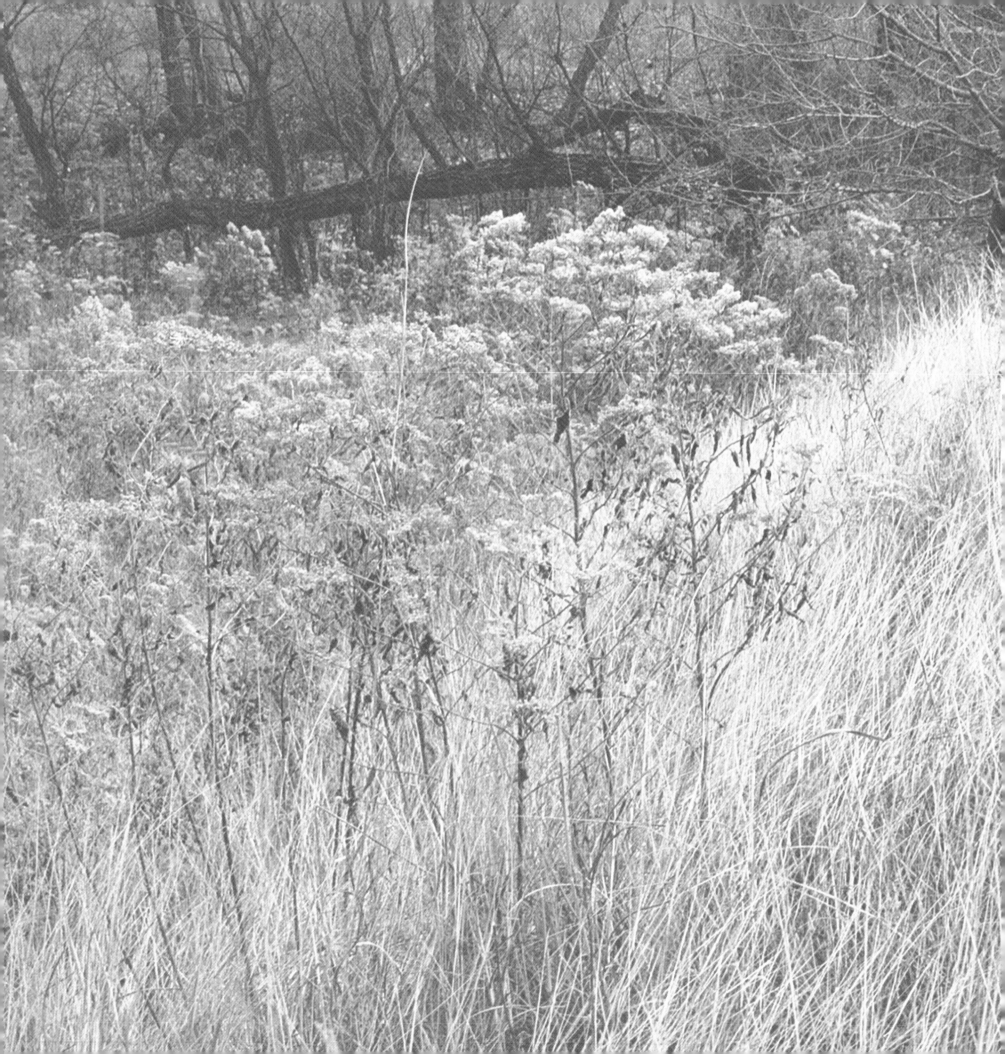

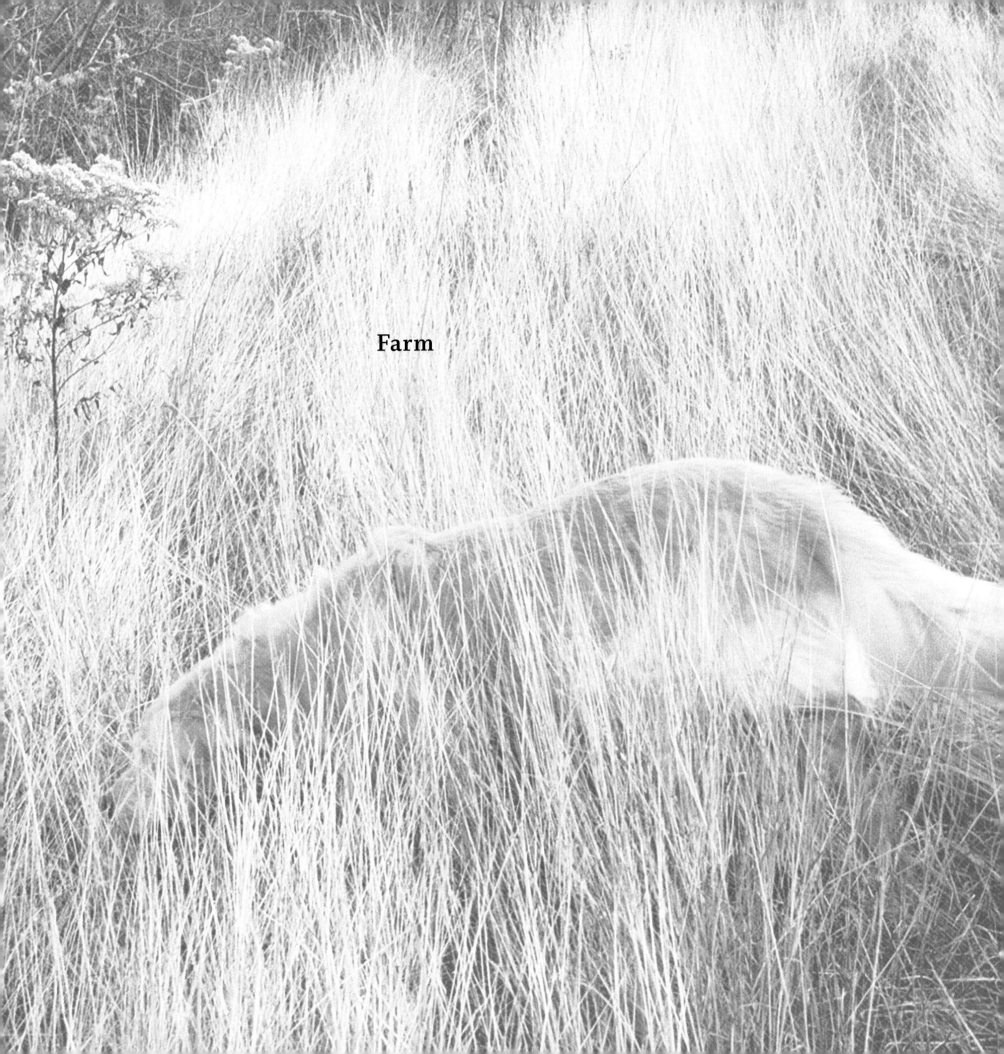

Farm

FARM

The family farm outside Salina was originally purchased by

Evans's in-laws. As newlyweds, Sam and Terry rented the property

for five years before moving into Salina. The Farm carries precious

family memories for both of them, and they return to it regularly.

It remains a quiet place of retreat and recuperation—the couple's

beloved "cabin on the plain." Evans photographs there on every

visit, strictly for her own pleasure.

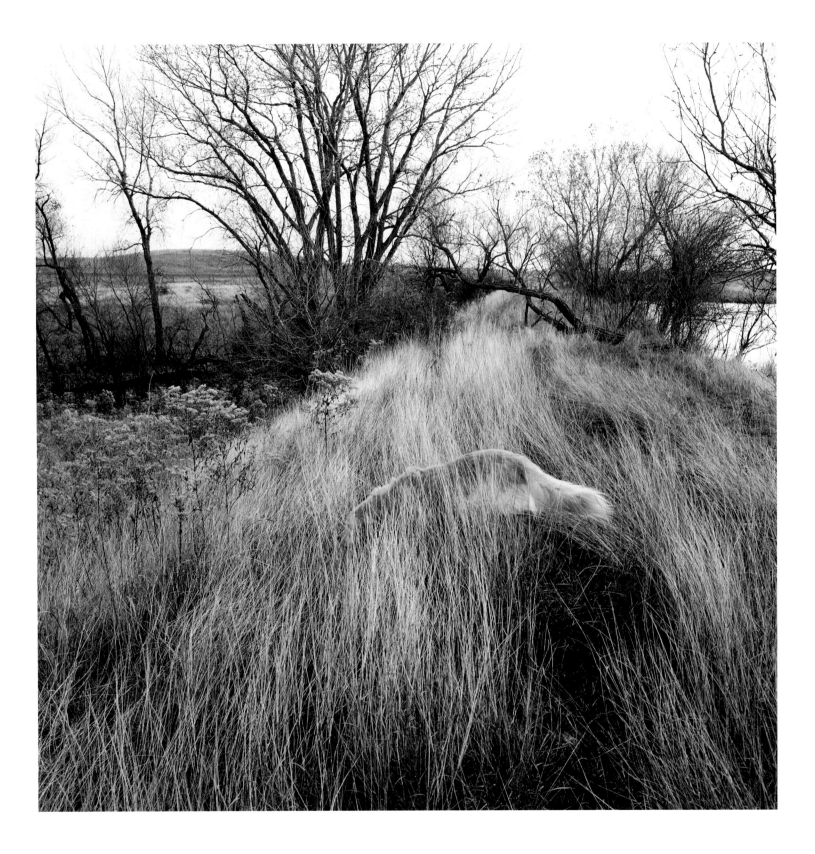

PLATE 103 *Zephyr in grass, east of the house,* 1996.
Inkjet print (printed 2012). Gift of the Hall Family Foundation, 2012.17.82.

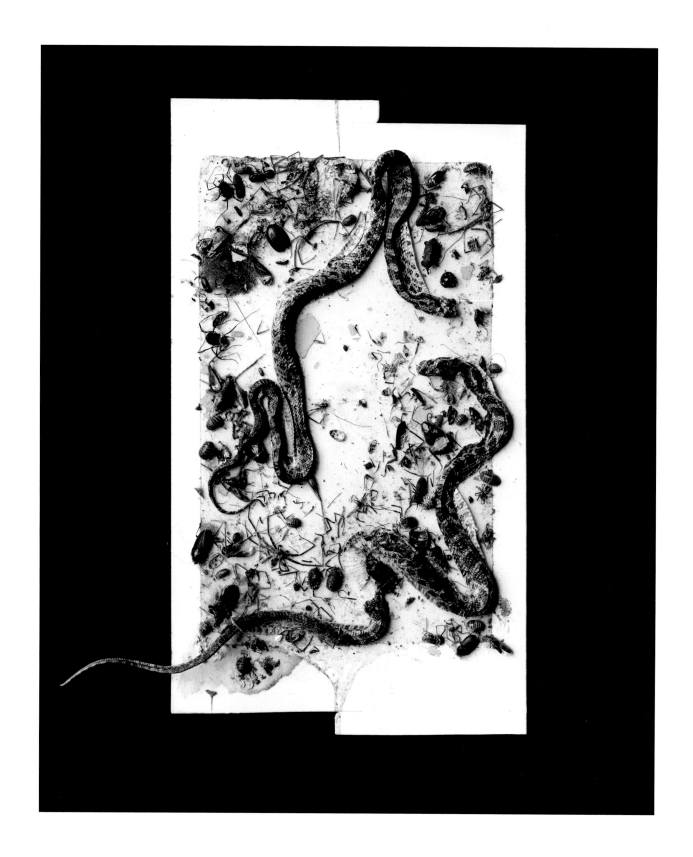

PLATE 104 *Snakes under the refrigerator*, 2008.
Inkjet print (printed 2012). Gift of the Hall Family Foundation, 2012.17.70.

PLATE 105 *Trees and grass, above little pond*, 2010.
Inkjet print (printed 2012). Gift of the Hall Family Foundation, 2012.17.78.

201

PLATE 106 *Corey and bedroom,* 2010.
Inkjet print (printed 2012). Gift of the Hall Family Foundation, 2012.17.19.

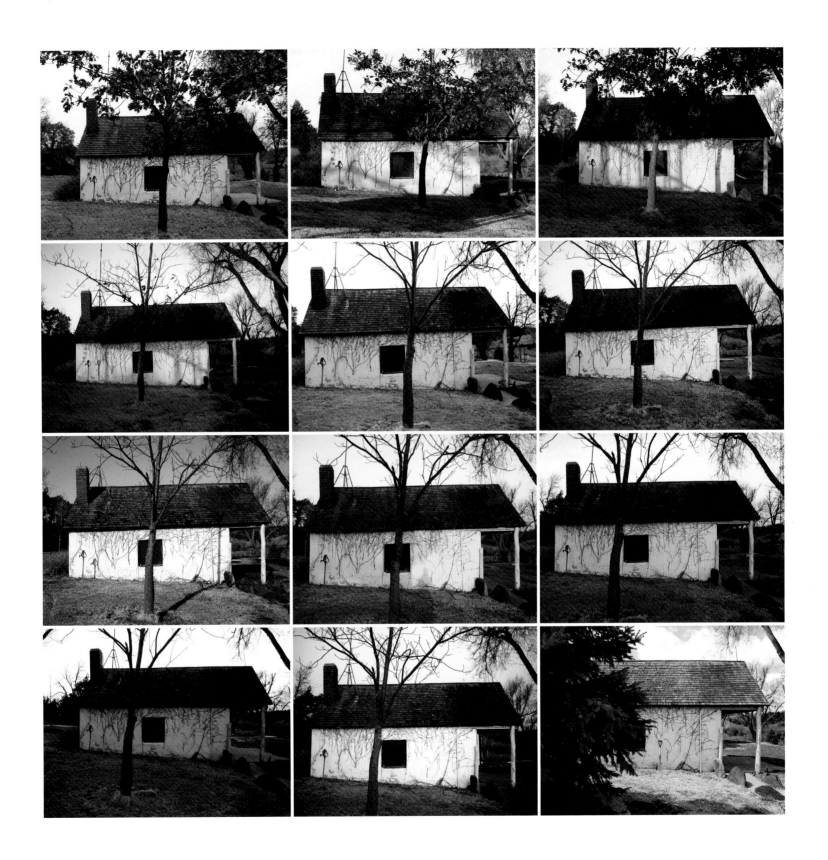

PLATE 107 *Little building, 2010–2011.*
Inkjet print. Gift of the Hall Family Foundation, 2012.17.50.

PLATE 108 *Sam at sunrise*, 2008.
Inkjet print (printed 2012). Gift of the Hall Family Foundation, 2012.17.67.

TERRY EVANS

Chronology

BY KAITLYN BUNCH

Unless otherwise noted, all quotes are the artist's.

1944

August 30, Terry Jo Hoyt born in Kansas City, MO. Grows up around the portrait photography studio work of parents, Dale and Norman Hoyt.

1963

Enters University of Kansas, Lawrence.

1968

Begins photographing when Robert F. Kennedy comes to University of Kansas to announce his presidential candidacy. Borrows Nikon from her father and is allowed on the floor of Allen Fieldhouse with the press. "For the first time I understood the interface that photography can be between the physical world and the photographer."

Receives B.F.A. in drawing, painting, and commercial art from University of Kansas.

November 23, marries Samuel Dean Evans Jr. and moves to a farm north of Salina, KS.

1970

August 29, son David Dean Evans born.

Establishes Salina Consumers for a Better Environment with Dana Jackson, Penny Geis, and Ivy Marsh. The group of mothers works to encourage more environmentally sound practices in their community.

1971

Begins a personal project to photograph conditions of poverty. Works primarily with Crosslines Cooperative Council in Kansas City, KS, directed by the Rev. Donald Bakely, who introduces Evans to their work and clients. Evans visits local neighborhoods to photograph people; she makes many return visits, bringing prints to her subjects. Later, she continues the project in other Kansas communities—Salina, Lawrence, and Belleville—working with local antipoverty agencies.

1972

First solo exhibition, curated by James Enyeart.

SOLO EXHIBITION

Poverty in Kansas, Spooner Hall, University of Kansas, Lawrence, KS.

1973

Begins a documentary project (sponsored by the Kansas Committee for the Humanities) with James Enyeart, titled "Kansas in Transition." Evans photographs rural people in her state. The resulting exhibition and accompanying symposium encourage viewers to look at their environment to see how industrialization and urbanization have changed social behavior. The photographs show what is happening to traditionally rural areas of the state, and the results of migration of Kansas farm dwellers to the cities. The show travels to Colby, Garden City, Wichita, Coffeyville, Shawnee Mission, and Topeka. Each venue opens with a symposium/panel discussion.

Terry, Sam, and David move into the city of Salina. Although they no longer live on the farm, Terry and her family often return for summers and relaxation. The visits continue to this day, providing Terry with a peaceful place to rest and pursue photography for her own pleasure.

1974

Begins using Hasselblad camera. "This camera and the square format became very important for me; it determined the way I thought about how photographs should be contained in a frame and influenced me for years thereafter."

With Larry Schwarm, is invited by James Enyeart to participate in a documentary project funded by a National Endowment for the Arts grant. The Kansas Survey (with book titled *No Mountains in the Way*) aims to create an aesthetic survey of Kansas. Evans makes portraits, Enyeart photographs architecture, and Schwarm focuses on the landscape. During this short-term summer project, Evans works in the town of Abilene and around Saline County, KS.

November 19, daughter Corey Hoyt Evans born.

GROUP EXHIBITION

No Mountains in the Way, University of Kansas Museum of Art, Lawrence, KS.

1975

For two years after the birth of her daughter, Evans works on a personal photographic journal about her family. "I always had the camera with me, using it all the time to photograph what happens to the relationships in a family when a new child is born. It was important to me to stay engaged with photography while I wanted to be at home with my very young children and this was a way to integrate the two." [FIG. 28]

GROUP EXHIBITION

There Is No Female Camera, Neikrug Gallery, New York, NY (other artists in the exhibition include Patty Carroll, Martine Franck, Dianora Niccolini, and Naomi Savage).

PUBLICATION

Exhibition catalogue: *No Mountains in the Way, Kansas Survey: NEA*, by James Enyeart, Terry Evans, and Larry Schwarm. Lawrence, KS: University of Kansas Museum of Art.

Wes Jackson establishes the Land Institute in Salina, KS; Terry's husband Sam is a founding board member. The organization is on the forefront of progressive views regarding land use and sustainable agriculture. Evans is deeply influenced by the organization's philosophy and work.

In commemoration of the U.S. Bicentennial, and influenced by the Farm Security Administration documentary project, Evans organizes the Kansas Album project with the support of the Kansas Bankers Association. In all, nine photographers (Jim Alinder, Terry Evans, Mark Goodman, Robert Grier, Earl Iversen, Lawrence McFarland, Jim Richardson, Larry Schwarm, and Garry Winogrand) participate in the project, working in the period June–October.

PUBLICATION

If . . . A Big Word with the Poor, by Donald C. Bakely. Newton, KS: Faith and Life Press.

PERIODICAL

"Documentary Photography USA," by Richard Busch, *Popular Photography* 40:12 (December): 91–101.

1977

Begins a new portrait project: travels in Kansas, New Mexico, and California to meet and photograph couples. Intends for this to evolve into a major body of work and continues into June 1978, making a trip to San Francisco to photograph gay couples. This work is never completed; "the prairie intervenes."

PUBLICATIONS

Family of Children, edited by Jerry Mason. New York: Grosset and Dunlap.

Kansas Album, edited by James Enyeart. Topeka, KS: Kansas Bankers Association, distributed by Addison House, Danbury, NH.

PERIODICAL

"Kids without Cliché," by Andy Grundberg and Mary O'Grady, *Modern Photography* 41:2 (February): 86–91.

1978

Begins to focus on the prairie as a subject. Wes Jackson of the Land Institute asks Evans to photographically record survey work that he and his students are doing on an 80-acre plot of virgin prairie near her home in Salina. "While they worked, I wandered around looking . . . and the realization came that I could stand in one spot and look at the ground for at least an hour and still not see everything happening at my feet." On her own, she begins visiting the area, owned by Nick and Joyce Fent, every day; she makes more than 4,000 black-and-white pictures of the ground over the next year.

Influences at this time include the flat, aerial perspective of medieval icons, Persian miniature paintings,

FIG. 27 Norman Hoyt, American (1914–2001). *Terry Evans with portrait drawing,* ca. 1955. Gelatin silver print. Collection of Terry Evans.

FIG. 28 *David Diving, Salina, Kansas,* July 1976. Gelatin silver print. Collection of the artist.

Chinese scroll paintings, and cave paintings. For Evans, these influences seem to be an expression of artists who were not setting themselves apart from the environment but placing themselves within it, becoming part of, and depicting, a larger whole. This idea is central to her approach to photographing the prairie ecosystem. Another influence is the New Topographics work of Joe Deal.

Teaches a summer workshop at Ghost Ranch in Abiquiu, NM. Continues to teach every summer until 1993, coteaching from 1983 to 1993 with the writer Lesley Poling-Kempes and the scholar of feminist theology Jan Swearingen.

GROUP EXHIBITION

Twelve Photographers: A Contemporary Mid-America Document, Mid-America Arts Alliance (five-state tour: Arkansas, Kansas, Nebraska, Missouri, Oklahoma).

PUBLICATIONS

Exhibition catalogue: *The Photographer's Image: Self-Portrayal.* Carmel, CA: Friends of Photography.

Exhibition catalogue: *Twelve Photographers: A Contemporary Mid-America Document,* edited by Jim Alinder. Kansas City, MO: Mid-America Arts Alliance.

1979

Begins to photograph the prairie sky. "One day in April I took a picture of some sage coming through the grass, and the plants were in a sort of spiral configuration of sage, old straw grass, and new grass. As I looked at the photographic image later, the sage looked like stars and the grass like a galaxy, and suddenly I realized that the sky was a part of the prairie too. I began to point my lens at the sky."

Receives a Kansas Committee for the Humanities grant with Jim Peterson, a scientist working with the Land Institute, for the project Prairie Roots/Human Roots, to produce photographs for a traveling exhibition and panel.

In September, at a mental health conference, meets Gregory Bateson, an anthropologist whose work on the mind and environment is powerfully influential. Invites him to see the Konza prairie; "he was down on the ground looking at plants and beetles." Evans later invites Bateson to write the introduction for her first monograph, which is completed shortly before his death.

In the fall, takes a two-week trip to India.

SOLO EXHIBITION

Colorado Mountain College, Leadville, CO.

FIG. 29 *Sky seen from plane over Salina, Kansas*, December 1980. Chromogenic print. Collection of the artist.

FIG. 30 *Arlene's horse, Matfield Green, Kansas*, June 1997. Inkjet print. Collection of the artist.

GROUP EXHIBITIONS

Artists Choose Artists, University of Missouri, Kansas City, MO.

7 x 7 Gallery, Lawrence, KS.

1980

In March, takes three-week trip to China.

Curious about how the prairie ecosystem would look from above, takes her first flight to capture aerial views of the virgin native prairie. "It astonished me that I could see how the land looked similar from above, which reminded me of the saying 'As above, so below.'" [FIG. 29]

SOLO EXHIBITIONS

Emporia State University, Emporia, KS.

Sheldon Memorial Art Gallery, University of Nebraska Art Galleries, Lincoln, NE.

GROUP EXHIBITION

Likeness: Portrait Photographs from the Collection, Spencer Museum of Art, University of Kansas, Lawrence, KS.

1981

GROUP EXHIBITIONS

Mulvane Art Center, Washburn University, Topeka, KS.

Salina Art Center, Salina, KS.

1982

Becomes a board member for the Land Institute, Salina, KS; retains the position until 2012.

SOLO EXHIBITION

Nebraska Wesleyan University, Lincoln, NE.

GROUP EXHIBITIONS

Ranchos de Taos: A Photographic History, Sheldon Memorial Art Gallery, University of Nebraska Art Galleries, Lincoln, NE.

U.S. Biennial, Museum of Art, University of Oklahoma, Norman, OK.

Strecker Gallery, Manhattan, KS.

1983

Receives a Mid-America Arts Alliance/National Endowment for the Arts Fellowship.

Moves studio into an office space in downtown Salina.

Participated in the establishment of a community group in Salina interested in peace activism. Later in the year, the group walks from Salina to Wichita, to promote a nuclear freeze. The walk, named the Prairie Peace Pilgrimage, took a week and the group stayed overnight in churches along the way.

GROUP EXHIBITIONS

An Open Land: Photographs of the Midwest, 1852–1982, Art Institute of Chicago.

Terry Evans / Earl Iversen: Kansas Photographs, Spencer Museum of Art, University of Kansas, Lawrence, KS; exhibition tours the state the following year.

PUBLICATIONS

Exhibition catalogue: *An Open Land: Photographs of the Midwest*, by Rhondal McKinney. Chicago: Art Institute of Chicago.

Exhibition catalogue: *Terry Evans/Earl Iversen: Kansas Photographs*, by Thomas W. Southall. Lawrence, KS: Spencer Museum of Art, University of Kansas.

1984

SOLO EXHIBITION

Bethel College, Newton, KS.

GROUP EXHIBITION

Exposed and Developed, National Museum of American Art, Washington, D.C..

PUBLICATION

Exhibition catalogue: *Exposed and Developed: Photography Sponsored by the National Endowment for the Arts*, by Merry A. Foresta. Washington, D.C.: Smithsonian Institution Press for the National Museum of American Art.

1985

Moves away from taking pictures of the undisturbed prairie. "After spending eight years photographically exploring the fragmentary but still extant undisturbed prairie in Kansas, I came to a stopping point. It wasn't that I was bored with its intricate life, its sensuous colors and textures of grass, wind, and sky. It was just that I had photographed it to the limits of my vision."

Returns to portraiture and begins experimenting with composite pictures, influenced by the work of David Hockney. Applying similar ideas of structures and pattern, Evans explores the experience of the prairie in multiple images and montages.

During the mid-1980s, becomes involved in many community organizations, establishes a peace center for abused women at the First Presbyterian Church, called the Drop-In Center, and is active with the Salina Arts Center. "Living in a small town the size of Salina things are not separate, no one is doing just one thing."

GROUP EXHIBITIONS

Landscape: Issues and Ideals, Southern Illinois University, Carbondale, IL.

Winners, traveling exhibition throughout the Midwest sponsored by the Mid-America Arts Alliance.

1986

PUBLICATION

Monograph: *Prairie: Images of Ground and Sky*, with essays by Gregory Bateson and Wes Jackson. Lawrence: University Press of Kansas.

1987

GROUP EXHIBITIONS

Five-State Photography Show, Hays Art Council, Hays, KS.

Skyborne: Aerial Photography, North Dakota Museum of Art, University of North Dakota, Grand Forks, ND.

Women in the Great Plains, Center for Great Plains Studies, Lincoln, NE.

Society for Contemporary Photography, Kansas City, MO.

1988

Begins teaching photography at Bethany College, Lindsborg, KS; continues until 1992.

GROUP EXHIBITION

Faculty Show, Sandzen Gallery, Lindsborg, KS.

1989

Feeling the need to return to the landscape, begins photographing the inhabited prairie. Experiments with color, but initially finds the chromatic addition distracting and returns to black and white. "I realized that the inhabited prairie was part of the body of prairie and that I could not understand prairie if I didn't look at the whole of it.

The disturbed, cultivated, militarized, industrialized prairie had been abused and I began to photograph it."

In October, Evans attends the conference The Political Landscape, at Anderson Ranch Arts Center, Snowmass, CO, which incorporates presentations and extensive conversation with an active group of like-minded photographers, including Mark Klett, Robert Dawson, Gregory Conniff, Peter Goin, Laurie Brown, Wanda Hammerbeck, and Martin Stupich. She becomes part of the resulting Water in the West Project. The group aims to address cultural attitudes toward water in the arid West, with the primary goal of creating a body of work to contribute to the dialogue concerning water as a commodity vs. as a vital source of life. Over the following years, the contributors work separately and meet periodically to discuss their work and ideas. For Evans, this is an important project—an opportunity to meet and collaborate with artists with similar interests.

Receives a Salina, Kansas, Arts and Humanities Commission grant for a Salina aerial photography project.

SOLO EXHIBITIONS

Terry Evans, Foreign and Familiar: Portrait Photographs, Salina Art Center, Salina, KS.

Land Institute, Salina, KS.

GROUP EXHIBITIONS

Current Works, Society for Contemporary Photography, Kansas City, MO.

Experimental Work, Reuben Saunders Gallery, Wichita, KS.

PUBLICATION

Exhibition catalogue: *Terry Evans, Foreign and Familiar: Portrait Photographs*, edited by Andy Grundberg. Salina, KS: Salina Art Center.

PERIODICALS

"Back to Eden," by Evan Eisenberg, *Atlantic Monthly*, November, 57–89 and cover.

"Kansas Landscape Photography," by Jessica Reichman, *Journal of the West* 28:1: 24–28.

1990

Begins to take flights in a Cessna 172 with pilots Duane Gulker and Major Jonathan Baxt, and continues aerial photography of the rural landscape around Salina for next five years. "The reason the virgin prairie was so fascinating was that I could see a tremendous richness and multitude and variety of plants and growth, but if you look at any other piece of land, it's very simplified—a cornfield is corn and ground, a monoculture. I realized that the inhabited prairie landscape had been simplified and if I wanted to see the patterns and relationships on the human changed landscape, I felt I needed to go into an aerial perspective."

The Land Institute establishes a site in Matfield Green as a model for an ecological accounting system—a way

to calculate true energy cost. Wes Jackson introduces Evans to the town, which she immediately begins photographing. The first Matfield Green photographs are of abandoned houses, exploring ideas of personal history, loss, and the passage of time. Evans continues to visit Matfield Green until 1998, then revisits in 2008–10. [FIG. 30]

Begins collaborating on a project in Nebraska with Greg Conniff of Madison, WI, whom she met during the Water in the West Project.

SOLO EXHIBITIONS

Foreign and Familiar, University of Kansas, Lawrence, KS.

Wichita Art Museum, Wichita, KS.

GROUP EXHIBITIONS

Faculty Show, Bethany College, Lindsborg, KS.

Ten Photographers, Emporia State University, Emporia, KS.

Bethel College, Newton, KS.

PERIODICAL

"Wilderness as Saint," by Wes Jackson, *Aperture*, no. 120 (late Summer): 50–55.

1991

On one of many trips to Matfield Green, meets Toots Conley at the Hitchin' Post Bar and Grill. Toots provides introductions to the residents of Matfield Green, leading to Evans's first significant group of portraits since 1978. Evans visits Toots whenever she is in Matfield Green, and the two remain friends.

Hosts a gathering of the Water in the West group at her house in Salina.

Receives a Salina, Kansas, Arts and Humanities Commission grant for the Matfield Green project.

GROUP EXHIBITIONS

The Country Between Us: Contemporary American Landscape Photography, Huntington Gallery, Massachusetts College of Art, Boston, MA.

Haystacks, Land Institute, Salina, KS (with Gregory Conniff).

Water in the West, Salina Art Center, Salina, KS.

The Water in the West Project, Sheppard Gallery, University of Nevada, Reno, NV.

PUBLICATION

A River Too Far: The Past and Future of the Arid West, by Joseph Finkhouse, Mark Crawford, et al. Reno: Nevada Humanities Committee, distributed by University of Nevada Press.

PERIODICAL

"PrairyErth: Portraits from Chase County, Kansas," by William Least Heat-Moon, *Atlantic Monthly*, September, 45–74.

1992

Concludes her Inhabited Prairie series.

Begins working with Greg Conniff at the Cheyenne Bottoms wetlands in western Kansas, exploring the competing claims from environmentalists and farmers on scarce water resources for the project Western Waters. Work from this project is exhibited and published in a catalogue in 1996.

GROUP EXHIBITIONS

Between Home and Heaven: Contemporary American Landscape Photography, Smithsonian American Art Museum, Washington, D.C.; Carnegie Museum of Art, Pittsburgh, PA.

Reinterpreting the Land, Center for Great Plains Studies, University of Nebraska, Lincoln, NE.

PUBLICATION

Exhibition catalogue: *Between Home and Heaven: Contemporary American Landscape Photography*, by Merry A. Foresta, Stephen Jay Gould, Karal Ann Marling, et al. Washington, D.C.: National Museum of American Art, Smithsonian Institution, in association with the University of New Mexico Press, Albuquerque, NM.

1993

In January, Sam's work requires a move to Chicago; Terry remains in Salina, unsure of what Chicago would offer in terms of her photography.

Matfield Green becomes the main focus of her creative effort; she moves her darkroom to the basement of the old school in the town.

SOLO EXHIBITIONS

Land Institute, Salina, KS.

Smoky Hill Bombing Range, Salina, KS.

Texas Christian University, Ft. Worth, TX.

GROUP EXHIBITIONS

Between Home and Heaven: Contemporary American Landscape Photography, New Orleans Museum of Art; New York State Museum, Albany, NY.

Water in the West, University of Colorado, Boulder, CO.

PUBLICATIONS

Ansel Adams, New Light, edited by Robert Dawson. San Francisco: Friends of Photography.

Arid Waters: Photographs from the Water in the West Project, by Peter Goin, Ellen Manchester, et al. Reno: University of Nevada Press.

PERIODICAL

"Water in the West," by Steven Durland, *High Performance* 16:2: 32–41.

1994

Begins to visit Matfield Green on a monthly basis to photograph and work in darkroom.

Meets John Szarkowski, recently retired MoMA curator and photographer, historian, and critic whose writing on Wright Morris Evans admires, during his time as a guest lecturer at the University of Kansas in Lawrence. She invites his seminar class to Salina and Matfield Green and organizes a symposium for the group. Szarkowski stays in Kansas for an extra week and photographs with Evans.

In the fall, moves to Chicago.

Photographs Prairie Crossing, an area of farmland north of Chicago, after meeting owners Vicki and George Ranney. Evans photographs the landscape and evolution of this site: the preservation of the farmland and its transformation to a conservation village focused on sustainability. The project leads Evans to realize that the work she pursued in Kansas can be continued in Chicago.

Meets ecologist Jack White, who introduces her to the Joliet Army Arsenal in Will County, IL.

GROUP EXHIBITIONS

Center for Great Plains Studies, Lincoln, NE.

Philbrook Museum, Tulsa, OK.

1995

In February, with the assistance of Gerald Adelmann, the director of the Openlands Project, Evans visits the Joliet Army Arsenal, once one of the world's largest TNT factories, currently in the process of being transferred to the U.S. Forest Service. For two years, until fall 1997, Evans photographs the layers of history on the site: old military buildings, foundations of homes razed in order to build the arsenal, a Civil War–era fence, an Indian burial ground. To see the land from above, she is flown by Steve Keibler in a yellow Piper Cub plane at an altitude of 700 feet. These photographs are later published in the book *Disarming the Prairie* in 1998.

Is invited by James Enyeart, along with thirty-four other photographers and fifteen writers, to record American life and culture for the National Millennium Survey, commissioned by the Anne and John Marion Center for Photographic Arts of the College of Santa Fe. Artists in the survey are instructed: Tell me what it's like; tell me how it looks. What do you see? What do you hear? Sample the American Scene in all its diversity. The project continues until 2000; the photographs and writings are exhibited and published in 2002.

1996

Receives John Simon Guggenheim Memorial Fellowship to create a photographic aerial survey of mixed-grass prairie, covering the full area of its ecological boundaries, from central Saskatchewan to central Texas. The project, titled Canada to Texas, proves to be a technical challenge, as she has never before photographed with pilots she doesn't already know. She works systematically,

finding ecological boundaries and calling area airports to hire pilots. This continues as she works her way south, making multiple trips through 1999.

The Canada to Texas project leads Evans to read about expeditions to the western United States in the nineteenth century. Most important to her is John Wesley Powell's expedition through the Grand Canyon in 1869, which included the botanist George Vasey.

Begins using a Fuji 617 panoramic camera for Matfield Green and Canada to Texas projects. Before this, Evans has been creating panoramas in the diptych and triptych formats, which she finds akin to the way in which one experiences the landscape, one view at a time. Her experiments with panoramas provide a new way to experience an expansive view: to enter a single frame and look around.

Presidential appointment by President Clinton to the National Council on the Arts for the National Endowment for the Arts; serves until 2002.

GROUP EXHIBITIONS

Crossing the Frontier: Photographs of the Developing West, 1849 to the Present, San Francisco Museum of Modern Art, San Francisco, CA (to 1997).

Midwestern Landscapes, Columbia College, Chicago, IL.

Plain Pictures, University of Iowa Museum of Art, Iowa City, IA.

Western Waters, Spencer Museum of Art, University of Kansas, Lawrence, KS.

PUBLICATIONS

Exhibition catalogue: *Crossing the Frontier: Photographs of the Developing West, 1849 to the Present*, by Sandra S. Phillips. San Francisco: San Francisco Museum of Modern Art.

Exhibition catalogue: *Plain Pictures: Images of the American Prairie*, by Joni Kinsey. Washington, D.C.: Smithsonian Institution Press for the University of Iowa Museum of Art.

Exhibition catalogue: *Western Waters*, by John Pultz. Lawrence, KS: Spencer Museum of Art.

1997

Photographs a book of botanical specimens collected by Anton Olsen, found in Matfield Green by Wes Jackson. Evans is fascinated by the practice of extracting, examining, and collecting individual plants. Interested in the ways this practice is connected to her other photography work, she decides to find other means to explore this idea.

After photographing botanical specimens with her Hasselblad without desirable results, Evans purchases a 4 x 5 inch view camera. "Looking through the ground glass brought me wonderment at the beauty and tactile quality of the mounted plant specimens, and the large (for me) rectangle negatives introduced me to a way to get closer in printing to the feeling of the extraordinary presence of the specimens."

Has first major solo exhibition at the Art Institute of Chicago. The exhibition opens in the fall and continues through the spring of 1998. It includes photographs from four projects: The Inhabited Prairie, Disarming the Prairie, Matfield Green, and Canada to Texas. After closing at the Art Institute of Chicago, the exhibition travels to other museums, including the Smithsonian.

SOLO EXHIBITION

In Place of Prairie: Photographs by Terry Evans, exhibition in celebration of thirty-fifth anniversary of the Open Lands Project, Art Institute of Chicago, Chicago, IL.

GROUP EXHIBITION

Crossing the Frontier: Photographs of the Developing West, 1849 to the Present, San Francisco Museum of Modern Art; Yale University Art Gallery; Phoenix Art Museum.

PUBLICATION

The Lure of the Local: Senses of Place in a Multicentered Society, by Lucy Lippard. New York: New Press.

1998

In an effort to find ways to continue her prairie work in her current urban setting, Evans begins visiting the Field Museum of Natural History in Chicago, eventually making her way to the specimen collections. Using a list of native prairie plants she collected during her work on *Prairie Images of Ground and Sky*, she goes through the museum's botanical collections with Dr. Berger, a collections manager. "I am equally moved by the beauty of both the virgin prairie and the carefully collected and preserved specimens." In the fall, she begins a series of large-format photographs of Field Museum herbarium sheets of prairie plants. Dr. Berger introduces Terry to other collections in the museum including mammals and amphibians and fishes, where she learns to use a polarizing filter as all the specimens are housed in glass jars. "My specimen photography is a kind of homage: to both the plants and creatures collected and to the collectors themselves." This specimen work continues until 2002. The photographs are made with a 4 x 5 inch camera, and usually printed on 24 x 30-inch paper, rendering the specimens about life size.

"Years ago, when my children were little, I began picking up dead birds and an occasional mouse I'd see when I was out for a walk. I'd zip these creatures into plastic bags and put them in the freezer in order to take them out later to photograph them. My daughter would be aghast when, after school, she would bring a friend home, open up the freezer for a Popsicle, and find it populated with dead birds. So, when I started working in the birds collection at The Field and discovered that they have a freezer, I felt I'd come home."

Because of her many projects and interests in Chicago, Evans suspends her frequent trips to Matfield Green.

SOLO EXHIBITIONS

Matfield Green, Ehlers Caudill Gallery, Chicago, IL.

Prairie Stories, Oregon College of Arts and Crafts, Portland, OR.

GROUP EXHIBITIONS

Contemporary Photography, Museum of Modern Art, New York, NY.

Crossing the Frontier: Photographs of the Developing West, 1849 to the Present, Tokyo Metropolitan Museum of Photography.

Land Used, Carleton College, Northfield, MN.

PUBLICATIONS

Monograph: *Disarming the Prairie*, with essay by Tony Hiss. Baltimore, MD: Johns Hopkins University Press.

Monograph: *The Inhabited Prairie*, with essay by Donald Worster. Lawrence: University Press of Kansas.

PERIODICALS

"Bombs into Blossoms," by Tony Hiss, *Preservation* 50:4 (July/August): 74–81.

"In Progress," *DoubleTake* 4:2 (Spring): 18–23.

1999

Begins work on Indivisible, a multi-artist project of the Center for Documentary Studies at Duke University in partnership with the Center for Creative Photography, Tucson, and funded by the Pew Charitable Trusts. The project explores what it means to live responsibly by providing examples from twelve communities across the United States. Evans contributes photographs for the section titled "A Forest Home." The section focuses on the Yaak Valley Forest Community in Yaak Valley, MT, a community working to overcome conflicts about logging, forest use and access, and issues of environmental recovery and sustainability. Evans continues this project through 2000.

SOLO EXHIBITION

In Place of Prairie: Photographs by Terry Evans, National Museum of Natural History, Smithsonian Institution, Washington, D.C. (through 2000).

GROUP EXHIBITIONS

Altered Landscapes, Nevada Museum of Art, Reno, NV.

As Far as the Eye Can See, Atlanta College of Art, Atlanta, GA.

PUBLICATIONS

The Altered Landscape, by Peter E. Pool. Nevada: Nevada Museum of Art in association with University of Nevada Press.

Recovering the Prairie, by Bob Sayre. Madison: University of Wisconsin Press.

PERIODICALS

"Lay of the Land," by Stephen Longmire, *Afterimage* 27:2 (September): 14.

"The Prairie under a Magnifying Glass," by Sunshine Flint, *Popular Photography* 63:5 (May): 240.

2000

Is invited to photograph the Tallgrass Prairie Preserve in Oklahoma for the Nature Conservancy project In Response to Place. For the next three years, continues to photograph for the Nature Conservancy, working in Conasauga River, GA [FIG. 31]; Poconos, PA; Nassawango Creek, MD; and Kankakee Sands, IN.

SOLO EXHIBITIONS

In Place of Prairie: Photographs by Terry Evans, Kansas City Public Library, Kansas City, MO.

Carol Ehlers Gallery, Chicago, IL.

Yancey Richardson Gallery, New York, NY.

GROUP EXHIBITIONS

Chicago in the Year 2000, Field Museum of Natural History, Chicago, IL.

Crossing the Line: Photography Reconsidered, Art Institute of Chicago, IL.

Indivisible, Terra Museum, Chicago, IL (traveling exhibition).

The Inhabited Prairie, Blue Sky Gallery, Portland, OR.

Visions of the Prairie, Center for Great Plains Study, Lincoln, NE.

Water in the West, Humboldt State University, Eureka, CA.

Wendy Cooper Gallery, Madison, WI.

PERIODICALS

"Ending Up and Landing Out in the Prairie," by Joni L. Kinsey, *Iowa Review* 30:3 (Winter): 132–44.

Iowa Review 30:1–3 (Spring/Summer, Fall, Winter), covers feature photographs by Evans.

2001

Becomes adjunct faculty in the photography department at Columbia College, Chicago, in September, and continues to present. Initially teaches only a seminar in which students spend an entire semester creating and developing a personal project; later adds a Documentary Methods class to her teaching.

SOLO EXHIBITIONS

In Place of Prairie: Photographs by Terry Evans, Center for Great Plains Studies, Lincoln, NE.

Specimens, Yancey Richardson Gallery, New York.

Dolphin Gallery, Kansas City, MO.

GROUP EXHIBITIONS

All Terrain, Contemporary Art Center of Virginia, Virginia Beach, VA.

Chicago in the Year 2000, Chicago Cultural Center, Chicago, IL.

In Response to Place, Corcoran Gallery of Art, Washington, D.C.

Indivisible: Stories of American Community, Akron Museum of Art, Akron, OH; Center for Creative Photography, Tucson, AZ; North Carolina Museum of Art, Raleigh, NC (through 2002).

This Is North America / Is This North America?, University of Rhode Island, Fine Arts Center, Kingston, RI.

This Landscape We Make, Evanston Art Center, Evanston, IL.

PUBLICATION

Exhibition catalogue: *In Response to Place: Photographs from the Nature Conservancy's Last Great Places*, by the Nature Conservancy. Boston: Bulfinch.

PERIODICALS

"Modernist Ruins," by Elizabeth Blackmar, *American Quarterly* 53:2 (June): 324–39.

"Where Bombs Were born," by Jane C. Loeffler, *Design Book Review* 44/45 (Winter/Spring): 46–49.

2002

In April, lectures at the Cedar Rapids Art Museum in Iowa. Takes a ride in a hot air balloon owned by a museum board member. The balloon floats over the suburbs, rather than the intended open landscape. She is surprised that the photographs she takes on this outing resemble an important painting to her, *The Birthplace of Herbert Hoover* (1931) by the Iowa artist Grant Wood. Intrigued by the suburban landscape, she begins to consider a photography project on Chicago.

Spends time in August in Idaho to participate in The Whole Salmon, a multi-artist project to explore the impact of the Salmon River on the nearby population and the human impact on the river.

SOLO EXHIBITIONS

Disarming the Prairie, Gaylord Building Historic Site, Lockport, IL.

From Prairie to Field: Photographs by Terry Evans, Field Museum of Natural History, Chicago, IL.

Tales from the Prairie, Yancey Richardson Gallery, New York, NY.

GROUP EXHIBITIONS

A Century of Photography, Cedar Rapids Museum of Art, Cedar Rapids, IA.

Gallery Artists 2002, Catherine Edelman Gallery, Chicago, IL.

In Response to Place, Houston Museum of Science, Houston, TX; Bellevue Art Museum, Seattle, WA; High Museum of Art, Atlanta, GA.

Indivisible: Stories of American Community, Museum of Contemporary Art, San Diego, La Jolla, CA; John and Mable Ringling Museum of Art, Sarasota, FL; Philadelphia Museum of Art, Philadelphia, PA; Anchorage Museum of History and Art, Anchorage, AK.

Masterworks of American Photography, Amon Carter Museum, Ft. Worth, TX.

Midwestern Art, U.S. Embassy, Berlin, Germany.

Natural History, Aron Packer Gallery, Chicago, IL.

Photographers, Writers, and the American Scene: Visions of Passage, Museum Photographic Arts, San Diego, CA.

The View from Here, Ludwig Museum Budapest–Museum of Contemporary Art, Budapest, Hungary, November 14, 2002–February 16, 2003.

Visions of America: Photographs from the Whitney Museum of American Art, 1940–2001, Whitney Museum of American Art, New York, NY.

What Were You Thinking?, Catherine Edelman Gallery, Chicago, IL.

What's New: Recent Acquisitions in Photography, Whitney Museum of American Art, New York, NY.

PUBLICATIONS

Exhibition catalogue: *From Prairie to Field: Photographs by Terry Evans*, Chicago: Field Museum.

Exhibition catalogue: *Photographers, Writers, and the American Scene: Visions of Passage*, by James Enyeart. Santa Fe, NM: Arena Editions.

Exhibition catalogue: *Visions of America: Photographs from the Whitney Museum of American Art*, New York: Whitney Museum of American Art.

PERIODICAL

"Terry Evans," *New Yorker* (October 7): 20, 25.

2003

Is invited by Gerald Adelmann of Openlands (with whom she worked on her project at the former Joliet Arsenal), to do an aerial survey of Chicago. The two work together on Revealing Chicago for the next three years, photographing the city and the surrounding metropolitan region in all four seasons. Evans makes forty-six flights in helicopters, hot air balloons, and Piper Cub airplanes. The project results in a large book and the photographs being exhibited in the newly opened Millennium Park, in 2005.

On the merits of her specimen work at the Field Museum, is invited by the Museum of Science and Industry to explore its collections storage area. "I was not just interested in what these objects are, but also in the careful and fine ways they were made and protected in wooden boxes, like jewels." [FIG. 32]

SOLO EXHIBITIONS

From Prairie to Field, Salina Art Center, Salina, KS; Columbus Museum of Art, Columbus, OH.

In Flight: New Views by Terry Evans, Catherine Edelman Gallery, Chicago, IL.

GROUP EXHIBITIONS

Curators Choice, Spencer Museum of Art, University of Kansas, Lawrence.

In Response to Place, Indianapolis Museum of Art, Indiana.

The Land through a Lens, Samuel P. Harn Museum of Art at University of Florida, Gainesville, FL; Art Museum at Florida International University, Miami, FL; National Museum of Wildlife Art, Jackson Hole, WY (through 2004).

Midwest Photographers Project: Tom Bamberger, Terry Evans, Paul J. Clark, Museum of Contemporary Photography, Chicago, IL (through 2004).

New to View, Art Institute of Chicago.

The View from Here, Stone Bell House, City Gallery of Prague, Prague, Czech Republic; Ohio Arts Council's Riffe Gallery, Columbus, OH; SPACES, Cleveland, Ohio; Minnesota Center for Photography, Minneapolis, MN.

The Whole Salmon, Sun Valley Center for the Arts, Sun Valley, ID.

PUBLICATIONS

Exhibition catalogue: *The Land through a Lens: Highlights from the Smithsonian American Art Museum*, by Andy Grundberg. Washington, D.C.: Smithsonian American Art Museum.

Exhibition catalogue: *The View from Here: Recent Pictures from Central Europe and the American Midwest*, by Catherine Evans. Minneapolis, MN: Arts Midwest.

Exhibition/project catalogue: *The Whole Salmon: A Multidisciplinary Commission Project*. Sun Valley, ID: Sun Valley Center for the Arts.

American Photography, by Miles Orvell. New York: Oxford University Press.

PERIODICALS

"Restoration Art," by Jennifer Hattam, *Sierra Magazine* 88:3 (May/June): 42–50.

"Terry Evans: Prairie Air," *Georgia Review* 57:2 (Summer): 268–76.

2004

GROUP EXHIBITIONS

The Altered Landscape, Presentation House Gallery, North Vancouver, BC.

FotoFest 2004: The Tenth International Month of Photography, FotoFest Biennial, Houston, TX.

In Response to Place, Chicago Cultural Center, Chicago, IL; Cincinnati Museum Center, Cincinnati, OH; Contemporary Art Center of Virginia, Virginia Beach, VA.

The Land through a Lens, Lauren Rogers Museum of Art, Laurel, MS; Louisiana Art and Science Museum, Baton Rouge, LA; Lakeview Museum of Arts and Sciences, Peoria, IL.

FIG. 31 *By the Conasauga River, Georgia,* July 2002. Inkjet print. Collection of the artist.

FIG. 32 *Museum of Science and Industry, course and distance protractor, U.S. Air Corps,* 2003. Inkjet print. Collection of the artist.

The View from Here, Erie Art Museum, Erie, PA.

The Whole Salmon, Nevada Museum of Art, Reno, NV; Prichard Art Museum, Moscow, ID.

2005

In the fall, visits a steel mill in East Chicago, Indiana, that she had studied from the air during the Revealing Chicago project. "I wanted to see what these structures contained. The dangerous and thrilling processes of steel production astonished me and I began an intense photographic exploration." Evans makes more than thirty visits to mills at Indiana Harbor, and Burns Harbor, IN; Cleveland, OH; and Coatesville, PA. Continues to photograph steel production until 2007.

After realizing certain areas of the steel mill are inaccessible to her 4 x 5 camera, begins using a medium-format Mamiya 7, which allows her to work more flexibly. She also uses it occasionally for aerial work—her first use of any format other than the 2¼-inch square.

SOLO EXHIBITION

Revealing Chicago: An Aerial Portrait, Millennium Park, Chicago, IL.

GROUP EXHIBITIONS

Homage to the Flint Hills, Spencer Museum of Art, University of Kansas, Lawrence, KS.

In Response to Place, Renaissance Center, GM Headquarters, Detroit, MI; Boston Public Library, Boston, MA; Blue Star Contemporary Art Center, San Antonio, TX; Academy Art Museum, Easton, MD.

Off the Wall: A Rotation of Gallery Artists, Catherine Edelman Gallery, Chicago, IL.

On View: Photographing the Museum, Yancey Richardson Gallery, New York City, NY.

Otherworlds, School of Fine Arts Gallery, Indiana University.

National Academy of Science, Washington, D.C.

PUBLICATIONS

Monograph: *Revealing Chicago: An Aerial Portrait.* New York: Harry N. Abrams.

2006

Receives Anonymous Was a Woman Fellowship.

SOLO EXHIBITION

Chicago's Backyards, Gallery Luisotti, Santa Monica, CA.

GROUP EXHIBITIONS

100 Great Photographs, Amon Carter Museum, Ft. Worth, TX.

The Altered Landscape, organized by Nevada Museum of Art, National Academy of Sciences, Washington, D.C.

Artists and Specimens: Documenting Contemporary Experience, Ronna and Eric Hoffman Gallery of Contemporary Art, Lewis and Clark College, Portland, OR.

Cabinets of Curiosity, Spencer Museum of Art, University of Kansas, Lawrence, KS.

Drawn, Exposed, and Impressed: Recent Works on Paper from the Cleveland Museum, Cleveland Museum of Art, Cleveland, OH.

Eyes on Collections, Los Angeles Museum of Natural History, Los Angeles, CA.

In Response to Place, Clay Center, Charleston WV; Bruce Museum of Arts and Science, Greenwich, CT (through 2007).

Land and Spirit, North Dakota Museum of Art, Grand Forks, ND.

Photographs by the Score: Personal Visions Twenty-Some Years Apart, Art Institute of Chicago, Chicago, IL.

Recent Acquisitions, Museum of Contemporary Photography, Chicago, IL.

Summer in the Central Court, Spencer Museum of Art, University of Kansas, Lawrence, KS.

Begins Prairie Scrolls project. "I decided to return to this earliest work [prairie photos from 1978–79] and to scan some of these negatives. Japanese scroll books . . . convinced me to make scrolls from my grasses pictures. In the original work, I did not include the pictures I'd made for myself of my friends and family and dogs. Now, almost thirty years later, I understand that they are part of the story, too. These scrolls are not the re-printing of earlier work; they are instead, a body of work that has required almost thirty years to become fully realized."

"In 2007 I returned to the Museum of Science and Industry. . . . I realized the collections storage areas still fascinated me most so I photographed in those rooms to show the amazing juxtapositions of objects, combinations of time and memory that puzzled and delighted me."

Ends work on steel production, turning now to the raw materials of steel. "After two years of photographing in steel mills, I'm now photographing the sources of raw materials for making steel. I've done both ground and aerial photography near Virginia, Minnesota, where iron ore is mined. These pictures raise questions about the destruction of land necessary to produce steel which feeds many of our desires." Evans continues this series until 2009.

SOLO EXHIBITIONS

From Prairie to Field: Photographs by Terry Evans, North Dakota Museum of Art, Fargo, ND; Arkansas Arts Center, Little Rock, AR.

Prairie Scrolls, Environmental Law and Policy Center, Chicago, IL.

Revealing Chicago, Clam-Gallas Palace, Prague, Czech Republic.

Terry Evans: Steel, Catherine Edelman Gallery, Chicago, IL.

GROUP EXHIBITIONS

Claimed: Land Use in Western America, Spencer Museum of Art, Lawrence, KS.

To Fly: Contemporary Aerial Photography, Boston University Art Gallery, Boston, MA.

While All the Tribes of Birds Sang: Bird and Human Relationships in Art, Illinois State Museum, Springfield, IL.

PUBLICATION

Exhibition catalogue: *To Fly: Contemporary Aerial Photography*, by Kim Sichel. Boston: Boston University Art Gallery.

2008

From June 23 to 30, travels to Greenland at the invitation of the Spencer Museum of Art, University of Kansas, to respond to the work being done by the KU Center for Remote Sensing of Ice Sheets (CReSIS). CReSIS measures the depth of ice sheets in Greenland and Antarctica to find the rate of melting and thus better understand the rate of climate change. "I could not understand what I was seeing because there were no human markers below me on the ice. . . . My own frustration in trying to understand the scale of the glacier pointed out to me that understanding the scale of climate change is equally difficult. The landscape in Greenland on Pre-Cambrian rock, where there are no trees, was splendid to my eye. I explored the fen that has a rocky path leading to the ice fjord that leads to the mouth of the glacier. I kept remembering the prairies of Kansas."

SOLO EXHIBITION

Exploring the Collection: Photographs of Terry Evans, Museum of Science and Industry, Chicago, IL.

GROUP EXHIBITIONS

Art Now, Lubnik Gallery of Art, Michigan City, MI.

Made in Chicago, Chicago Cultural Center, Chicago, IL.

Masterworks in the Collection, Amon Carter Museum, Ft. Worth, TX.

Picturing Modernity: The Photography Collection, San Francisco Museum of Modern Art, San Francisco, CA.

Remembering Dakota, North Dakota Museum of Art, Grand Forks, ND; Chazen Museum of Art, Madison, WI.

Silk Steel Clay, Dolphin Gallery, Kansas City, MO.

2009

SOLO EXHIBITIONS

A Greenland Glacier: The Scale of Climate Change, Photographs by Terry Evans, Spencer Museum of Art, University of Kansas, Lawrence, KS.

Steel, Gallery Luisotti, Santa Monica, CA.

GROUP EXHIBITION

Panoramic Prairie Landscapes, Elder Gallery, Lincoln, NE.

2010

In April, Evans and her son David, who is in Iraq, begin exchanging a digital picture every day. From this time forward, she carries a Lumix GF1 camera with her everywhere. "The photo exchange has opened me to looking at the world in a way that is not just project-oriented. Similarly to when I began photography, I am once again looking at the world in a way in which anything might be a picture. This is not only fun, but good exercise."

GROUP EXHIBITIONS

On the Road: A Legacy of Walker Evans, Lehman Art Center, Brooks School, Andover, MA.

Poetics of Space, Kemper Museum of Contemporary Art, Kansas City, MO.

Proof, Catherine Edelman Gallery, Chicago, IL.

PUBLICATIONS

Exhibition catalogue: *On the Road: A Legacy of Walker Evans*. North Andover, MA: Robert Lehman Art Center.

A New American Photographic Dream: Us Today After, by Gilles Mora. Milan: Silvana.

2011

Begins a project in North Dakota with the writer Elizabeth Farnsworth exploring the oil boom in the White Earth Valley near Williston. They approach this subject from many angles, focusing on the complexities of the politics of land use, and how oil and gas extraction is affecting the people and the prairie.

Begins using a digital camera for the first time (Canon 5D Mark 2) for serious work, in addition to her film cameras.

SOLO EXHIBITION

Matfield Green, Ulrich Museum of Art, Wichita, KS.

GROUP EXHIBITIONS

The Altered Landscape, Nevada Museum of Art, Reno, NV.

Beautiful Vagabonds, Yancey Richardson Gallery, New York, NY.

Earth Now: American Photographers and the Environment, New Mexico Museum of Art, Santa Fe, NM.

Eye Wonder, from the Bank of America Collection, National Museum of Women in the Arts, Washington, D.C.

Masterworks, Amon Carter Museum of American Art, Ft. Worth, TX.

Public Works, Museum of Contemporary Photography, Chicago, IL.

Winged Shadows, North Dakota Museum of Art, Grand Forks, ND.

PUBLICATIONS

Exhibition catalogue: *The Altered Landscape: Photographs of a Changing Environment*, by Ann M. Wolfe, David B. Walker, et al. New York: Skira Rizzoli.

Exhibition catalogue: *Earth Now: American Photographers and the Environment*, by Katherine Ware. Santa Fe: Museum of New Mexico Press.

2012

Returns to North Dakota to photograph in April, May, and August

SOLO EXHIBITIONS

Heartland: The Photographs of Terry Evans, The Nelson-Atkins Museum of Art, Kansas City, MO.

Catherine Edelman Gallery, Chicago, IL.

PUBLICATIONS

Monograph: *Terry Evans: Prairie Stories*. Santa Fe: Radius Books.

Monograph: *Heartland: The Photographs of Terry Evans*. Kansas City: Hall Family Foundation / The Nelson-Atkins Museum of Art.

SOURCES AND INFLUENCES

A Personal Bibliography

BY TERRY EVANS

Abbey, Edward. *Desert Solitaire: A Season in the Wilderness*. New York: McGraw Hill, 1968.

Adam, Hans Christian. *Karl Blossfeldt: 1865–1932*. Cologne: Taschen, 1999.

Adams, Robert. *From the Missouri West: Photographs*. New York: Aperture, 1980.

Adams, Robert. *Prairie: Photographs*. Denver: Denver Art Museum, 1978.

Adams, Robert. *Summer Nights, Walking: Along the Colorado Front Range, 1976–1982*. New Haven, CT, and New York: Yale University Art Gallery / Aperture, 2009.

Adams, Robert. *Turning Back*. San Francisco: Fraenkel Gallery, 2005.

Adams, Robert. *What We Bought: The New World: Scenes from the Denver Metropolitan Areas, 1970–1974*. Hanover: Stiftung Niedersachsen, 1995.

Adams, Robert, and William Stafford. *Listening to the River: Seasons in the American West*. New York: Aperture, 1994.

Agee, James, and Walker Evans. *Let Us Now Praise Famous Men*. New York: Ballatine Books, 1970.

Ambrose, Stephen E. *Undaunted Courage: Meriwether Lewis, Thomas Jefferson, and the Opening of the American West*. New York: Simon and Schuster, 1996.

Arthus-Bertrand, Yann. *Earth from Above*. New York: Abrams, 2002.

Aujoulat, Norbert. *Lascaux: Movement, Space, and Time*. New York: Abrams, 2005.

Avedon, Richard. *In the American West, 1979–1984*. New York: Abrams, 1985.

Aymonin, Gérard G. *The Besler Florilegium: Plants of the Four Seasons*. 1987. New York: Abrams, 1989.

Bartlett, Richard A. *Great Surveys of the American West*. Norman: University of Oklahoma Press, 1962.

Bateson, Gregory. *Mind and Nature: A Necessary Unity*. New York: Dutton, 1979.

Bateson, Gregory, and Margaret Mead. *Balinese Character: A Photographic Analysis*. New York: New York Academy of Sciences, 1942.

Bätzner, Nike. *Masters of Italian Art: Andrea Mantegna*. Cologne: Könemann, 1998.

Beck, Peggy V., and A. L. Walters. *The Sacred: Ways of Knowledge, Sources of Life*. Tsaile, AZ: Navajo Community College Press, 1977.

Behler, John L., and F. Wayne King. *National Audubon Society Field Guide to North American Reptiles and Amphibians*. New York: Knopf, 2000.

Berger, John, Sven Blomberg, Chris Fox, Michael Dibb, and Richard Hollis. *Ways of Seeing*. Harmondsworth, UK: Penguin Books, 1972.

Berger, Paul, Leroy Searle, and Douglas Wadden. *Radical Rational Space Time: Idea Networks in Photography*. Seattle: Henry Gallery, University of Washington, 1983.

Bergon, Frank, ed. *The Journals of Lewis and Clark*. New York: Penguin Books, 1989.

Berry, Wendell. *Jayber Crow: The Life Story of Jayber Crow, Barber, of the Port William Membership, as Written by Himself; a novel*. Washington, D.C.: Counterpoint, 2000.

Berry, Wendell. *Watch with Me: And Six Other Stories of the Yet-Remembered Ptolemy Proudfoot and His Wife, Miss Minnie, née Quinch*. New York: Pantheon Books, 1994.

Bodsworth, Fred. *Last of the Curlews*. Washington, D.C.: Counterpoint, 1995.

Bull, John, and John Farrand Jr. *National Audubon Society Field Guide to North American Birds: Eastern Region*. New York: Knopf, 2000.

Burnham, Daniel H., Edward H. Bennett, and Kristen Schaffer. *Plan of Chicago*. New York: Princeton Architectural Press, 1993.

Cahan, Richard, and Michael Williams. *The Lost Panoramas: When Chicago Changed Its River and the Land Beyond*. Chicago: CityFiles Press, 2011.

Callahan, Harry. *Harry Callahan*. New York: Museum of Modern Art, 1967.

Callahan, Harry, and A. R. Ammons. *Water's Edge*. Lyme, CT: Callaway Editions, 1980.

Cather, Willa. *My Ántonia*. Boston: Houghton Mifflin, 1970.

Cather, Willa. *O Pioneers!* 1913. Reprint, Boston: Houghton Mifflin, 1988.

Catlin, George. *Letters and Notes on the Manners, Customs, and Conditions of the North American Indians; written during eight years' travel (1831–1839) amongst the wildest tribes of Indians in North Amnerica*. New York: Dover, 1973.

The Chinese Exhibition: A Pictorial Record of the Exhibition of Archaeological Finds of the People's Republic of China. Kansas City, MO: Nelson Gallery–Atkins Museum, 1975.

Conniff, Gregory. *Common Ground: An American Field Guide*. New Haven, CT: Yale University Press, 1985.

Corrin, Lisa Graziose, Miwon Kwon, and Norman Bryson. *Mark Dion*. New York: Phaidon, 1997.

Crane, Barbara, Estelle Jussim and Paul Vanderbilt. *Barbara Crane: Photographs 1948–1980*. Tucson, AZ: Center for Creative Photography, 1981.

Crawford, William. *The Keepers of Light: A History and Working Guide to Early Photographic Processes*. Dobbs Ferry, NY: Morgan and Morgan, 1979.

Cronon, William. *Changes in the Land: Indians, Colonists, and the Ecology of New England*. New York: Hill and Wang, 1983.

Cronon, William. *Nature's Metropolis: Chicago and the Great West*. New York: W. W. Norton, 1991.

Crosby, Alfred W., Jr., and Otto von Mering. *The Columbian Exchange: Biological and Cultural Consequences of 1492*. Westport, CT: Greenwood, 1972.

Curtis, Gregory. *The Cave Painters: Probing the Mysteries of the World's First Artists*. New York: Knopf, 2006.

Davis, Keith F. *An American Century of Photography: From Dry-Plate to Digital*. Kansas City, MO: Hallmark Cards Inc. in association with Harry N. Abrams, 1999.

Davis, Keith F. *American Horizons: The Photographs of Art Sinsabaugh*. Manchester, VT: Hudson Hills, 2004.

Davis, Keith F., and Jane L. Aspinwall. *The Origins of American Photography: From Daguerreotype to Dry-Plate, 1839–1885*. Kansas City, MO: Hall Family Foundation/Nelson-Atkins Museum of Art, 2007.

Davis, Keith F., and Jane L. Aspinwall, with François Brunet, John P. Herron, and Mark Klett. *Timothy H. O'Sullivan: The King Survey Photographs*. Kansas City, MO: Hall Family Foundation/Nelson-Atkins Museum of Art, 2011.

Dillard, Annie. *Teaching a Stone to Talk: Expeditions and Encounters*. New York: Harper and Row, 1982.

Dinesen, Isak. *Last Tales*. New York: Vintage Books, 1975.

Eliade, Mircea. *The Sacred and the Profane: The Nature of Religion. The Significance of Religious Myth, Symbolism, and Ritual within Life and Culture*. New York: Harvest, 1957.

Epstein, Mitch. *American Power*. Göttingen, Steidl, 2009.

Evans, Roy H., R. Evelyn Ross, and Lyle Ross. *Mimbres Indian Treasure in the Land of Baca: Excavating an Ancient Pueblo Ruin*. Kansas City, MO: Lowell, 1985.

Findlen, Paula. *Possessing Nature: Museums, Collecting, and Scientific Culture in Early Modern Italy*. Berkeley: University of California Press, 1994.

Foresta, Merry A., and Jeana K. Foley. *At First Sight: Photography and the Smithsonian*. Washington, D.C.: Smithsonian Books, 2003.

Foshay, Ella A. *Reflections of Nature: Flowers in American Art*. New York: Alfred A. Knopf, 1994.

Foster-Rice, Greg, and John Rohrbach. *Reframing the New Topographics*. Chicago: Center for American Places at Columbia College Chicago, 2010.

Foucault, Michel. *The Order of Things: An Archaeology of the Human Sciences*. New York: Vintage Books, 1994.

Fox, William L. *Aereality: Essays on the World from Above*. Berkeley, CA: Counterpoint, 2009.

Fox, William L. *Driving to Mars*. Emeryville, CA: Shoemaker and Hoard, 2006.

Frank, Robert. *The Americans*. New York: Aperture, 1969.

Frank, Waldo, Lewis Mumford, Dorothy Norman, Paul Rosenfeld, and Harold Rugg, eds. *America and Alfred Stieglitz: A Collective Portrait*. New York: Doubleday, Doran and Co., 1934.

Galassi, Peter. *Henri Cartier-Bresson: The Early Work*. New York: Museum of Modern Art, 1987.

Galvin, James. *The Meadow*. New York: Harry Holt, 1992.

Garnett, William, and Martha A. Sandweiss. *William Garnett: Aerial Photographs*. Berkeley: University of California Press, 1994.

Gates, Frank C. *Grasses in Kansas. Kansas State Board of Agriculture, Report 220-A*. Topeka: Kansas State Board of Agriculture, 1937.

Gates, Frank C. *Wildflowers in Kansas. Kansas State Board of Agriculture, Report 204-B*. Topeka: Kansas State Board of Agriculture, 1932.

Gilligan, Carol. *In a Different Voice: Psychological Theory and Women's Development*. Cambridge, MA: Harvard University Press, 1982.

Gilmore, Melvin R. *Uses of Plants by the Indians of the Missouri River Region*. Lincoln: University of Nebraska Press, 1977.

Goetzmann, William H. *Army Exploration in the American West 1803–1863*. Lincoln: University of Nebraska Press, 1959.

Goetzmann, William H., David C. Hunt, Marsha V. Gallagher, William J. Orr. *Karl Bodmer's America*. Lincoln: Joslyn Art Museum and University of Nebraska Press, 1984.

Gohlke, Frank. *Thoughts on Landscape: Collected Writings and Interviews*. Tucson, AZ: Hol Art Books, 2009.

Goin, Peter. *Nuclear Landscapes*. Baltimore, MD: Johns Hopkins University Press, 1991.

Goldberg, Jim. *Open See*. Göttingen, Germany: Steidl, 2009.

Goodman, Mark. *A Kind of History: Millerton, New York 1971–1991*. San Francisco: Markerbooks/Custom & Ltd. Editions, 1999.

Goodrich, Norma Lorre. *Ancient Myths: A Vivid Re-creation of the Great Myths of Mankind from Ancient Sumer to Imperial Rome*. New York: Mentor, 1960.

Gowin, Emmet. *Emmet Gowin: Photographs*. Philadelphia: Philadelphia Museum of Art, 1990.

Gruchow, Paul. *The Necessity of Empty Places*. New York: St. Martin's, 1988.

Grundberg, Andy, and Kathleen McCarthy Gauss. *Photography and Art: Interactions since 1946*. New York: Cross River/Abbeville Press, 1987.

Guy, John, Jorrit Britschgi. *Wonder of the Age: Master Painters of India 1100–1900*. New York: Metropolitan Museum of Art, 2011.

Hendrickson, Paul. *Looking for the Light: The Hidden Life and Art of Marion Post Wolcott*. New York: Alfred A. Knopf, 1992.

Hirsh, Edward. *The Demon and the Angel: Searching for the Source of Artistic Inspiration*. Orlando: Harcourt, 2002.

Hiss, Tony. *The Experience of Place: A New Way of Looking at and Dealing with Our Radically Changing Cities and Countryside*. New York: Vintage Books/Random House, 1990.

Hitchcock, A. S. and Agnes Chase. *Manual of the Grasses of the United States*. 2nd ed. Edited by Agnes Chase. Washington, D.C.: United States Government Printing Office, 1950.

Huxley, Aldous. *The Art of Seeing*. Seattle: Montana Books, 1978.

Ivins, William M., Jr. *Prints and Visual Communication*. Cambridge, MA: MIT Press, 1969.

Jackson, John Brinckerhoff. *Discovering the Vernacular Landscape*. New Haven, CT: Yale University Press, 1984.

Jackson, John Brinckerhoff. *A Sense of Place, a Sense of Time*. New Haven, CT: Yale University Press, 1994.

Jackson, Wes. *Altars of Unhewn Stone: Science and the Earth*. San Francisco: North Point, 1987.

Jackson, Wes. *Becoming Native to This Place*. Lexington: University Press of Kentucky, 1994.

Jackson, Wes. *New Roots for Agriculture*. San Francisco: Friends of the Earth, 1980.

Jenny, Hans. *Kymatik=Cumatics*. Basel: Basilius Presse, 1974.

Johnson, Elmer W., and Donald L. Miller. *Chicago Metropolis 2020: The Chicago Plan for the Twenty-First Century*. Chicago: University of Chicago Press, 2001.

Jussim, Estelle, and Elizabeth Lindquist-Cock. *Landscape as Photograph*. New Haven, CT: Yale University Press, 1985.

Kadloubovsky, E., and G. E. H. Palmer, trans. *Writings from the Philokalia on Prayer of the Heart*. London: Faber and Faber, 1979.

Kanter, Laurence, and Pia Palladino. *Fra Angelico*. New York: Metropolitan Museum of Art, 2005.

Kindscher, Kelly. *Edible Wild Plants of the Prairie: An Ethnobotanical Guide*. Lawrence: University Press of Kansas, 1987.

Klett, Mark, and William L. Fox. *The Half Life of History*. Santa Fe, NM: Radius Books, 2011.

Klett, Mark, Patricia Nelson Liverick, and Thomas W. Southall. *Revealing Territory: Photographs of the Southwest by Mark Klett*. Albuquerque: University of New Mexico Press, 1992.

Kohl, Judith, and Herbert Kohl. *The View from the Oak: The Private Worlds of Other Creatures*. San Francisco: Sierra Club Books, 1977.

Koreny, Fritz. *Albrecht Dürer and the Animal and Plant Studies of the Renaissance*. Boston: Little, Brown, 1988.

Kurth, Willi, ed. *The Complete Woodcuts of Albrecht Dürer*. New York: Dover Publications, 1963.

Lange, Dorothea, and Beaumont Newhall. *Dorothea Lange Looks at the American Country Woman*. Ft. Worth: Amon Carter Museum Press, 1967.

Larson, Erik. *The Devil in the White City: Murder, Magic, and Madness at the Fair That Changed America*. New York: Crown Publishers, 2003.

Laskowski, Birgit. *Piero della Francesca, 1416/17–1492*. Köln: Könemann, 1998.

Le Clézio, J. M. G. *Desert*. Ann Arbor, MI: Sheridan Books, 2009.

Lippard, Lucy R. *The Lure of the Local: Senses of Place in a Multicentered Society*. New York: New Press, 1997.

Little, Elbert L. *The Audubon Society Field Guide to North American Trees: Eastern Region*. New York: Alfred A. Knopf, 1980.

Lopez, Barry. *The Rediscovery of North America*. New York: Vintage Books, 1992.

Lopez, Barry Holstun. *Desert Notes: Reflections in the Eye of a Raven*. New York: Avon Books, 1976.

Mann, Charles C. *1493: Uncovering the New World Columbus Created*. New York: Alfred A. Knopf, 2011.

Manning, Richard. *Grassland: The History, Biology, Politics, and Promise of the American Prairie*. New York: Penguin Books, 1995.

Matthiessen, Peter. *The Snow Leopard*. New York: Penguin Books, 1987.

McCarthy, Cormac. *All the Pretty Horses*. New York: Alfred A. Knopf, 1993.

McGrath, Thomas. *Letter to an Imaginary Friend*. Port Townsend, WA: Copper Canyon Press, 1997.

McHarg, Ian L. *Design with Nature*. New York: J. Wiley, 1992.

McKelvey, Susan Delano,. *Botanical Exploration of Trans-Mississippi West 1790–1850*. Corvallis, Or.: Oregon State University Press, 1991.

McKinney, Rhondal. *An Open Land: Photographs of the Midwest, 1852–1982*. Chicago: Open Lands Project, 1983.

McMurtry, Larry. *All My Friends Are Going to Be Strangers*. New York: Pocket Books, 1973.

McMurtry, Larry. *Lonesome Dove*. New York: Pocket Books, 1986.

Meine, Curt, ed. *Wallace Stegner and the Continental Vision: Essays on Literature, History, and Landscape*. Washington, D.C.: Island Press, 1997.

Merton, Thomas. *New Seeds of Contemplation*. Norfolk, Conn.: New Directions, 1961.

Monet's Years at Giverny: Beyond Impressionism. New York: Metropolitan Museum of Art, 1978.

Morris, Errol. *Believing Is Seeing: Observations on the Mysteries of Photography*. New York: Penguin Press, 2011.

Morris, Wright. *The Field of Vision*. New York: Harcourt, Brace, 1956.

Morris, Wright. *God's Country and My People*. New York: Harper and Row, 1968.

Morris, Wright. *The Home Place*. New York: Charles Scribner's Sons, 1948.

Morris, Wright. *The Inhabitants*. New York: Charles Scribner's Sons, 1946.

Morris, Wright. *Wright Morris: A Reader*. New York: Harper and Row, 1942.

Morrison, Philip, Phylis Morrison. *Powers of Ten: A Book About the Relative Size of Things in the Universe and the Effect of Adding Another Zero*. New York: Scientific American Library, 1994.

Milne, Lorus, and Margery Milne. *National Audubon Society Field Guide to North American Insects and Spiders*. New York: A. A. Knopf, 2000.

Muybridge, Eadweard. *Horses and Other Animals in Motion: 45 Classic Photographic Sequences*. New York: Dover Publications, 1985.

Muybridge, Eadweard. *The Male and Female Figure in Motion: 60 Classic Photographic Sequences*. New York: Dover Publications, 1984.

Neihardt, John G. *Black Elk Speaks: Being the Life Story of a Holy Man of the Oglala Sioux*. New York: Pocket Books, 1977.

Newhall, Beaumont. *Airborne Camera: The World from the Air and Outer Space*. New York: Hastings House, 1969.

Newhall, Beaumont. *The History of Photography: From 1839 to Present Day*. New York: Museum of Modern Art, 1964.

Nordenfalk, Carl. *Celtic and Anglo-Saxon Painting: Book Illumination in the British Isles, 600-800*. New York: George Braziller, 1977.

Ouspensky, Leonid, and Vladimir Lossky. *The Meaning of Icons*. Crestwood, NY: St. Vladimir's Seminary Press, 1982.

Owensby, Clenton E. *Kansas Prairie Wildflowers*. Ames: Iowa State University Press, 1980.

Pamuk, Orhan. *My Name Is Red*. Translated by Erdag M. Göknar. New York: Vintage International, 2001.

Pasture and Range Plants. Hays, KS: Ft. Hays State University, 1986.

Peterson, Roger Tory. *A Field Guide to the Birds: A Completely New Guide to All the Birds of Eastern and Central North America*. Boston: Houghton Mifflin Company, 1980.

Peterson, Roger Tory. *A Field Guide to Western Birds: A Completely New Guide to Field Marks of All Species Found in North America West of the 100th Meridian and North of Mexico*. Boston: Houghton Mifflin, 1990.

Phillips, Sandra S., and John Szarkowski. *Wright Morris: Origin of a Species*. San Francisco: San Francisco Museum of Modern Art, 1992.

Piranese, Giovanni Battista. *The Prisons (Le Carceri)*. New York: Dover Publications, 1973.

Pirsig, Robert M. *Zen and the Art of Motorcycle Maintenance: An Inquiry into Values*. New York: Morrow Quill Paperbacks, 1979.

Pol de Limbourg, Jean Colombe, Jean Longnon, Raymond Cazelles, and Jean de France Berry. *The Très Riches heures of Jean, Duke of Berry*. New York: George Braziller, 1989.

Poling-Kempes, Lesley. *Valley of Shining Stone: The Story of Abiquiu*. Tucson: University of Arizona Press, 1997.

Prigogine, Ilya. *Order Out of Chaos: Man's New Dialogue with Nature*. New York: Bantam Books, 1984.

Proulx, Annie. *Close Range: Wyoming Stories*. New York: Simon and Schuster, 1999.

Quermann, Andreas. *Domenico di Tommaso di Currado Bigordi Ghirlandaio: 1449–1494*. Köln: Könemann, 1998.

Reichman, O. J. *Konza Prairie: A Tallgrass Natural History*. Lawrence: University Press of Kansas, 1987.

Robinson, Marilynne. *Gilead*. New York: Farrar, Straus and Giroux, 2004.

Sacks, Oliver W.. *The Man Who Mistook His Wife for a Hat and other clinical tales*. New York: Perennial Library, 1987.

Sander, August, Gunther Sander, and Golo Mann. *Men without Masks: Faces of Germany 1910–1938*. Translated by Maureen Oberli-Turner. Greenwich, CT: New York Graphic Society, 1971.

Sandoz, Mari. *The Story Catcher*. New York: Tempo Books, 1963.

Scarry, Elaine. *On Beauty and Being Just*. Princeton: Princeton University Press, 1999.

Sheeler, Charles, and William Carlos Williams. *Charles Sheeler: Paintings, Drawings, Photographs*. New York: Museum of Modern Art, 1939.

Sebald, Winfried G. *The Emigrants*. Translated by Michael Hulse. London: Harvill Press, 1996.

Smith, C. Lavett. *National Audubon Society First Field Guide: Fishes*. New York: Scholastic, 2000.

Solnit, Rebecca. *River of Shadows: Eadweard Muybridge and the Technological Wild West*. New York: Penguin Books, 2004.

Solnit, Rebecca. *Storming the Gates of Paradise: Landscapes for Politics*. Berkeley: University of California Press, 2007.

Solnit, Rebecca. *Wanderlust: A History of Walking*. New York: Penguin Books, 2000.

Sontag, Susan. *On Photography*. New York: Farrar, Straus and Giroux, 1977.

Stebbins, Theodore E., Jr., Gilles Mora, and Karen E. Haas. *The Photography of Charles Sheeler: American Modernist*. Boston: Bulfinch Press, 2002.

Stidworthy, John. *Snakes of the World*. Toronto: Bantam Books, 1971.

Storm, Hyemeyohsts. *Seven Arrows*. New York: Ballantine Books, 1972.

Stott, William. *Documentary Expression and Thirties America*. Chicago: University of Chicago Press, 1986.

Stryker, Roy Emerson, and Nancy C. Wood. *In This Proud Land: America 1935–1943 as seen in the FSA photographs*. New York: Galahad Books, 1973.

Szarkowski, John. *American Landscapes: Photographs from the Collection of the Museum of Modern Art*. New York: Museum of Modern Art, 1981.

Szarkowski, John. *The Idea of Louis Sullivan*. Minneapolis: University of Minnesota Press, 1956.

Szarkowski, John. *Looking at Photographs: 100 Pictures from the Collection of the Museum of Modern Art*. New York: Museum of Modern Art, 1973.

Szarkowski, John. *Mirrors and Windows: American Photography since 1960*. New York: Museum of Modern Art, 1978.

Szarkowski, John. *The Photographer's Eye*. New York: Museum of Modern Art, 1966.

Szarkowski, John. *Photography until Now*. New York: Museum of Modern Art, 1989.

Szarkowski, John. *Walker Evans*. New York: Museum of Modern Art, 1971.

Szarkowski, John, and Maria Morris Hambourg. *The Work of Atget. Vol. 1, Old France*. New York: Museum of Modern Art, 1981.

Szarkowski, John, and Maria Morris Hambourg. *The Work of Atget. Vol. 3, The Ancien Régime*. New York: Museum of Modern Art, 1983.

Szarkowski, John, and Maria Morris Hambourg. *The Work of Atget. Vol. 4, Modern Times*. New York: Museum of Modern Art, 1985.

Thomas, Lewis. *The Medusa and the Snail: More Notes of a Biology Watcher*. New York: Viking Press, 1979.

Pol de Limbourg, Jean Colombe, Jean Longnon, Raymond Cazelles, and Jean de France Berry. Tsujimoto, Karen. *Images of America: Precisionist Painting and Modern Photography*. Seattle: University of Washington Press, 1982.

Tuan, Yi-Fu. *Topophilia: A Study of Environmental Perception, Attitudes, and Values*. New York: Columbia University Press, 1974.

Tucker, Anne Wilkes, and Ray K. Metzker. *Unknown Territory: Photographs by Ray K. Metzker*. Millerton, New York: Aperture, 1984.

Tufte, Edward R. *The Visual Display of Quantitative Information*. Cheshire, CT: Graphics Press, 2001.

Von der Haegen, Anne Mueller. *Giotto di Bondone: um 1267–1337*. Köln: Könemann, 1998.

Waldrop, Mitchell. *Complexity: The Emerging Science at the Edge of Order and Chaos*. New York: Simon and Schuster, 1992.

Walker, Susan, Morris Bierbrier, Paul Roberts, and John Taylor. *Ancient Faces: Mummy Portraits from Roman Egypt*. London: British Museum Press, 1997.

Ware, Chris. *Jimmy Corrigan: The Smartest Kid on Earth*. New York: Pantheon Books, 2000.

Weaver, John E., and T. J. Fitzpatrick. *The Prairie*. Vol. 4, No. 2 of Ecological Monographs. 1934. Reprint, Durham: Duke University Press, 1980.

Webb, Walter Prescott. *The Great Plains*. Lincoln, NE: University of Nebraska Press, 1981.

Weiss, John, ed. *Venus, Jupiter and Mars: The Photographs of Frederick Sommer*. Wilmington: Delaware Art Museum, 1980.

Wells, Liz. *Land Matters: Landscape Photography, Culture and Identity*. New York: I. B. Tauris, 2011.

Weschler, Lawrence. *Mr. Wilson's Cabinet of Wonder*. New York: Vintage Books, 1995.

Westerbeck, Colin, Joe Deal, Susan Laxon, and Jason Weems. *Seismic Shift: Lewis Baltz, Joe Deal, and California Landscape Photography, 1944–1984*. Riverside: University of California Press, 2011.

Wheelock, Arthur K., Jr. and Fredrik J. Duparc. *Johannes Vermeer*. Washington, D.C.: National Gallery of Art, 1995.

Whitaker, John O., Jr. *National Audubon Society Field Guide to North American Mammals*. 2nd ed. New York: Alfred A. Knopf, 1996.

Wolfe, Ann M. *The Altered Landscape: Photographs of a Changing Environment*. New York: Skira Rizzoli, 2011.

Wood, Denis, and John Fels. *The Power of Maps*. New York: Guilford Press, 1992.

Worster, Donald. *Nature's Economy: The Roots of Ecology*. Garden City, NY: Anchor Books, 1979.

Worster, Donald. *A River Running West: The Life of John Wesley Powell*. New York: Oxford University Press, 2001.

Worster, Donald. *Rivers of Empire: Water, Aridity and the Growth of the American West*. New York: Pantheon Books, 1985.

Zim, Herbert S., and Hobart M. Smith. *Reptiles and Amphibians: A Guide to Familiar American Species*. New York: Golden Press, 1953.